Royal Nova Scotia International Tattoo

Also by Simon Falconer

**Canada's Black Watch: An Illustrated History
of the Regular Force Battalions 1951-1970**

Royal Nova Scotia International Tattoo

by SIMON FALCONER

GOOSE LANE EDITIONS

All photos courtesy of the Royal Nova Scotia International Tattoo.
Dust jacket photographs courtesy of the Royal Nova Scotia International Tattoo.
Cover design by Julie Scriver.
Book design by Jaye Haworth.
Printed in Canada.
10 9 8 7 6 5 4 3 2 1

Library and Archives Canada Cataloguing in Publication

Falconer, Simon
 Royal Nova Scotia International Tattoo / Simon Falconer.

Includes index.
ISBN 978-0-86492-620-3 — ISBN 978-0-86492-636-4 (leather bound) —
ISBN 978-0-86492-637-1 (cased)

 1. Royal Nova Scotia International Tattoo — History — Pictorial works. I. Title.

GT4013.H34F35 2010 791.6 C2010-900698-4

Goose Lane Editions acknowledges the financial support of the Canada Council for the Arts, the Government of Canada through the Book Publishing Industry Development Program (BPIDP), and the New Brunswick Department of Wellness, Culture and Sport for its publishing activities.

Goose Lane Editions
Suite 330, 500 Beaverbrook Court
Fredericton, New Brunswick
CANADA E3B 5X4
www.gooselane.com

Dedication

To the performers, staff, and crew who,
over the past three decades, have made the
Royal Nova Scotia International Tattoo
into an event that can stand
with any in the world.

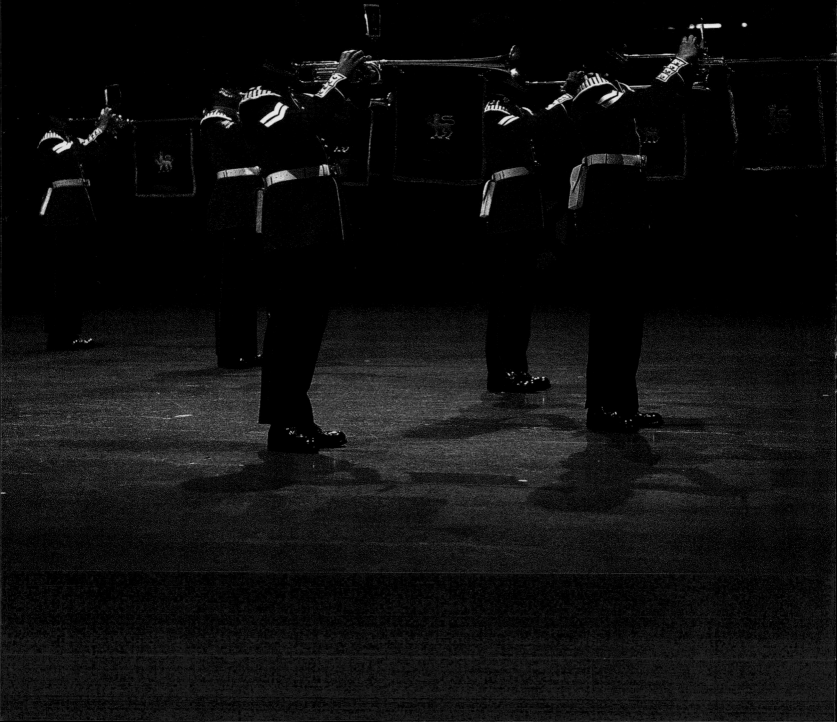

CONTENTS

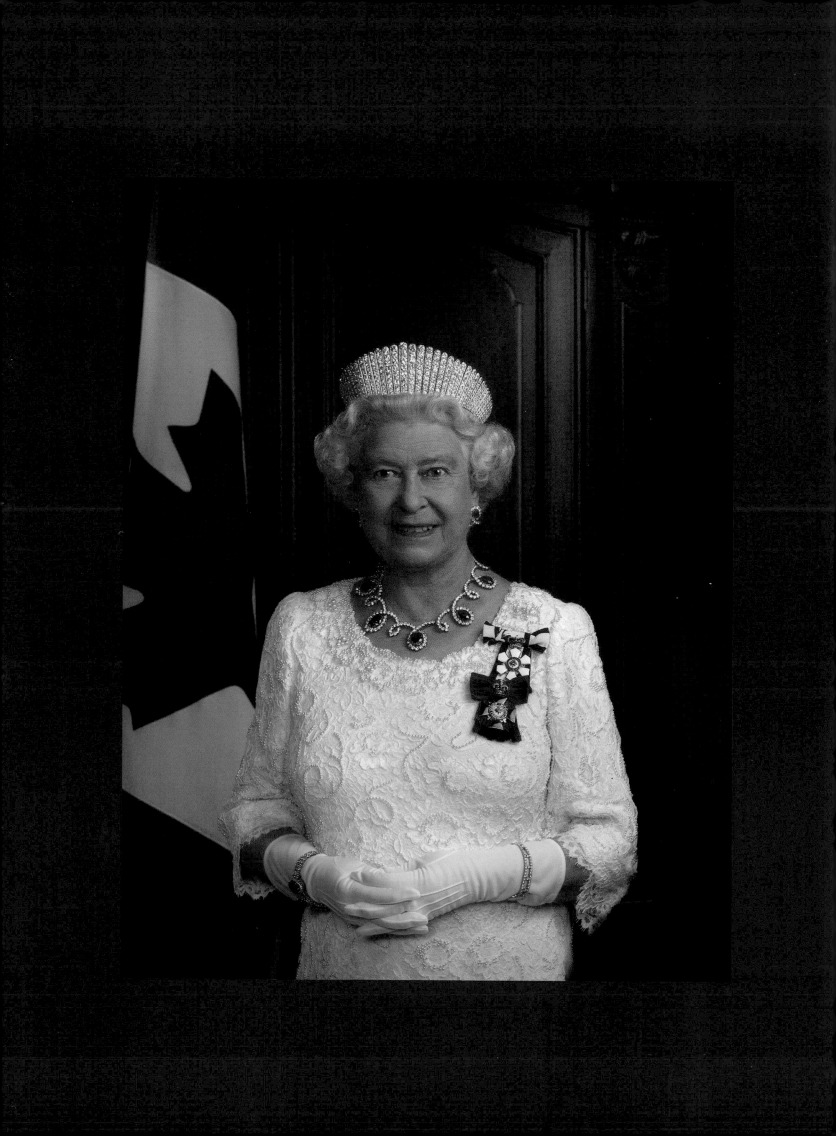

Over the past thirty years, the Royal Nova Scotia International Tattoo has been a source of great pride, not only for Canadians but for all those who have been involved from around the world.

A truly international undertaking, the Tattoo has strengthened the bond of friendship between countries and between the military and civilian communities since it was first opened in 1979 by my mother, Queen Elizabeth.

Over the years, the Tattoo has grown in scope, excitement, and splendour, but it has never lost the thread of family and friendship that runs through it, thanks to the dedicated work of some 2,000 old and new friends who come together every year to help with the organisation. Indeed, members of my own family have attended the show on four occasions.

As the Royal Nova Scotia International Tattoo embarks on the next thirty years of entertainment, culture, and education, it is encouraging to see that the spirit of internationalism, combined with a very special sense of Canadian pride, is thriving in Nova Scotia in such a colourful, vibrant, and spectacular fashion.

My sincere thanks go to everyone who is associated with this impressive undertaking.

Elizabeth R

Why Is It Called "TATTOO"?

It all goes back to the drum, the universal military instrument that signalled soldiers what to do.

British armies in the seventeenth-century Low Countries — now the Netherlands and Belgium — seldom campaigned in the winter. Instead the soldiers were often billeted in the towns and villages around the site of their last campaign and, like soldiers everywhere, they spent their evenings drinking in the public houses, inns, and taverns.

To signal the soldiers to return to their billets, a single drummer would march through villages and towns, beating a call that ordered innkeepers to turn off their taps. The Flemish term for the drummer's call was "doe den tap toe," which meant simply "turn off the taps." This was eventually shortened to "tap toe" and later, perhaps because of the sound of the drum, it became "Tattoo," a term the British Army has retained through the centuries.

Drummers from the Band of Her Majesty's Royal Marines
Portsmouth from the United Kingdom

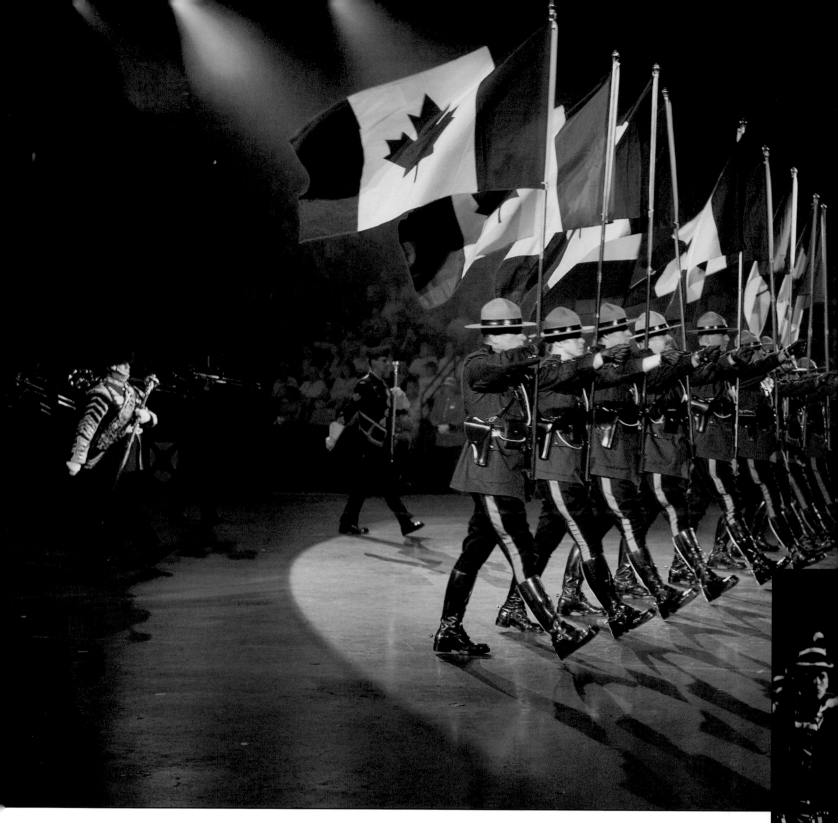

▲ The Royal Canadian Mounted Police

▶ Marching through the streets calling out "Doe Den Tap Toe"

In time, bands were added, and the ceremony evolved from a simple signal to close the taverns to a military display. By the 1930s, these productions reached their zenith in England with massive Tattoo performances at Aldershot and Tidworth featuring thousands of musicians and soldiers in some of the largest costumed historic pageants ever seen.

Times change.

Now Tattoo heralds the amazing and unique entertainment of the Royal Nova Scotia International Tattoo, with its marching bands, music, pipers, drummers, acrobats, dancers, and military competitions. Hundreds of Canadian and international military and civilian performers make the Royal Nova Scotia International Tattoo the world's largest annual indoor show.

As might be expected, the approach taken by the Royal Nova Scotia International Tattoo has raised the eyebrows of a few "Tattoo Traditionalists." One was heard to say, after seeing the show, "I admit I enjoyed it, but whatever it is, it certainly is not a Tattoo."

He was right about that.

A Tattoo is one drummer marching through the streets.

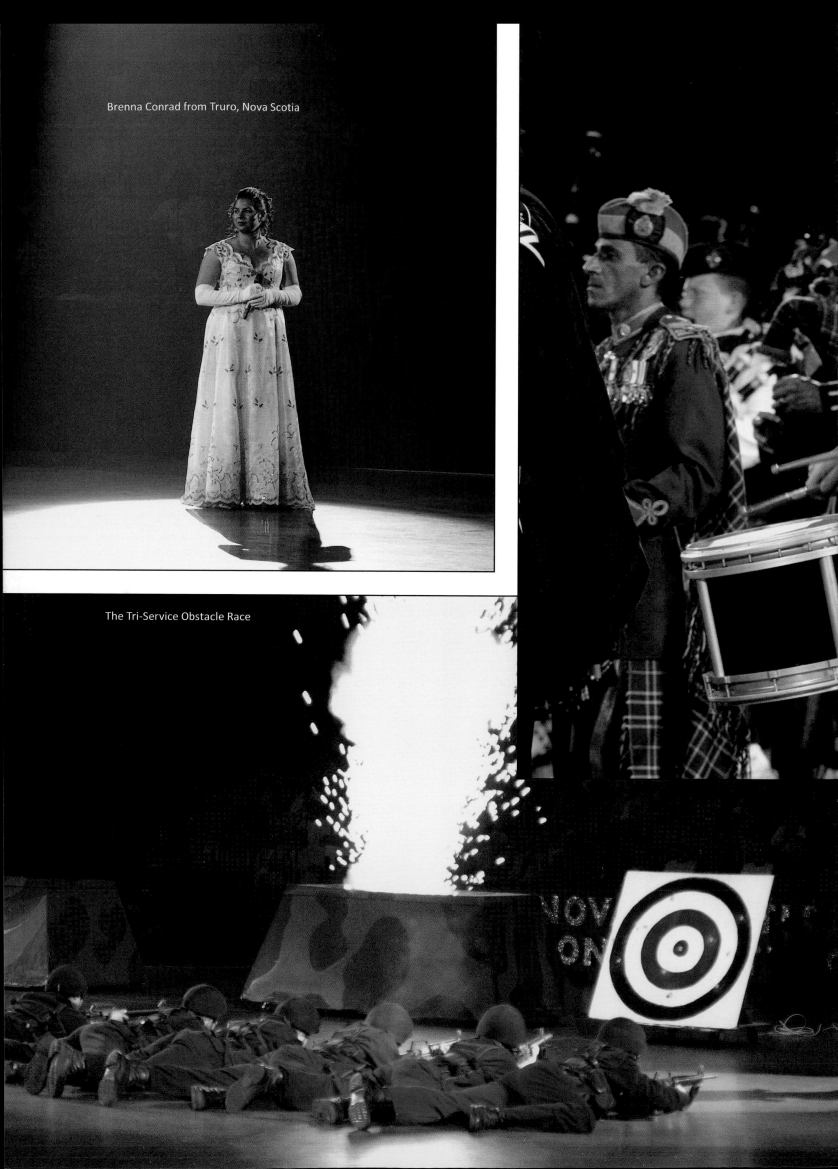

Brenna Conrad from Truro, Nova Scotia

The Tri-Service Obstacle Race

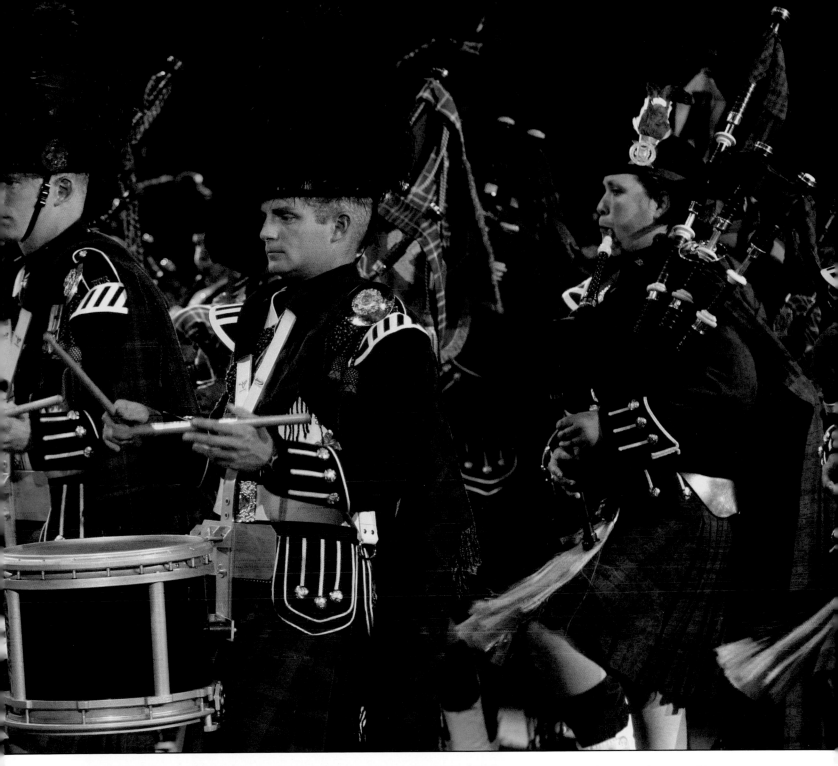

▲ The Massed Pipes and Drums

◄ Gym Wheel Team Taunusstein
from Germany

45

German military musicians take a look back through history
(Heeresmusikkorps 1)

Trumpeter from the Band of the Ceremonial Guard

▶ The Band of
Her Majesty's Royal Marines
Portsmouth from the United Kingdom

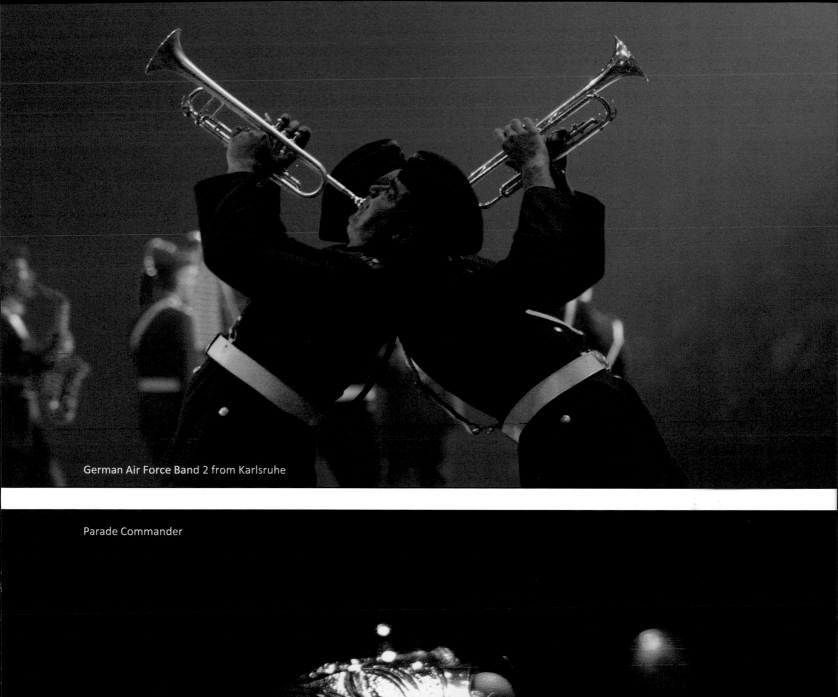

German Air Force Band 2 from Karlsruhe

Parade Commander

▲ Fanfare Trumpeters (their costumes were first designed for the 1981 Tattoo by Robert Doyle)

▼ Tattoo Extras pose for a period photograph

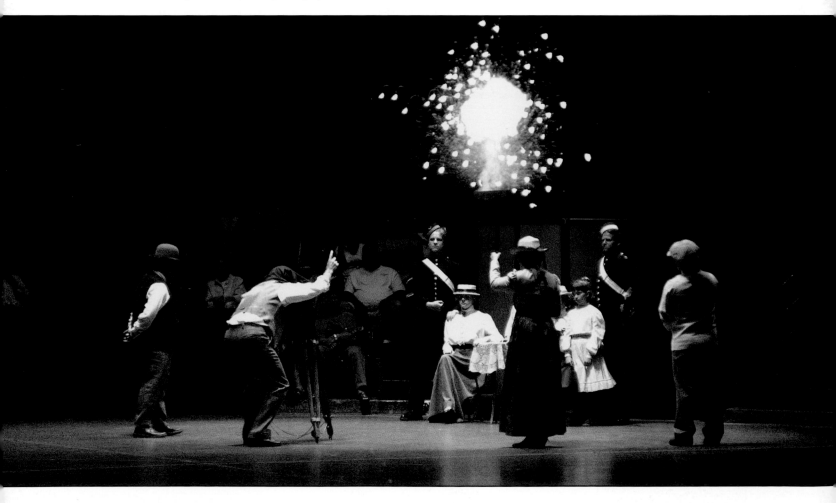

The Tattoo Tartan

With its deep Celtic roots and strong military ties, it is no wonder the Royal Nova Scotia International Tattoo has its own tartan. Since the Royal Highland Regiment of Canada is so deeply woven into the very fibre of the Tattoo, it only made sense that the Tattoo tartan should be based on the dark, rich colours of the Black Watch tartan.

Lochcarron of Scotland designed the tartan for the Tattoo in 2006 to complement the decision of Her Majesty The Queen to grant the Tattoo a "Royal" designation. Throughout history, a tartan has long been thought of as a symbol of pride and prestige.

Another common thread is woven with pride in the Tattoo tartan. Canada's three services are represented, with dark blue for the Navy, red for the Army, and light blue for the Air Force. Scarlet symbolizes both Canada and the Royal Canadian Mounted Police.

As a province steeped in history, Nova Scotia is the bright gold thread that ties it all together. The streak of light blue in the tartan represents the beauty of Canada's seacoast.

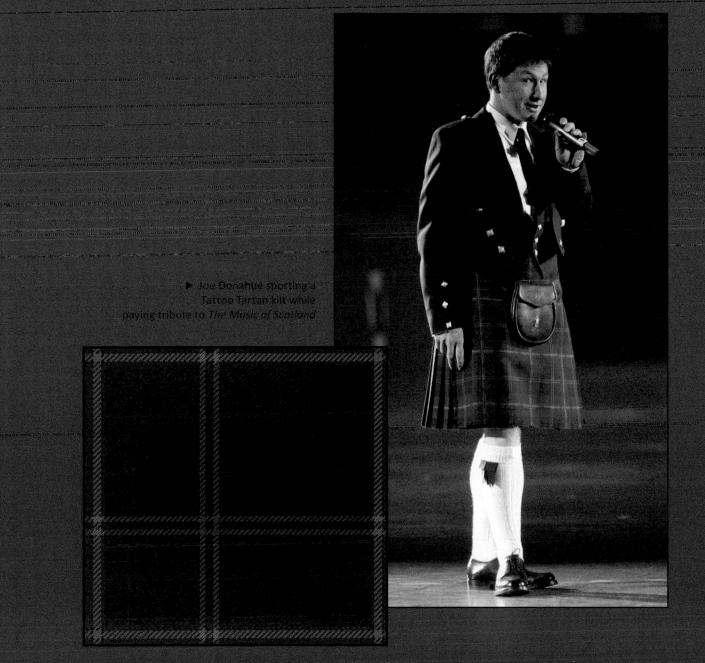

▶ Joe Donahue sporting a Tattoo Tartan kilt while paying tribute to *The Music of Scotland*

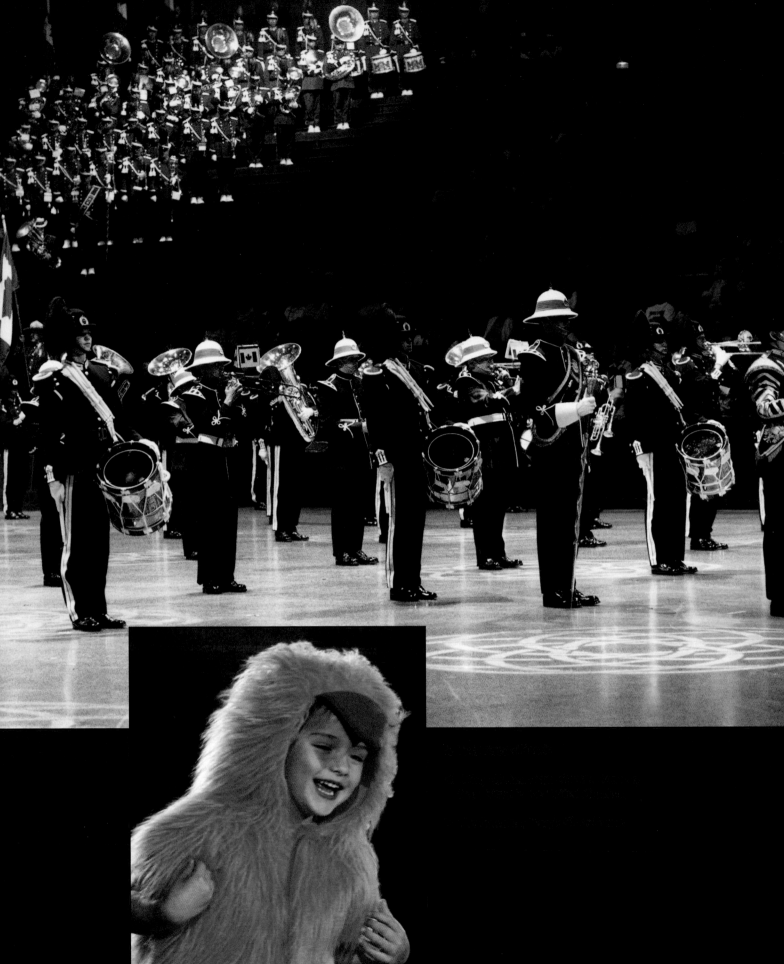

Marching to the Beat of
OUR OWN DRUMMER

"Much better than a Broadway production"
—James Garvey, Edgewater, Florida

"Outstanding! The highlight of our trip to Nova Scotia"
—John Krotzler, Vestal, New York

"It was pure show biz—the quality and imagination of Broadway"
—Jacqueline Kearney, Dusseldorf, Germany

"It was the eighth wonder of the world. Magical. Everyone should see this Tattoo at least once in their lifetime. Life-changing experience. I couldn't get enough of it"
—Barbara Clee, Cobble Hill, British Columbia

"Amazing—the precision, the talent, and the non-stop entertainment were fantastic!"
—Rob Cameron, Peterborough, Ontario

"A night that's part Cirque du Soleil in its variety and inventiveness, yet pure Gaelic sentiment too, and one of the most moving nights of entertainment I've ever experienced"
—Linda Jacobs, *Hamilton Spectator*

Audience reaction to the performances of the Royal Nova Scotia International Tattoo over the past thirty years has been amazing. Thousands of comments have followed every show from the very first in 1979 — presented for Her Majesty Queen Elizabeth The Queen Mother to open the Nova Scotia International Gathering of the Clans — to the thirtieth anniversary Tattoo in 2009, now a world-class international event being copied all over the world.

But how did all of this happen?

In 1980, under some pressure to follow up the enormously successful first show, the government of Nova Scotia and the Navy jointly agreed that the Tattoo should become an annual event. That led to

another decision that was to have a profound impact on the future of the Tattoo.

The Army staff attached to the Navy in Halifax, given the responsibility for planning the next show, recognized that, if the Tattoo was to be primarily a Canadian Forces event, its future was doubtful at best. Simply put, the resources of the services were already stretched to the limit, and it was obvious that things were not going to improve much in the long term. But the Army staff also knew that even if the Canadian Forces, by some miracle, were able to provide all the performers the Tattoo needed, times were changing rapidly. Irrespective of anything else, a traditional military Tattoo, based on marching bands and the occasional military act thrown in to provide a modicum of variety, had questionable longevity. The

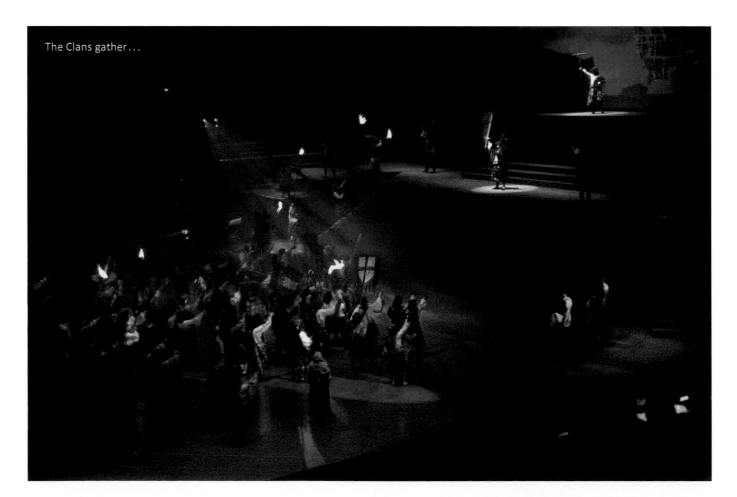

The Clans gather...

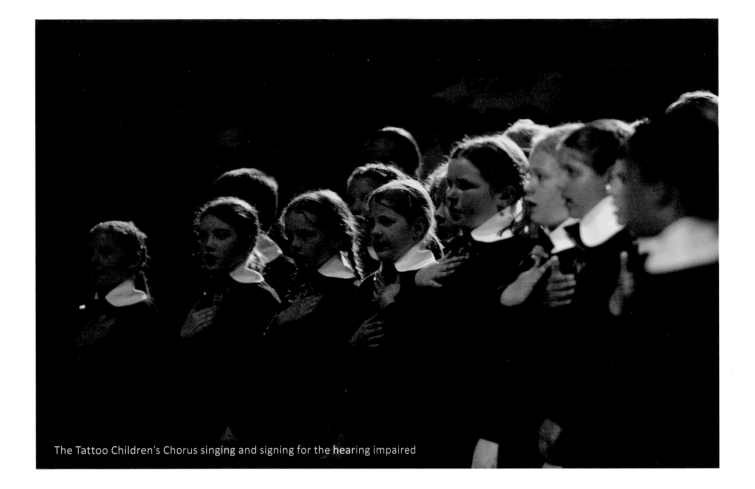

The Tattoo Children's Chorus singing and signing for the hearing impaired

older generation might accept the traditional format, but it was not likely to appeal sufficiently to a younger audience to generate much of a future for the show. The planning team made the decision that, if the Nova Scotia Tattoo was to survive, it had to move in a direction that was completely different from that of any other military Tattoos being staged in the United Kingdom and Europe.

As part of the move to broaden the show's appeal, and reflecting the mix of the 1979 edition, it was decided to make the Tattoo a combined military/civilian event. The principle was simple. The Canadian Forces, the Royal Canadian Mounted Police, and military and police performers from around the world — with all the pageantry, colour, pride, patriotism, and tradition inherent in any military production — would join

▼ Seven Swiss Dwarfs from D'Holmikers ride off after their Snow White scene

▼ The Russian Cossack State Dance Company

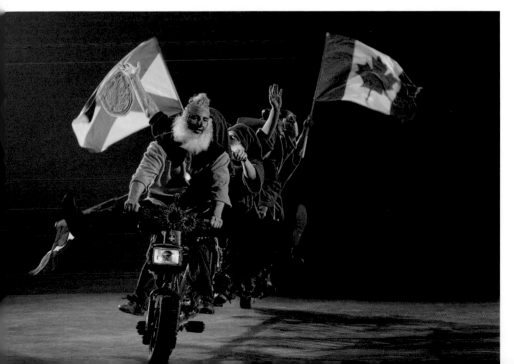

▼ The Russian Cossack State Dance Company

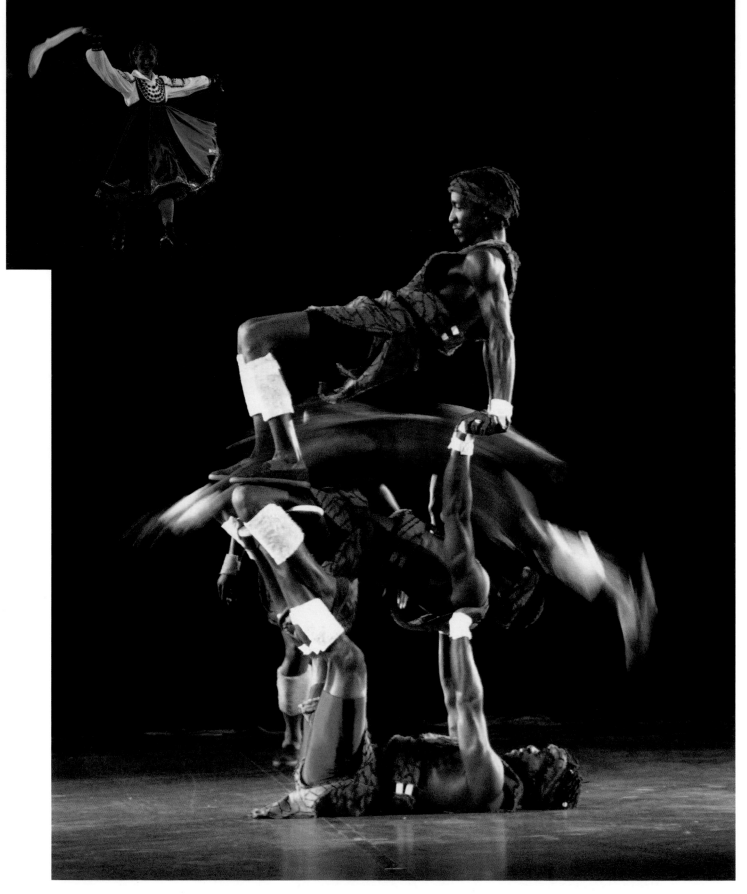

▲ Afro Jambo from Kenya

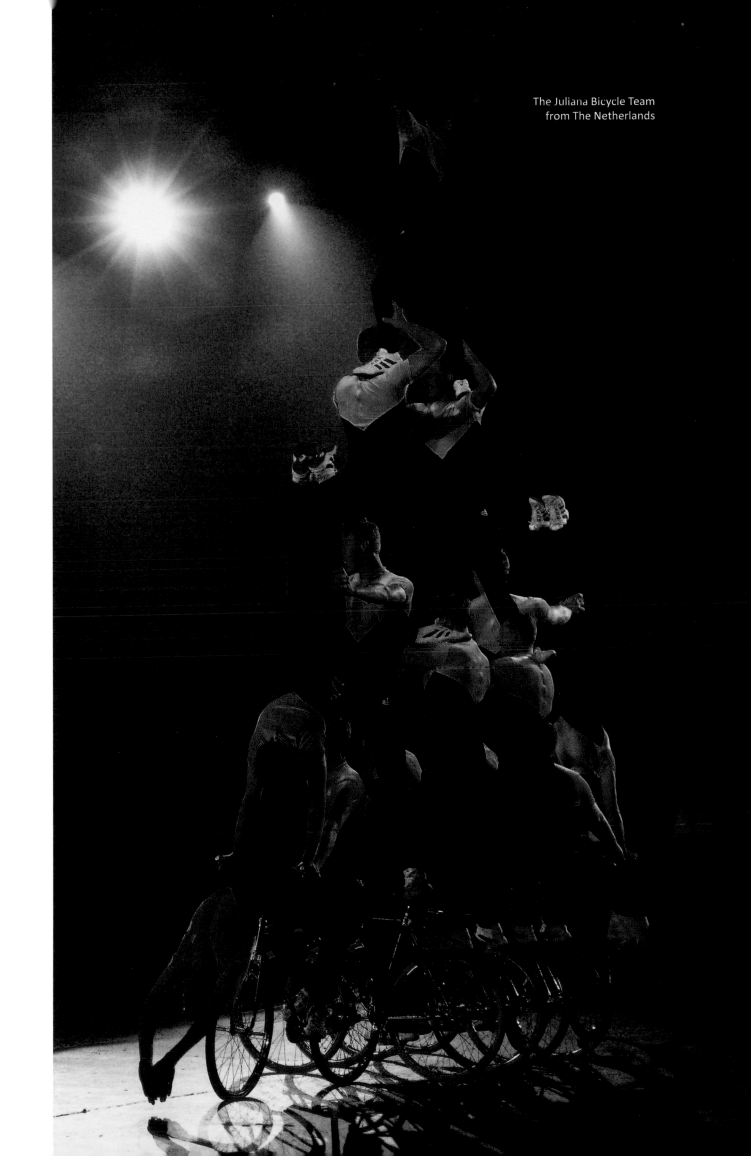

The Juliana Bicycle Team
from The Netherlands

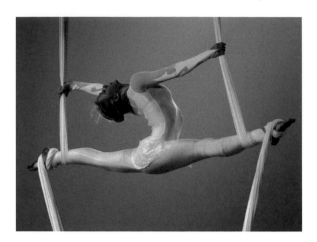

▲ Club Piruett from Estonia

with the best civilian performers from Canada and abroad. Not only would the combination bring the military/police and civilian communities closer; it would also greatly widen the entertainment spectrum of the production and, in the process, allow Nova Scotia to give the cultural world something totally unique. Military bands, pipes and drums, competitions, and military and police displays would always be an important component of the show. But the addition of civilian performers would take the production to the next level. There were virtually no limits: international gymnasts, bicycle and motorcycle acts, classic and modern music, comedy, aerial acts, opera singers, acts with a touch of the circus, dancers, items for and with children — every entertainment genre would be explored.

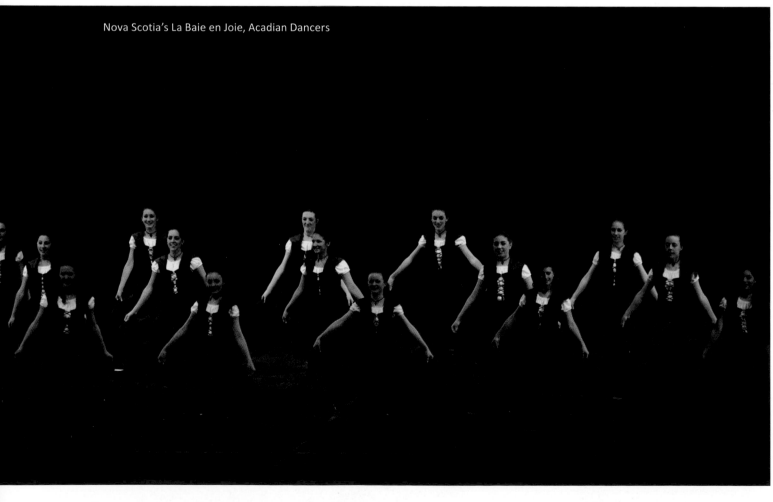

Nova Scotia's La Baie en Joie, Acadian Dancers

In the years that followed, the format of the Nova Scotia production moved away from that of every other Tattoo. Its reputation found international acclaim, with performers from twenty-three countries taking part and bringing home with them the lessons of the show's unique combination. One minute the audience would be stirred by massive military bands or pipes and drums...then charmed by aesthetic gymnasts from Estonia...excited by the Canadian Naval Gun Run or the Army Obstacle Race...moved to tears by a dramatic display focusing on the sacrifices of young Canadians in the cauldron of war...thrilled by military bands from around the world...mesmerized by Highland and modern dancers...taking pride in the RCMP Ceremonial Troop...laughing at Germany's

Tattoo Extras

The Flying Danish Superkids
from Aarhus

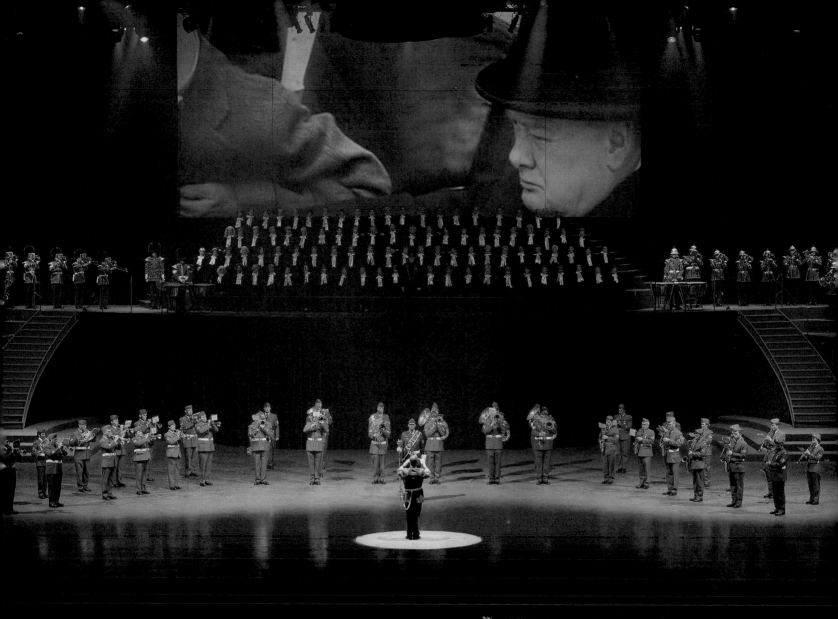

▲ *The Power of Flight*

▶ Period Tattoo Extras

34

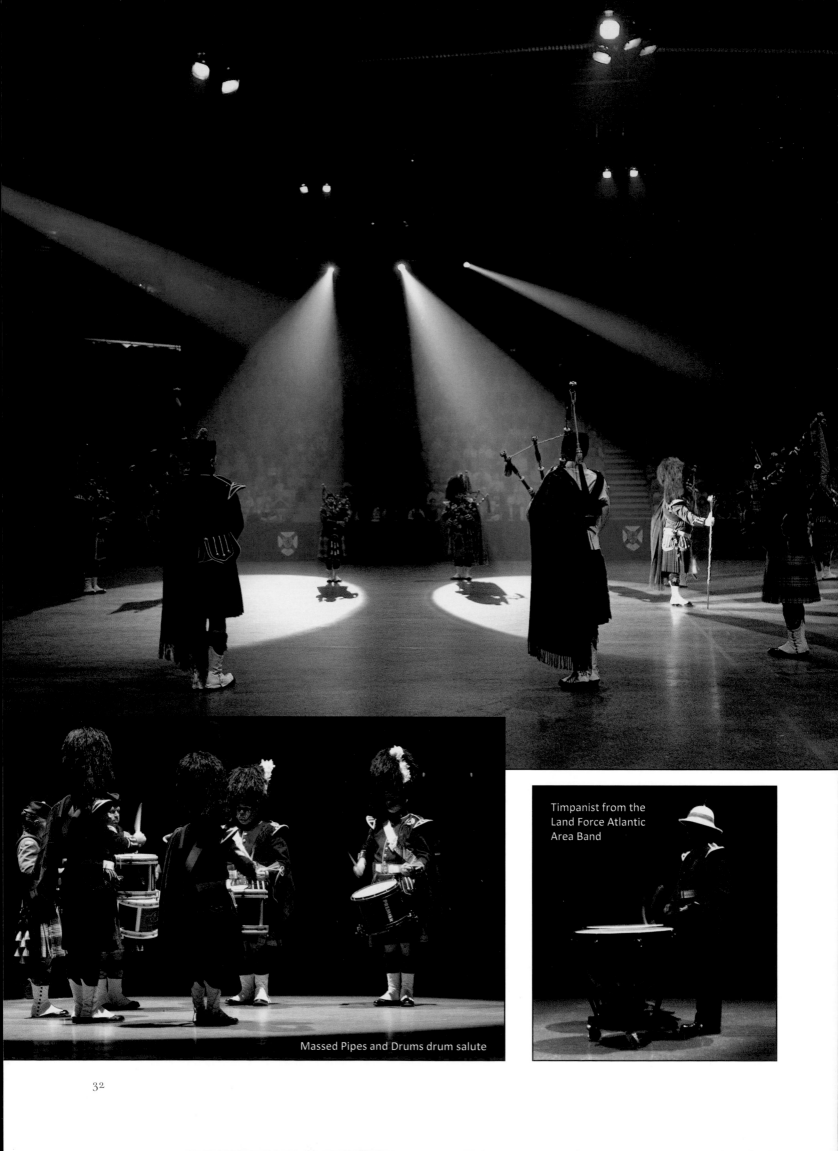

Massed Pipes and Drums drum salute

Timpanist from the
Land Force Atlantic
Area Band

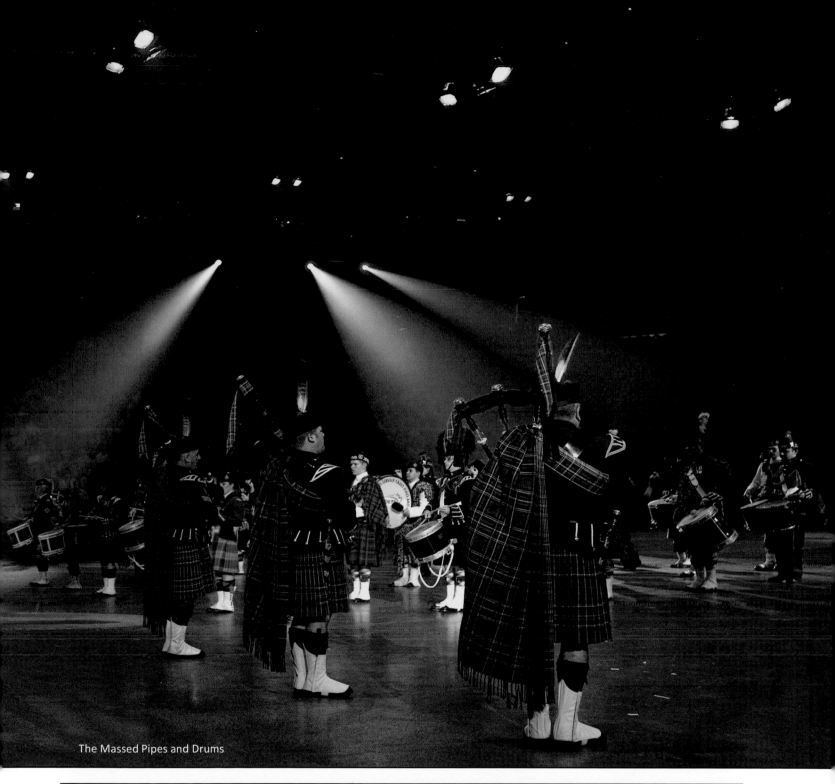

The Massed Pipes and Drums

German Alphorns

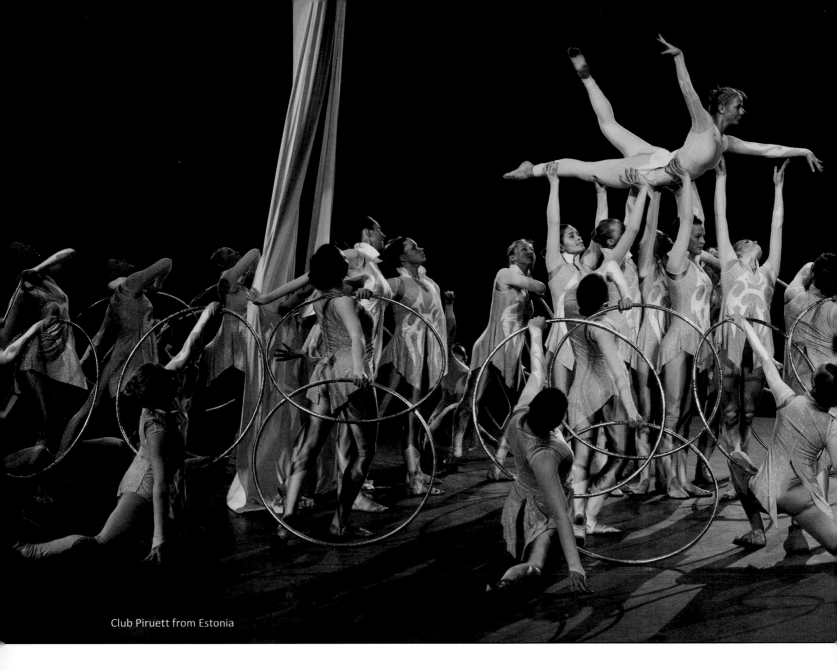

Club Piruett from Estonia

▲ Naval swinging ladder routine

Flying Grandpas... watching children dance and perform like professional troupers... perhaps even learning how Mozart, Bach, Purcell, Beethoven, Sousa, and Alford could blend with The Beatles, Hank Snow, Irving Berlin, and even the rock music of Queen.

It is heady stuff.

The theatrical community — choreographers, costume, set, and lighting designers, props builders, wardrobe staff, music arrangers, composers, technicians, costumers, hairdressers and make-up artists — have been part of the equation from the start. They have brought to the Canadian Forces team the skills and lessons they learned in the theatre, adding a new dimension to the production.

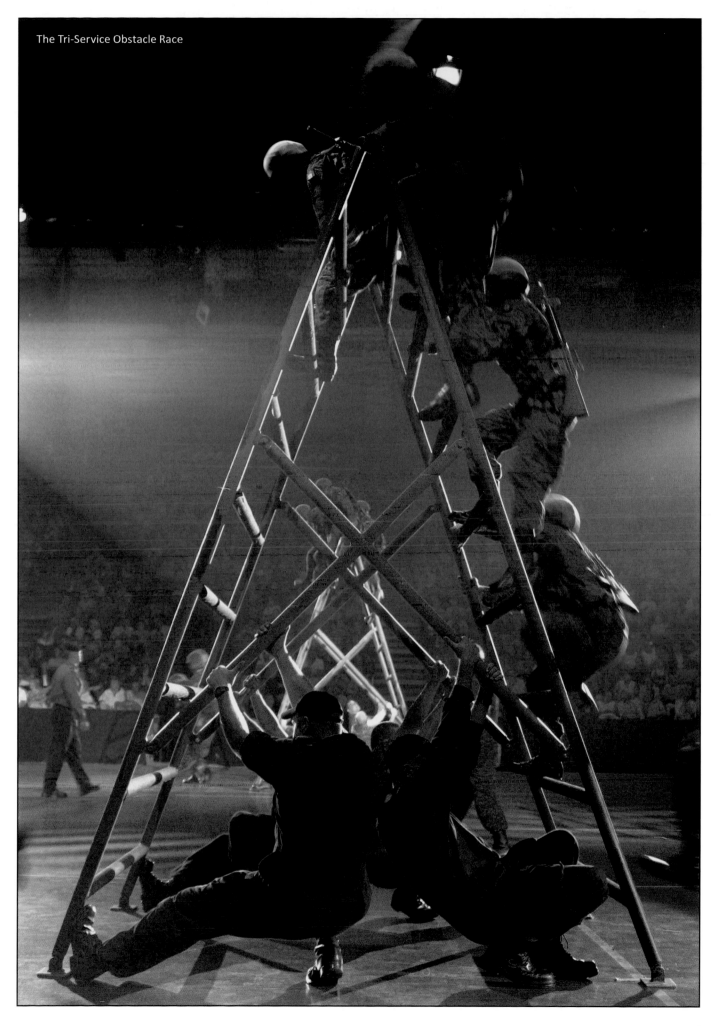

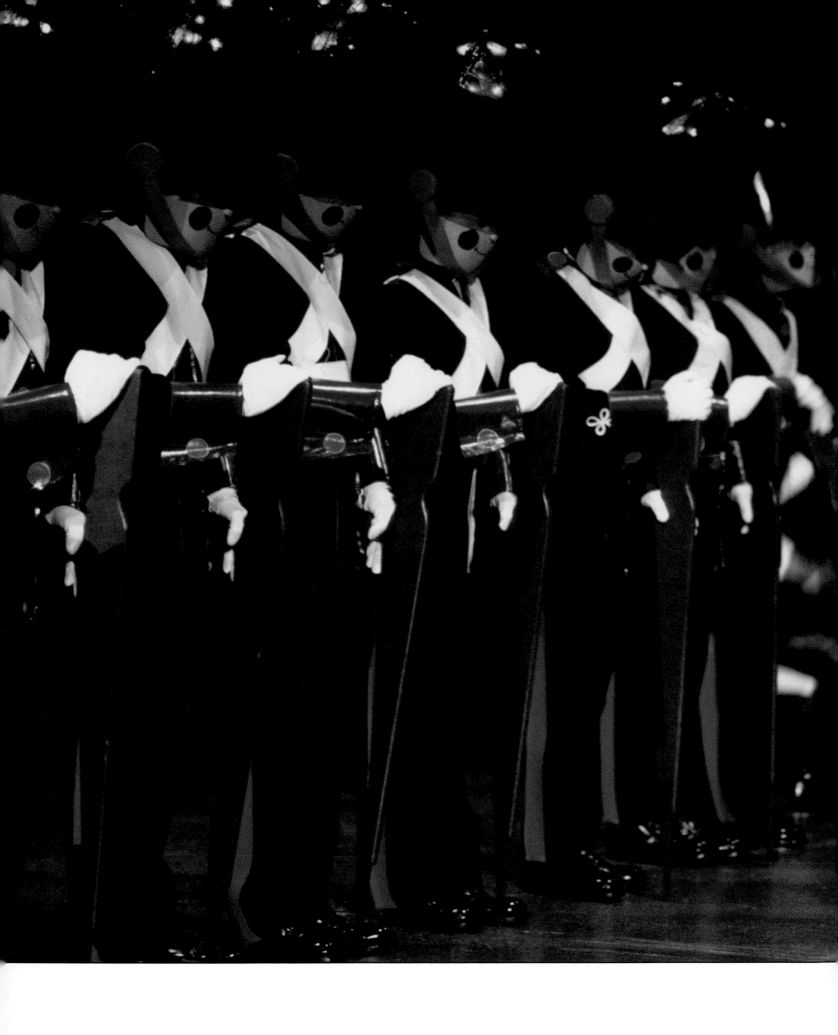

Tattoo Extras perform *Your King and Your Country*

A Toyshop Fantasy

Their creativity and experience blends with the pageantry, discipline, tradition, and ability to get things done efficiently that is the hallmark of the military. The best of both worlds is ever-present.

Then there is the approach the Tattoo staff takes to rehearsals — a lesson learned from the first production in 1979, which stood on the edge of failure because of a lack of rehearsal time in the Metro Centre and which drove home the importance of adequate preparation to give the audience the best possible product. The guiding principle is a professional approach based on the axiom, "amateurs rehearse until they get it right while professionals rehearse until they can't get it wrong." Long, detailed, and occasionally agonizing rehearsals have become a rigid and dominant feature of the production. Indeed, that serious focus on rehearsal is another aspect that sets the Nova Scotia show apart from other Tattoos around the world.

▲ Trick Factory from Estonia

▼ *Over the Side* fantasy scene

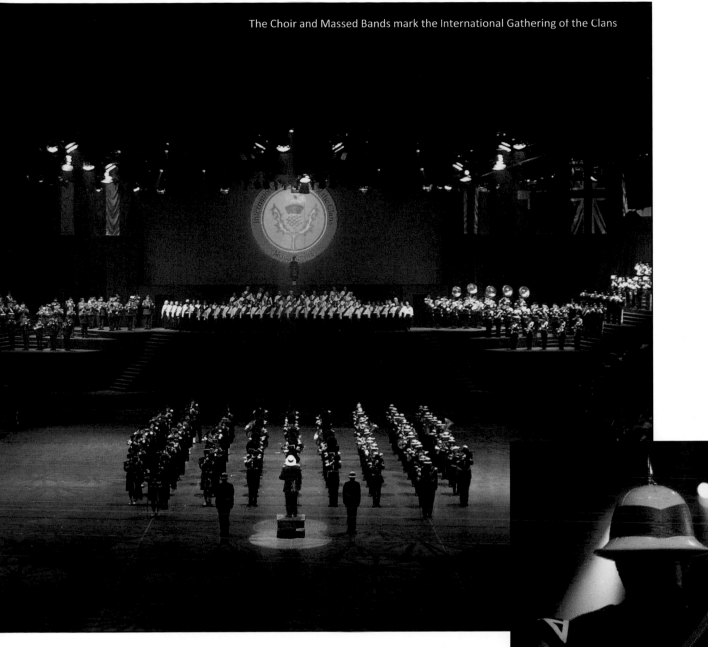

The Choir and Massed Bands mark the International Gathering of the Clans

▶ Land Force Atlantic Area Band Drum Major

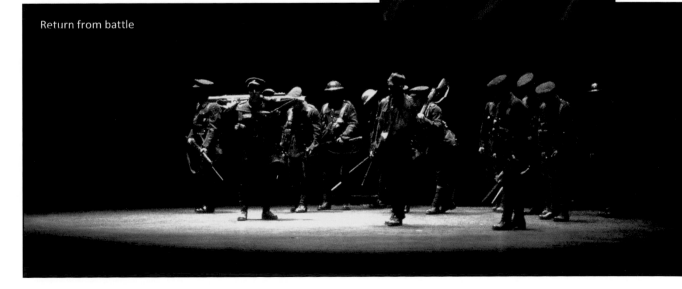

Return from battle

▲ Tattoo Extra

The Old Guard Fife and Drum Corps from Washington, DC

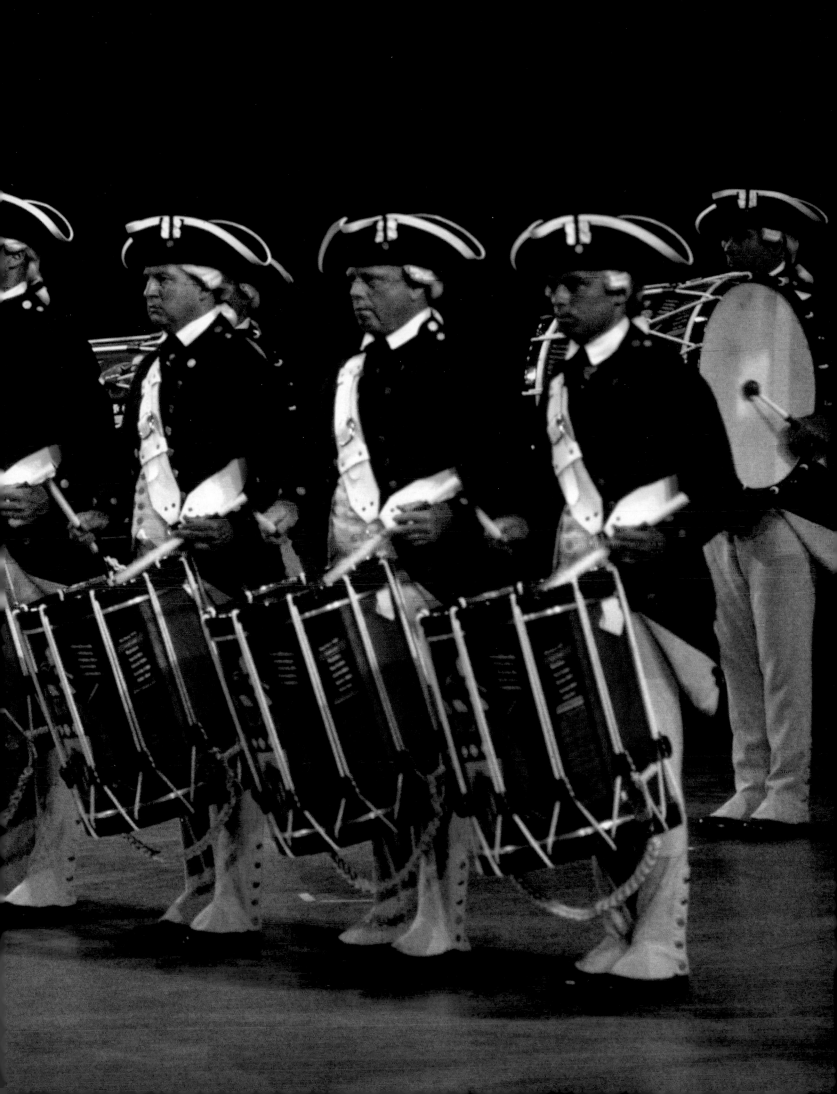

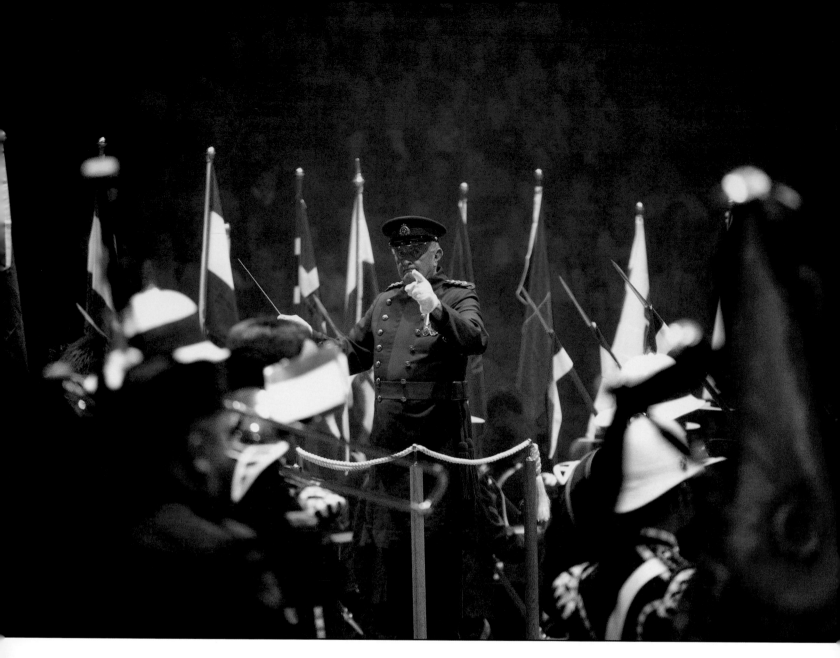

In 1981, the Nova Scotia Tattoo began to survey its audience every year, seeking to draw a road map for the next production by determining strengths and weaknesses and identifying acts, both Canadian and international, that worked and those that did not. This process has taught many valuable lessons: include as much variety as possible; mix civilian and military acts; hold firmly to the essential military components and never sacrifice that; give the audience what it wants, but, above all, do not fall into the pit of presenting propaganda or entertaining yourself. Finally, give directors full artistic control over every aspect of the show.

To meet the expectations of an audience conditioned by the rapidity of television, the show's tempo must be as rapid and as smooth as possible — think theatre, think entertainment,

▲ The Juliana Bicycle Team
from The Netherlands

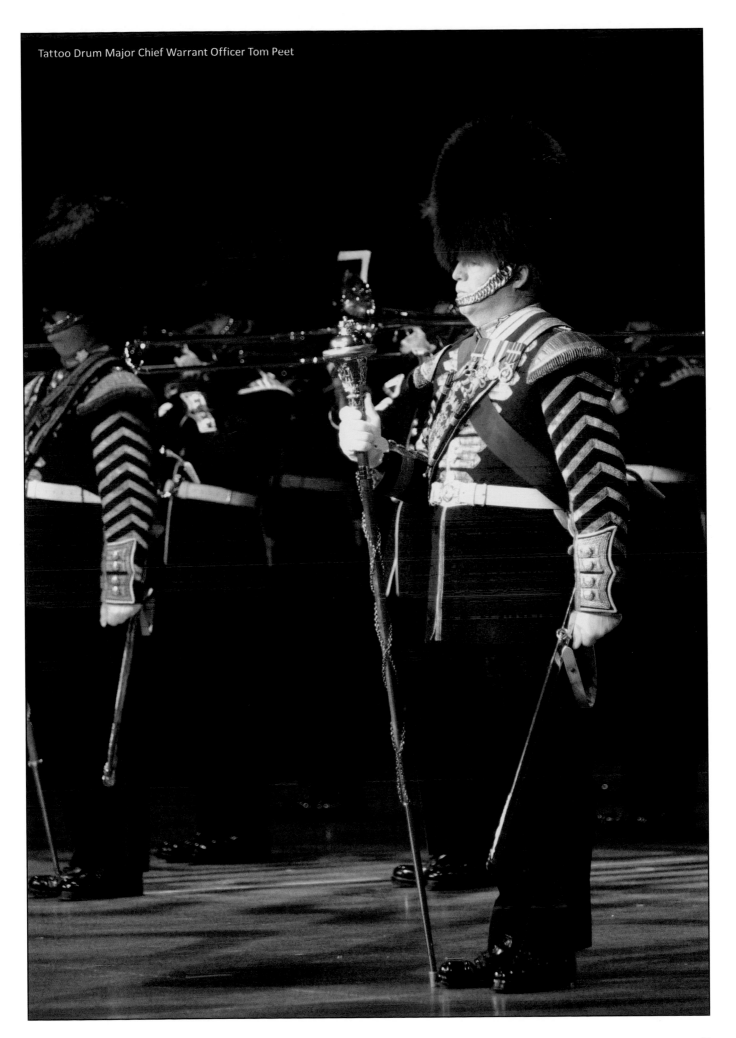

Tattoo Drum Major Chief Warrant Officer Tom Peet

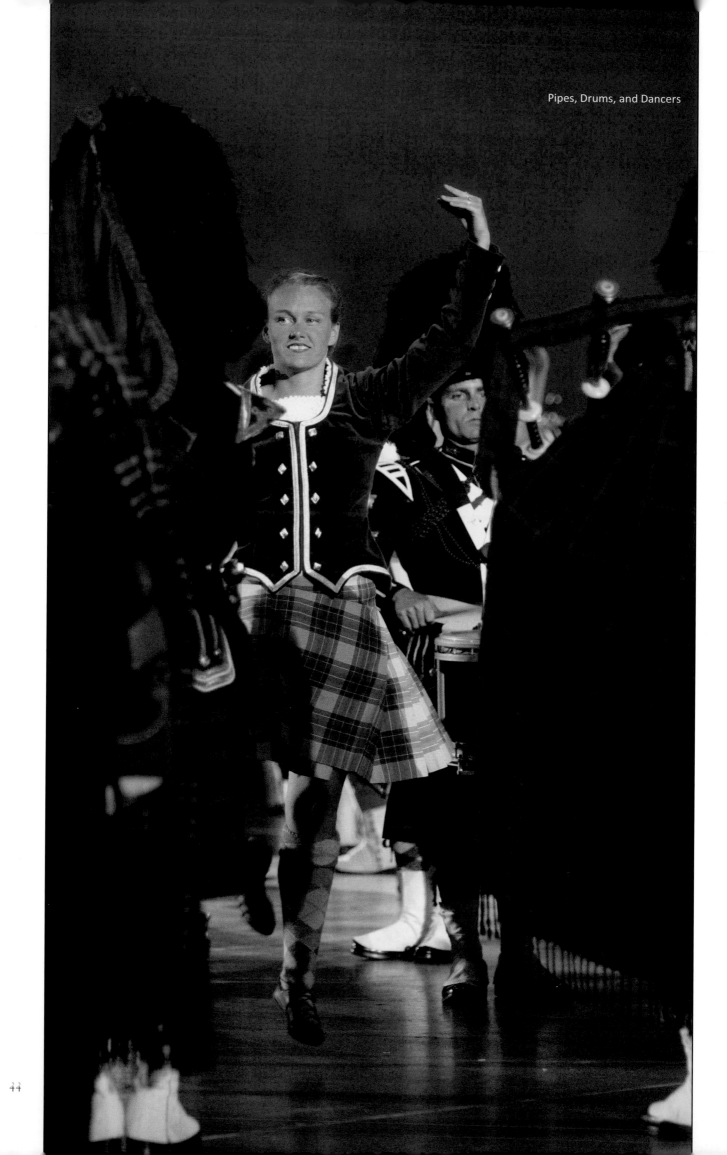

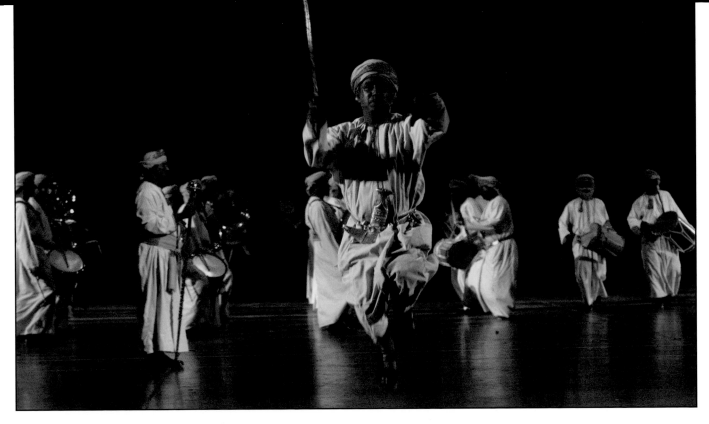

▲ A dancer from the Royal Air Force of Oman

▼ Charlie Chaplin (Cadet Matthew Smith of The Citadel, The Military College of South Carolina) gets a shock during Intermission

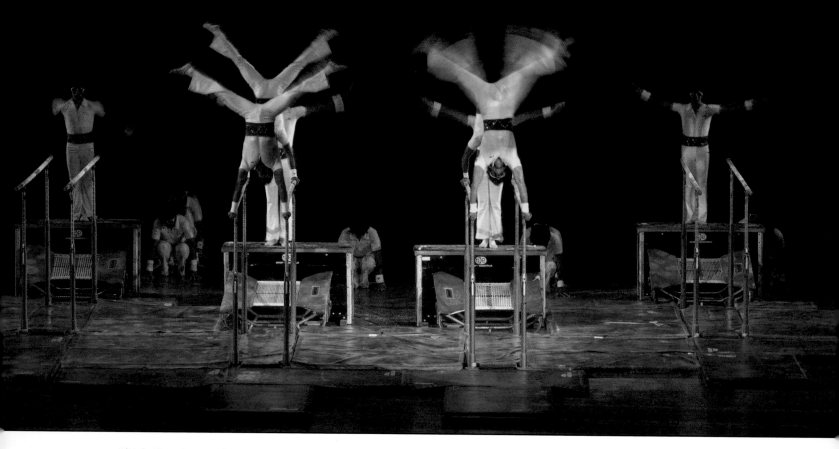

▲ D'Holmikers from Mels, Switzerland, perform their Elvis routine

think variety, think "show business"—but
the production must never lose sight of the
importance of the pageantry, ceremony, colour,
and skill that the military from Canada and
around the world can offer. Enhanced by state-
of-the-art lighting, sound, and electronic systems
and a regularly rebuilt stage, the Tattoo advances
with the times.

The organizers have freely admitted they made
every mistake imaginable, but, as one observer
noted, "They never made the same mistake
twice. They never stopped learning from their
mistakes or the mistakes made by others. Above
all they were enormously self-critical and that,
combined with learning from their mistakes
and observing those made by others, greatly
improved the show."

▶ Trumpeter from the United States
Continental Army Band

Club Piruett from Estonia

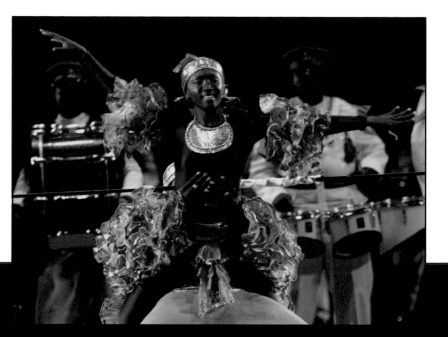

▶ Limbo Dancers from the
Trinidad and Tobago Defence Force
Steel Orchestra

▼ The Euroband from Rotterdam
from The Netherlands

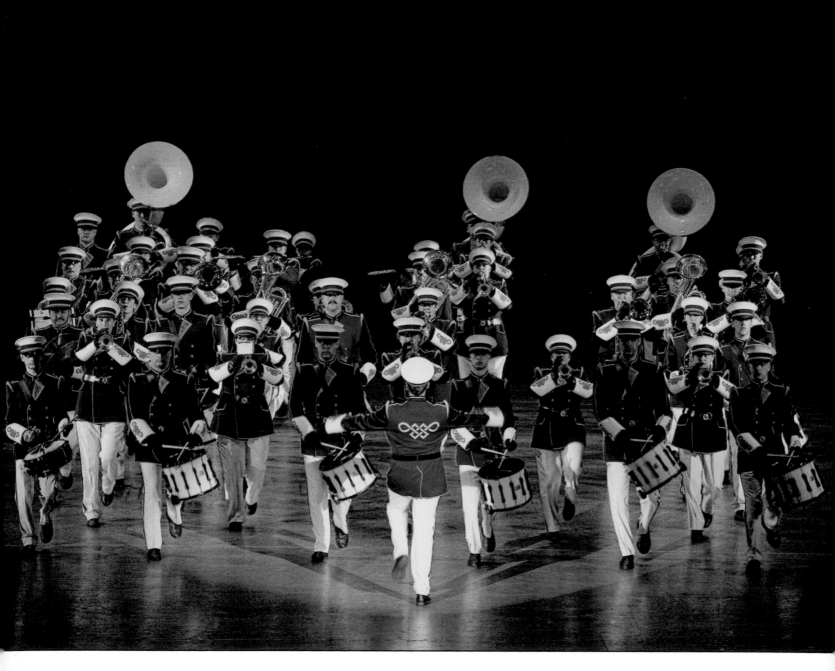

Over the years many of the military on staff
have retired and the Tattoo has become a civilian
production, but with the Canadian Forces and
the RCMP remaining an essential part of the
planning team. Faces have changed and the
Tattoo has continued to evolve, but it steadfastly
remains a combined theatrical and military
production, with military and civilian performers
from all over the world, representing every
possible entertainment genre, working in a huge
theatre in the round to present a unique event.

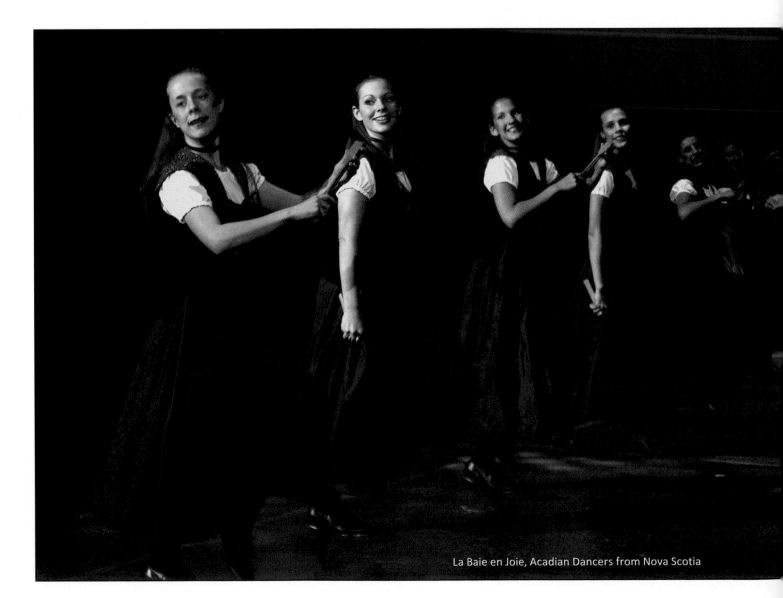

La Baie en Joie, Acadian Dancers from Nova Scotia

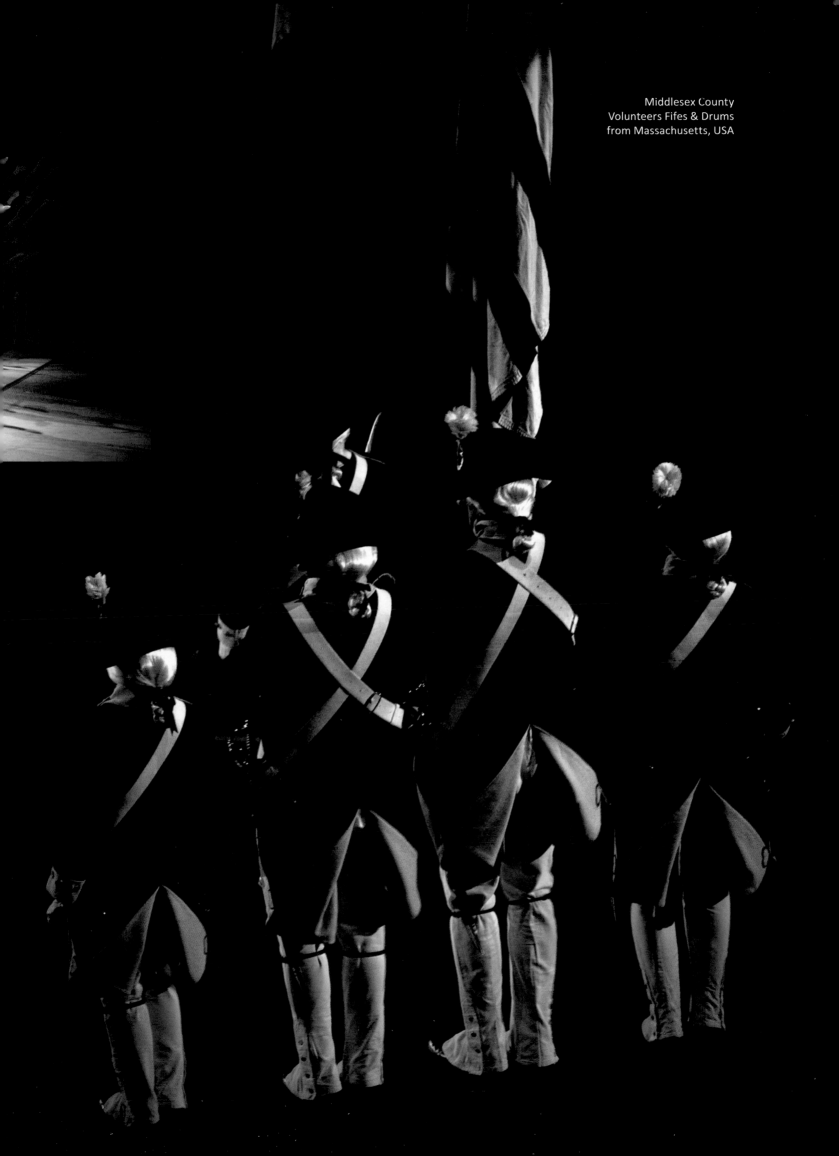

Middlesex County
Volunteers Fifes & Drums
from Massachusetts, USA

◀ Members of The Flying Danish Superkids

▲ Ciosmul Dancers from Barra in the United Kingdom

Arie Hakkert's Sea King Helicopter

When all is said and done, one rule has dominated the Tattoo over the past thirty performances. It is simple, straightforward, and can best be described by the following story.

In the late 1930s, Charlie Chaplin, the famed silent movie comedian, allegedly was approached by a keen young film student. "Mr. Chaplin," he said, "what is the secret to filming the old routine of a man slipping on a banana peel?"

Chaplin listened as the young man explained his problem.

"Should I focus the camera on the banana peel first and then focus on the man as he slips on it or should I show the man walking down the street, falling, and then show the banana peel?"

"Neither," Chaplin replied. Then he went on. "Show the banana peel, and show the man walking down the street."

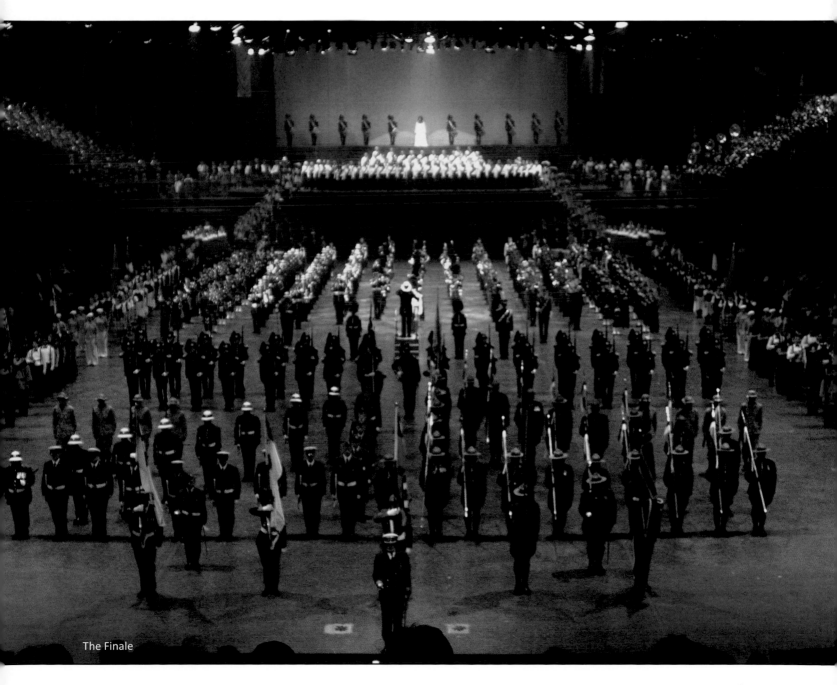

The Finale

Chaplin paused while the young film student absorbed what he had said. "Then," he continued, "the man sees the banana peel, grins knowingly at the camera, walks around the banana peel, and falls into an open manhole."

Chaplin paused again and then gave the young aspiring film student the key piece of advice. "The unexpected," Chaplin said, "that's the secret."

And that is also the principle that has guided the Royal Nova Scotia International Tattoo for the past thirty years. ✿

◄ *Changing the Watch*

► *Burial at Sea,*
one of the many historical,
commemorative reenactments

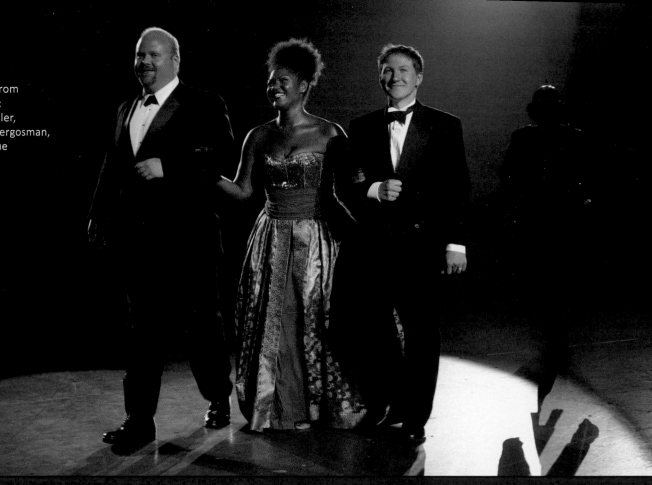

Three Soloists from
New Brunswick:
Derrick Paul Miller,
Measha Brueggergosman,
and Joe Donahue

Measha and Friends

Measha Brueggergosman is one of the foremost sopranos in the world. She has been featured with virtually every major symphony in North America and Europe, she performs in operas, she is an international recording star with Deutsche Grammophon, and she continues to dominate the music scene in Canada and abroad.

Measha is interesting for a number of reasons.

She was born and brought up in Fredericton, New Brunswick, and performed there during her early years before going on to study in Canada and Europe. Her wonderful talent was recognized when she was a small girl and encouraged by her family, who in simple terms held to the opinion that "Measha's voice was a gift from God."

While Measha was still in her late teens, Ann Montague, the assistant producer of the Tattoo, made contact with her through Joe Donahue, a regular featured Tattoo soloist at the time. Joe had performed with Measha on a number of occasions in New Brunswick. Ann then heard Measha sing, appreciated her talent, and invited her to take part in the Tattoo. Few people realize that Measha performed before a large audience for the first time at the 1998 Nova Scotia International Tattoo.

She immediately captured the hearts of the audience with a version of "Con te partiro" ("Time to Say Goodbye"), made famous by Andrea Bocelli and Sarah Brightman, that some thought improved on the original. Then, proving her versatility, Measha later sang Gershwin's "Someone To Watch Over Me." At every performance, the Metro Centre audience was overwhelmed with this young Canadian's great talent and the sixty thousand who attended the Tattoo that year were given a foretaste of what would soon captivate audiences around the world.

Measha has returned twice to perform, most recently in the stunning *A Night At The Opera* Act 1 Finale presentation in 2007. She appeared in that show with fellow New Brunswickers Joe Donahue of Saint John and Derrick Paul Miller, now of the Canadian Opera Company, who grew up with Measha in Fredericton. Both Donahue and Miller had performed with her in New Brunswick and all three remain fast friends.

Despite her fame and adulation, Measha has never forgotten her connection to the Tattoo or the friendships she has formed in Halifax, first as an aspiring young artist and later as a prestigious international performer. She visits the Tattoo when she can and always acknowledges the Tattoo's contribution to her career.

The Russian Navy

Tattoo staff will always recall the visit of The Song and Dance Ensemble of the Northern Fleet of the Russian Federation in 1993.

The performers, male and female — most of them professional civilian artists retained by the Russian Navy — had been on board ship for well over three weeks on their voyage from Murmansk to the Atlantic coast of North America for visits to Halifax and the eastern seaboard of the United States.

At the best of times, sailing the Atlantic from northern Russia is a daunting experience. This one was made a little worse by speculation that the ship might run out of food on the way, though that was never confirmed. By any standard, however, it had not been a pleasant journey for the performers, who had not even had an opportunity to rehearse along the way.

On arrival, the ensemble's director, who had been told to perform a six-minute number in the show, was adamant that he could not do it. He suggested that Ian Fraser, the Tattoo's producer, watch the performance and then decide what he wished to cut to keep within the allocated time.

Fraser had heard that sort of thing before and wasn't amused by the prospect. But he had no choice. The Russians moved onto the floor and the performance followed. Traditional music poured forth — they sang; sailors leaped in ethnic dances, then were joined by young women, and all plunged into yet another ethnic dance; a male chorus sang, small music groups came forward and played; and the voice of an astounding bass baritone with a huge walrus moustache soared to the rafters of the Metro Centre.

In the words of spellbound cast and staff, it was an amazing presentation. It was impossible to believe the ensemble had not rehearsed for more than three weeks.

Then the director came forward and apologized again that he could not meet the six-minute time constraint requested. What should he cut?

Fraser looked at his stop watch. The performance that was later to overwhelm the Tattoo audience had run exactly six minutes and four seconds! Stunned by the artistry and skill of what he had just witnessed, Fraser turned to the director. "I think we can live with the extra time."

▼ The Song and Dance Ensemble of the Northern Fleet of the Russian Federation

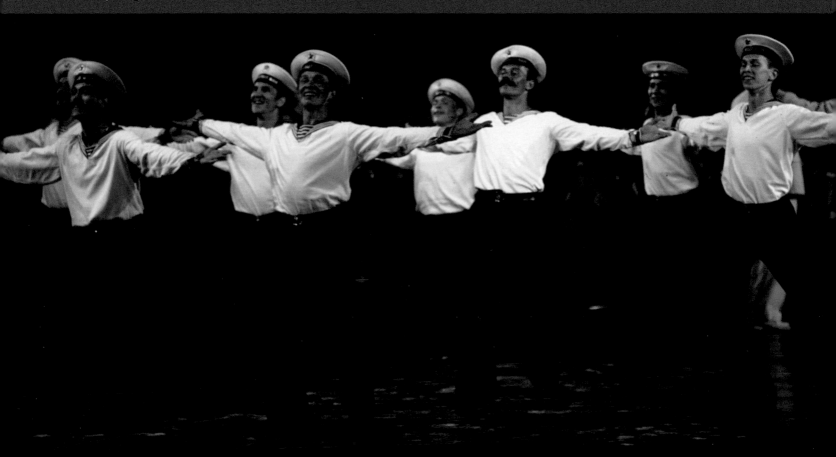

Nova Scotia Tattoo 1979
Nova Scotia Tattoo 1979
Nova Scotia Tattoo 1979
Nova Scotia Tattoo 1979

Nova Scotia Tattoo 1979

A unique Nova Scotia extravaganza involving extensive lighting, colorful costumes and set, wide range of music and more than 600 performers.

- Massed Pipes & Drums
- Highland and Scottish Country Dancers
- Military Bands
- Men of the Deeps Coal Miners Choir
- Gaelic Choir
- Regimental Tournament

Performances at
Halifax Metro Centre

TATTOO

▲ Canadian Armed Forces Tattoo, 1967

◄ The first ever Nova Scotia Tattoo Poster

THE GENESIS
1979

To say that the first Nova Scotia Tattoo got off to a smooth start would be a massive overstatement. In fact, it almost didn't happen.

Colonel Ian Fraser — who wrote, produced, and directed the hugely successful Canadian Armed Forces Tattoo that toured the country in 1967 as part of the Centennial celebrations — had been posted to Halifax from the National Defence College in September 1978 as director of regional operations on the staff of Vice-Admiral Andy Collier, the commander of Canada's Navy. Under Canada's unified defence structure, he was, in effect, the admiral's Army chief of staff.

Fraser, a former member of The Black Watch (Royal Highland Regiment) of Canada, the Royal Canadian Regiment, and the Canadian Airborne Regiment, which he had recently commanded prior to attending the National Defence College, wasn't the least bit interested in returning to the world of military show business. As far as he was concerned, he had left that behind over a decade earlier.

A year or so earlier, the newly elected Nova Scotia Conservative government of Premier John Buchanan, an ardent Cape Breton Scot, had lobbied and received agreement from the Scottish organizers to host the 1979 International Gathering of the Clans, the first ever held outside Scotland. In addition to its major international cultural aspect, the event had the potential to stimulate tourism greatly, which would have a significant impact on Nova Scotia's economy.

The Royal Nova Scotia International Tattoo/Black Watch Association Pipes and Drums

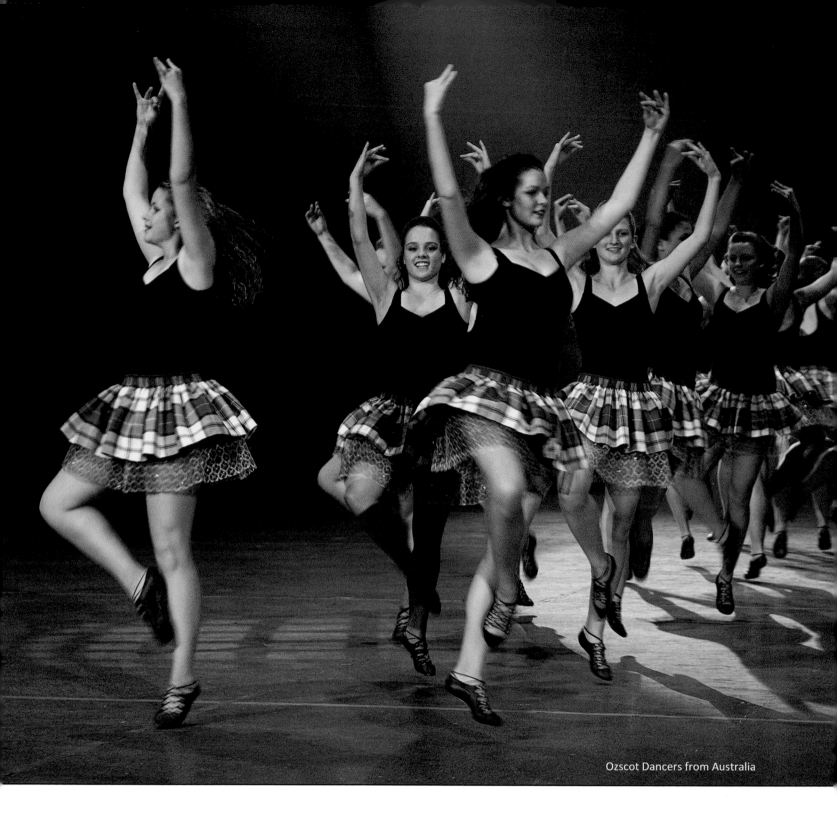

Ozscot Dancers from Australia

Premier Buchanan recruited Dr. A. Gordon Archibald, former president of the Maritime Telephone and Telegraph Company and recent recipient of an honorary doctorate from Dalhousie University, to form the Scottish Societies Association of Nova Scotia, which, in turn, would organize the Gathering of the Clans. The only problem was that the organizers lacked a centrepiece item with which to start the Gathering, which Her Majesty Queen Elizabeth The Queen Mother, herself an ardent Scot, would open. Unfortunately, there was no one at hand with sufficient experience to organize what someone a few months earlier had vaguely suggested should be a Tattoo.

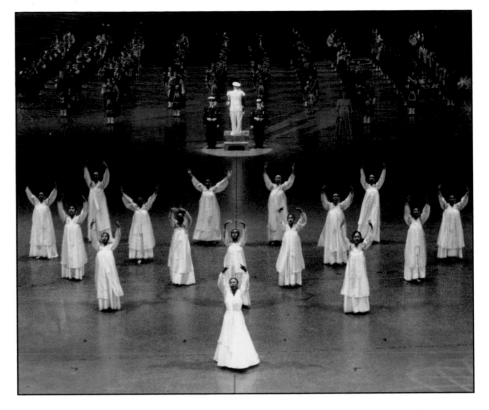

▲ Combined Bands and Korean Dancers

▼ Stadacona Band of Maritime Forces Atlantic

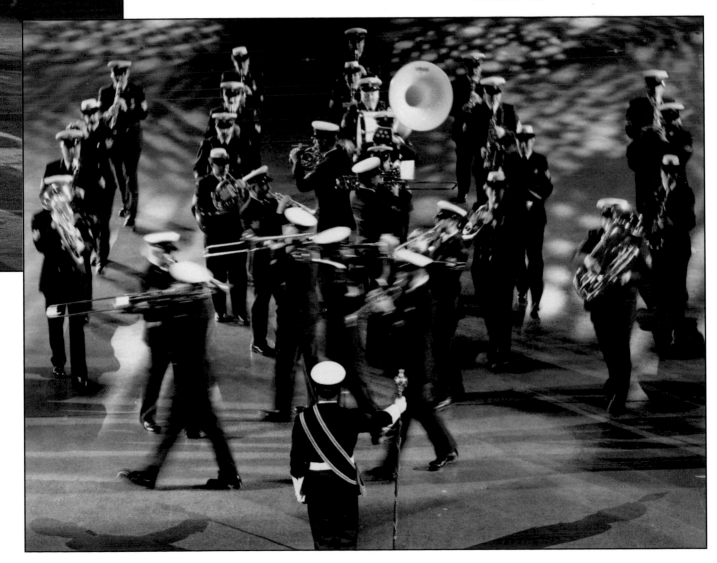

Colonel Fraser's brother, a university professor and close friend of the premier, and Joe Clarke, the premier's chief of staff — also known as "Oxford Joe" or "Clarke with an e" to differentiate him from Joe Clark, the prime minister at the time — tried to pressure him to do the job. The colonel flatly refused.

The option then was to try to convince Admiral Collier to take on the project, which the provincial government, with the support of Gordon Archibald, concluded was the only way to get Fraser on side. The admiral did not take the bait directly; instead, he asked Fraser to meet with Dr. Archibald to discuss the possibility of a Tattoo. By now it was mid-January, less than six months before The Queen Mother would arrive to open the Gathering.

Fraser did as he was told and met with Dr. Archibald, but the meeting did not go well. When he discovered that little or nothing had been done to plan the opening, Fraser bluntly told Dr. Archibald that he was out of his mind even to consider a project of the scope he proposed. Even a year or more to plan an event of that magnitude would not be enough time, and with less than six months to get the job done, it was bizarre to consider such a thing. As far as the colonel was concerned, that was the end of it.

The next day that changed.

The moment the usual morning operations meeting ended, a glowering Admiral Collier ordered Fraser into his office. The one-sided conversation that followed was direct and to the point. "Did you," the admiral

▼ Canadian Army unit patches in the Costume Shop

▲ The Band of the Canadian Naval Reserve

▶ Jason Davis from
Halifax, Nova Scotia

said, barely controlling his fury, "tell Dr. Archibald yesterday that he was out of his mind to try to mount a Tattoo for the opening of the International Gathering of the Clans?"

It was pretty obvious that Dr. Archibald had had a serious conversation with Admiral Collier. Fraser acknowledged that he had made a remark generally along the lines suggested by the admiral, but his attempt to explain was cut short.

"I don't want any explanations from you or anyone else," the admiral said, leaving no doubt in Fraser's mind about what was to follow. "You," he said, pointing at the colonel, "will organize a Tattoo to open the International Gathering of the Clans and it had better be the best event this city has ever seen."

It was to be a busy time

A few aspects had already been established: the show would be presented in the Halifax Metro Centre, a new air-conditioned, multi-purpose entertainment venue in the centre of the city. As well, an ad hoc committee that had taken on the task of organizing the opening ceremony had selected some performers and staff. The committee had done little more, however, so Fraser had his work cut out for him.

In addition to organizing a massive Tattoo, Fraser had to find a way to get through his normal Canadian Forces staff workload, which he knew would not diminish even though he had just been commanded to put on a major show for a member of the Royal Family in a few months' time. In stepped his deputy, Bob

An early Naval Gun Run

MacLean, an Air Force lieutenant-colonel, and a few others associated with the production.

Major George Tibbetts, who by coincidence grew up with Fraser in New Glasgow, Nova Scotia, and served with him in the Black Watch, was given the task of organizing the administration for the Tattoo. That was a major undertaking, but it did not require much production background or knowledge. Both Fraser and Tibbetts knew, however, that without a strong administrative base, the odds of failure were high. Their solution was to call on experienced Army officers from the Regional Operations staff to help out with the show — on top of their normal work. In typical soldier fashion, none objected; once briefed by Fraser, they set about doing what was required.

There was one disturbing element. Fraser was the only person who had even the faintest idea how to put a show together. Help had to be found for the myriad theatrical details that would have to be dealt with once the cast was selected and the script prepared — which Fraser himself would have to write.

That help would come from the theatre community. One task was to find someone who could design the stage, costumes, and props. Sam Leve, a New Yorker who had worked on the 1967 Tattoo, was an obvious choice, but a phone call confirmed he was not available. Then John Neville, artistic director of the Neptune Theatre in Halifax, provided the solution. "The best designer in Canada is a guy by the name of Robert Doyle," Neville said. "He lives right here in Halifax — give him a call."

Doyle, an ardent Royalist, was born in Scotland. Partly because of those factors, he was a perfect fit for the International Gathering of the Clans. He had designed costumes for Fortress Louisburg, had worked extensively in the theatre in Canada designing sets and costumes, and was then head of the Costume Studies Department at Dalhousie University.

He accepted the appointment in a flash.

◀ ▲ A few of the thousands of props in storage.

Although Doyle tended to think on a grand scale, he nearly had a stroke when Fraser told him he wanted a stage that could hold at least three hundred people. Doyle set about designing the stage and the various bits and pieces that went with it. Fraser's direction to him to "pull out all stops" was all he needed. He had never worked on an arena show, but thinking big and lavish was not a problem for Robert Doyle. Luckily, that attribute fitted in perfectly with Fraser's vision of the show.

Doyle brought others on side: stage carpenters, props builders, painters, wardrobe staff, cutters, and costumers. He arranged to have tartan backdrops painted—forty-five feet high and six feet wide, representing seventeen Scottish Clans. Then he threw in seventeen massive Clan crests and a ten-by-one-hundred-foot painted tartan main stage curtain. Doyle didn't want it to be a standard theatrical pulled curtain—a conventional curtain was too pedestrian for Doyle's image of the show. Instead, he cut it in strips from top to bottom and the performers simply marched through the split curtain. Under Doyle's direction, more than three hundred metres of white cotton had to be painted as tartan. It also had to be paid for, and that nearly gave George Tibbetts chest pain.

Doyle would design and build some costumes as well, but Fraser wanted a massive historic opening tableau with hundreds of performers. Where to find costumes for such a display? There was no time and not enough money to pay for making them; renting them would be far beyond the available resources. Fraser had an idea.

What about the thousands of costumes and props from the 1967 Tattoo? Were they still somewhere in Ottawa? It seemed unlikely, more than ten years later, but it was worth a shot. Lieutenant-Colonel Bob MacLean, Fraser's number two, took that one on—and much to everyone's amazement, he discovered them sitting in boxes in a dusty Canadian War Museum warehouse, awaiting disposal to the rag trade. MacLean went to Ottawa and somehow convinced the War Museum to give them up, then had them loaded in two forty-foot vans and shipped to Halifax.

Everything needed for a Canadian historic scene was there: thousands of early French and British costumes, uniforms, and accoutrements—French from the 1600s, British from 1775—Navy uniforms from 1812, Boer War, First and Second World War

D-Day: Before the Landing

▲ Black Watch
buttons

uniforms, toy soldier costumes, and boxes
upon boxes of other costumes. There were
props, small set pieces, drums, pikes, halberds,
swords, and muskets. There were even two
gorilla suits.

It was a treasure trove. Thanks to Bob
MacLean's initiative and his relentless pursuit of
the 1967 hoard, the Tattoo's costume and props
problem was solved. Just as important, given the
financial problems that were surfacing, it did not
cost a penny.

► ▼ Tattoo costumes

Musician from the Band of the Ceremonial Guard

◀ Royal Nova Scotia International Tattoo Coat of Arms

Lighting was another problem, but again Fraser drew on his 1967 contacts. Jim Fuller of Century Lighting in Toronto had worked on the 1967 Tattoo and understood full well what sort of lighting rig was required for an arena production. Fuller was an old-fashioned stagehand and lighting technician and had been involved in Canadian theatre since he was a teenager. He had worked on the Canadian Army's World War 2 Army Show, which featured, among others, comedians Wayne and Shuster. He also had a strong connection to the International Alliance of Theatrical and Stage Employees and, as far as he was concerned, providing the lights and the crew didn't offer much of a challenge.

But the Tattoo also needed a lighting designer, so, out of friendship with Fraser, Fuller undertook a recruiting process. He found Donald Acaster, then at Brock University, who had designed lighting for a great many Canadian productions, including Festival Canada at the National Arts Centre, the Canadian Opera Company, the Neptune Theatre, Expo 67, and the Shaw Festival. Another problem solved.

Fraser still had to find other staff, select the cast, and prepare the script, but already some performers had been tentatively booked. Don Tremaine, the well-known CBC radio and television announcer, had agreed to act as announcer/narrator for the show. Joe Wallin, a former member of the famed Buchta

Dancers and proprietor of a local dance school, had been tasked as choreographer and was well into the process of recruiting Highland dancers for the show.

Fraser and Tibbetts then recruited Pipe Major Don Carrigan, formerly of the Black Watch, who was serving at the Royal Military College in Kingston, Ontario. Carrigan was given a list of pipe bands that been selected previously for the opening ceremony; most of them were coming from Nova Scotia, but one would be from as far away as Hamilton, Ontario. For Carrigan, pulling together as many as two hundred pipers and drummers, some of dubious quality and most of whom had never worked in a massed band in an arena setting, would be an awesome task.

On the list were The Men of the Deeps, from Cape Breton, who had already developed an international reputation under the direction of John O'Donnell, a music professor at St. Francis Xavier University in Antigonish, Nova Scotia.

Also coming from Antigonish was The Gaelic Choir, whose director was Sister Agnes MacAdam, a feisty no-nonsense nun who made it clear from the outset that if the acoustics in the Metro Centre were as bad as she'd heard, she had every intention of marching her choir down from the stage and across the arena floor, where it would perform fifteen feet away from The Queen Mother and the other dignitaries in the VIP box. There was no doubt in anyone's mind that she would do exactly as she said, and if it came to that, there was nothing that could be done to stop her.

The military provided the Stadacona and Naval Reserve Bands along with the Vimy Band from Kingston, Ontario, teams from the Nova Scotia Highlanders for a "Regimental Tournament," and air cadets from Cape Breton to perform an unusual fantasy "Battle of the Clans" — essentially a *Star Wars*-like battle of small robots as space clansmen in the year 3001. Designing and building costumes for Highland robots based loosely on R2-D2 was right up Doyle's street.

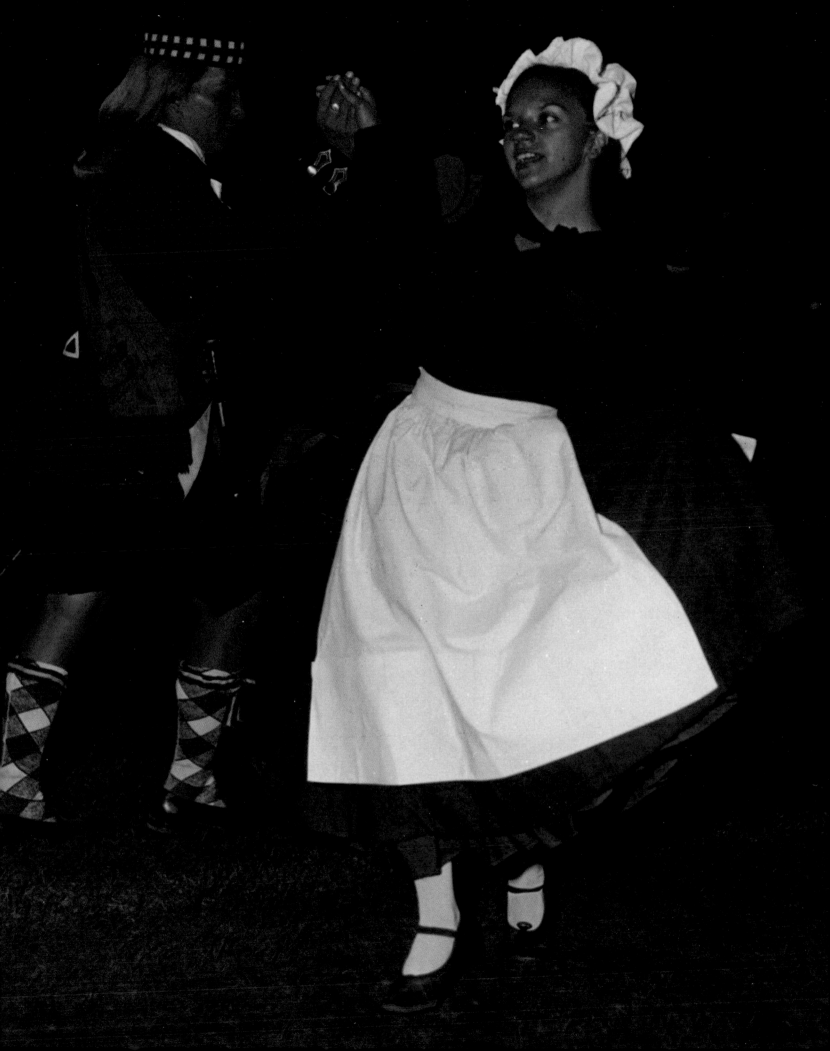

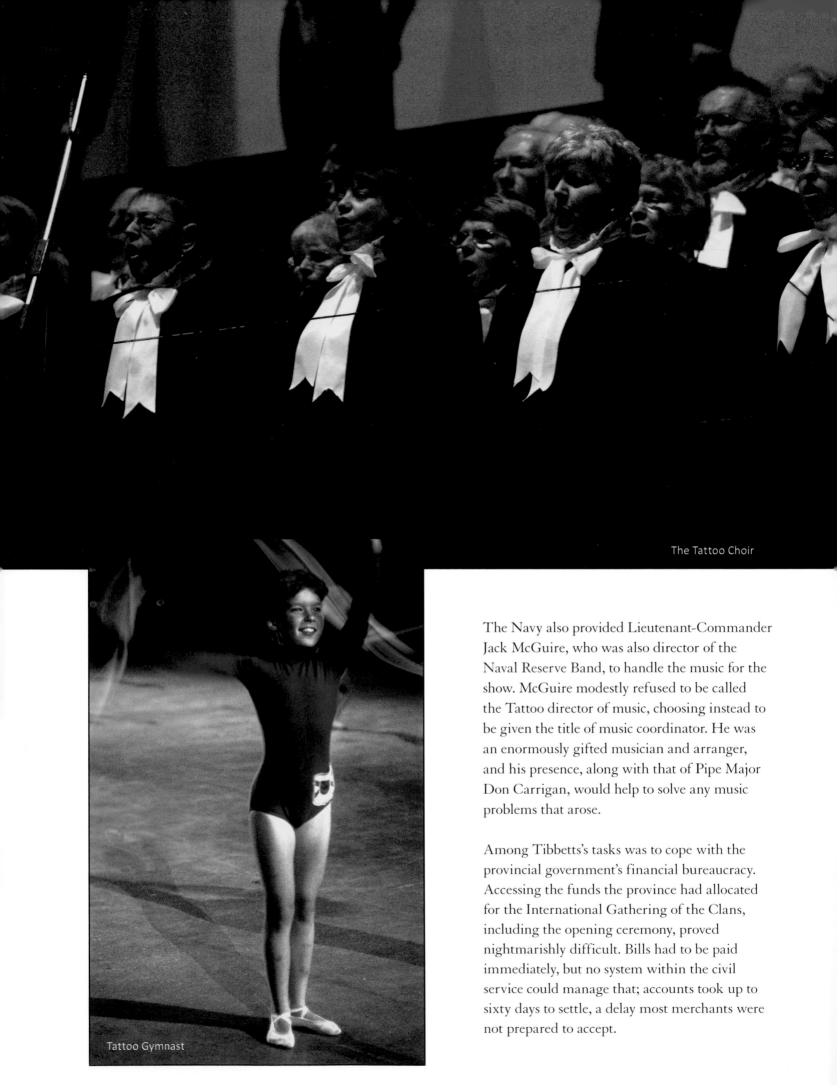

The Tattoo Choir

Tattoo Gymnast

The Navy also provided Lieutenant-Commander Jack McGuire, who was also director of the Naval Reserve Band, to handle the music for the show. McGuire modestly refused to be called the Tattoo director of music, choosing instead to be given the title of music coordinator. He was an enormously gifted musician and arranger, and his presence, along with that of Pipe Major Don Carrigan, would help to solve any music problems that arose.

Among Tibbetts's tasks was to cope with the provincial government's financial bureaucracy. Accessing the funds the province had allocated for the International Gathering of the Clans, including the opening ceremony, proved nightmarishly difficult. Bills had to be paid immediately, but no system within the civil service could manage that; accounts took up to sixty days to settle, a delay most merchants were not prepared to accept.

Joe Clarke, the premier's chief of staff, did his best to resolve the situation and cut through some of the red tape. Tibbetts concluded, however, that if the job was going to get done, some other arrangements would have to be made until Clarke and his staff could sort things out. He solved the problem temporarily in a very simple way: he paid the bills with his Visa card and hoped he would be repaid before his credit rating was completely fractured.

Slowly, things began to come together, but then another problem surfaced. This was a big one.

Fraser had been assured by his contacts in the provincial government and at the International Gathering of the Clans that the Metro Centre would be available for five days of set-up and four days of rehearsals. Twice as much time would have been nice, considering the cast and staff had never before worked in an arena production, but Fraser would make the best of the time he'd been allowed.

A scheduling conflict suddenly erupted, however, with a convention of dieticians and a trade show on the floor of the Metro Centre. Pleading failed to have any effect, and the Tattoo team was obliged to settle for around four days in which to set up a massive stage and rehearse a cast of seven hundred and fifty performers, none of whom had ever worked together before. On its last day, the trade show would be clear by five p.m.; only after that could the set-up begin.

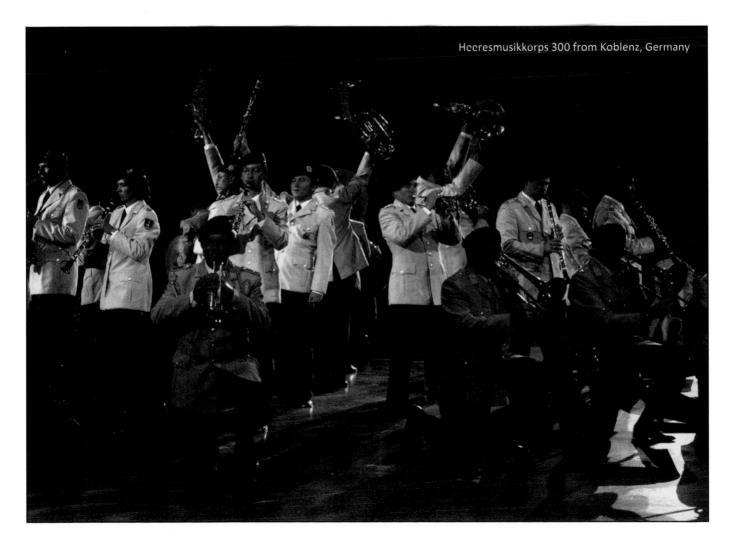

Heeresmusikkorps 300 from Koblenz, Germany

The crew and the staff worked around the clock. While the stage was still being set up, the cast began to rehearse on the arena floor. It was chaos. In the end, there was simply not enough time for anything other than a rudimentary rehearsal and certainly no time for a proper dress rehearsal.

Minutes before the doors of the Metro Centre opened for a full house, Bill Pike, the head carpenter, was putting the finishing touches on the stage and Doyle and his crew were daubing paint on the tartan backdrops and making final adjustments. What would happen over the next few hours was anybody's guess.

The crowd was enormous — probably the largest since the Metro Centre had opened — and the downtown streets were clogged with traffic. As the appointed time for the arrival of The Queen Mother and the VIP party drew near, there was no sign of announcer Don Tremaine, evidently held up by traffic. That was another blow, since Don was meant to be the glue who would hold the evening together if the cast floundered — which, in view of the lack of rehearsal — was not only possible, it was very likely.

Fraser recalled the incident. "Don's not being there," he said, "was pretty much the last straw, especially since none of us had had any sleep for the best part of the past four days." Fraser went on. "There was a radio announcer from CHNS, one of the local stations, on the catwalk to cover the arrival of The Queen Mother, so I went to him and asked if he had ever done a live announcement of an event. He seemed a bit startled, so I handed him a script and said, as gently

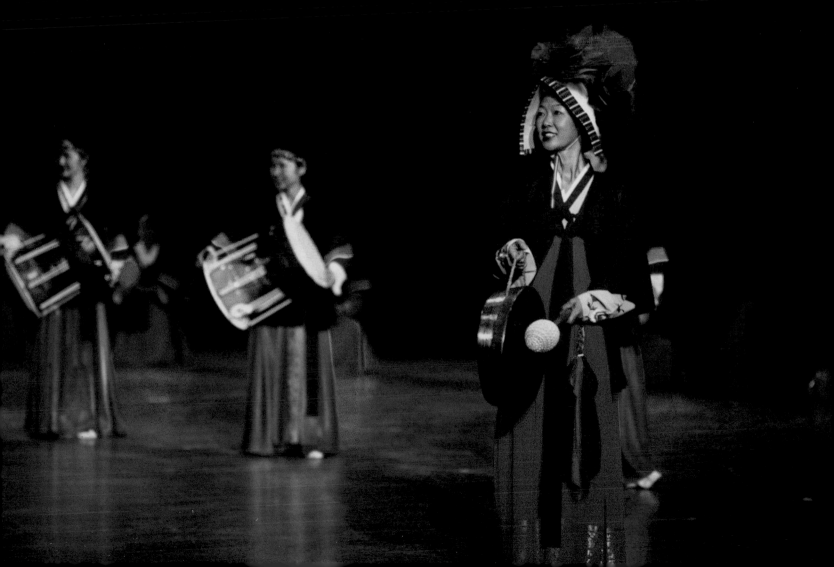

Drummers from the Korean Institute of Missionary Arts

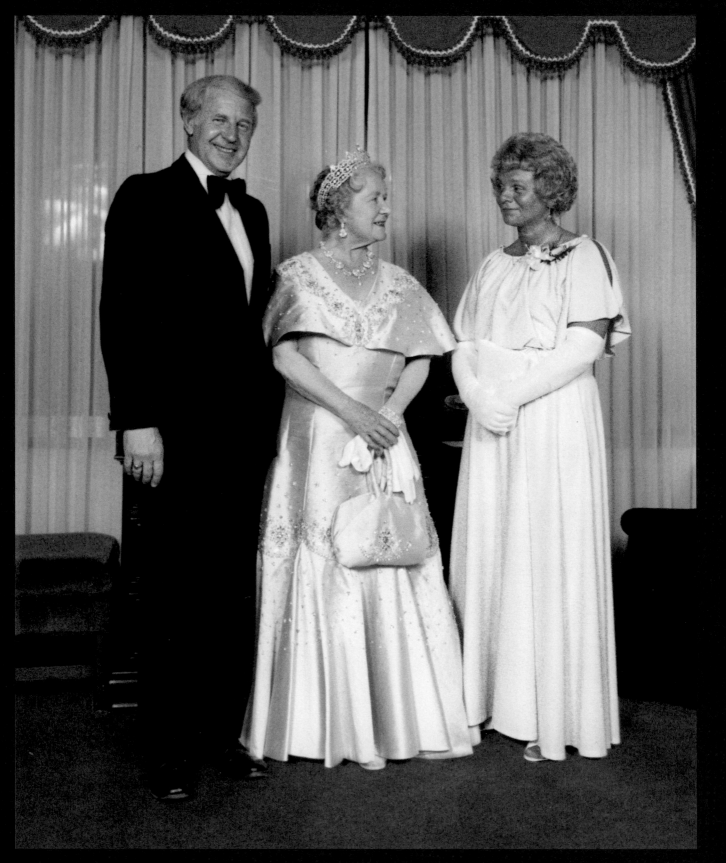

Her Majesty Queen Elizabeth The Queen Mother with Premier and Mrs. John Buchanan, 1979

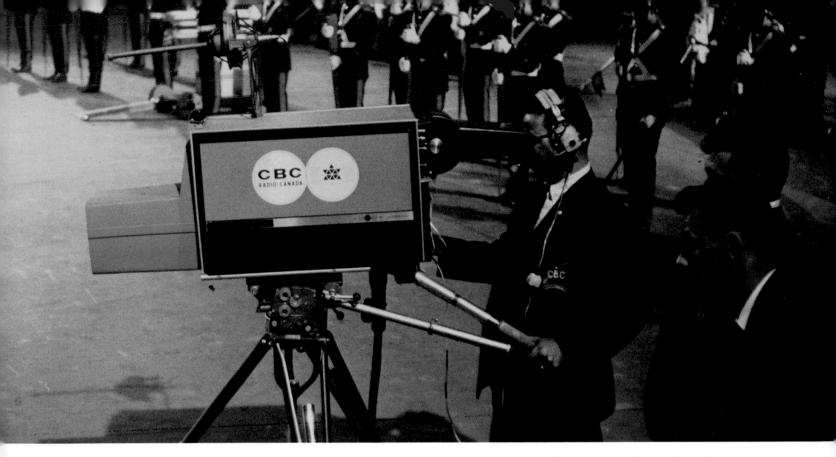

CBC captures the 1967 Tattoo for a wider audience

as I could, 'guess what, you are going to be doing it if Don Tremaine doesn't show up'." With less than five minutes to go, though, and much to the obvious relief of the terrified radio announcer, Don arrived.

As the band played Elgar's majestic "Pomp and Circumstance March No. 4," The Queen Mother drove slowly around the arena in a convertible. Eight thousand people spontaneously rose to their feet as one and their thunderous applause shook the rafters of the Metro Centre as they welcomed the seventy-nine-year-old Queen Mother to Nova Scotia. Then, in a gracious speech, she officially opened the International Gathering of the Clans. The lights dimmed, and the overture appropriately named "A Hundred Thousand Welcomes" heralded the first Nova Scotia Tattoo.

The cast rallied around and the adrenaline created by the presence of Her Majesty more than compensated for the woeful lack of rehearsal. The Queen Mother

was charmed by the performance, especially that of the young Highland dancers, whom she later described as reminding her of "wisps of thistledown," a compliment that would be greatly treasured by Nova Scotia's young Highland dancers for the next three decades.

Dr. A. Gordon Archibald and Premier Buchanan basked in the success of the Tattoo and the Royal Visit. Admiral Collier was delighted. And Nova Scotians, especially those with a love of all things Celtic, could not stop talking about the show. Harold Shea, the editor in chief of the Halifax *Chronicle Herald*, decried the possibility that the Tattoo might end. In words that thousands of Nova Scotians were thinking, he wrote, "It would be nothing short of sinful to allow it to disband, and not to reunite the talents in the years ahead."

The seeds of the future were sown.

The Centennial Connection

The event that had the greatest impact on the development of the Royal Nova Scotia International Tattoo was the "Canadian Armed Forces Tattoo" presented as part of Canada's Centennial celebrations in 1967. That show remains the largest touring production presented anywhere in the world, and it was created and staged entirely by members of the Canadian Forces. The Tattoo — essentially a massive historic pageant, larded with music and spectacle, with thousands of costumes and props and a storyline based on the history of the Canadian Forces — toured the country for eight months.

The staff that took on the 1967 Tattoo project probably did not know enough about the theatrical business to be concerned about what they were doing. To some degree, the statement that "fools rush in where angels fear to tread" was remarkably applicable. Nonetheless, on the theory that the military can do anything, the soldiers simply plunged in, wrote the show, designed the props and costumes, arranged the music, selected the cast, developed the production plan, and then implemented it. It took three years, but, in the process, the Canadian Army became the most skilled in the world in mounting large productions in stadiums and hockey arenas.

In addition to the small production team, a half-dozen other staff planners came from a Canadian Forces organization known simply as the Director General Centennial. Under the guidance of Brigadier Arnold Peck, they took on the massive task of organizing the show and arranging the formidable level of administration and logistics that went along with it — they were, in fact, the show's unsung heroes.

Empire Stadium, Vancouver
Canadian Armed Forces Tattoo, 1967

With a cast of more than 1,700, the "Canadian Armed Forces Tattoo" played to packed football stadiums in Victoria, Vancouver, Montreal, Ottawa, Toronto, and Hamilton during the summer of 1967. Preceding those huge performances were two smaller touring companies, each with a cast of two hundred and fifty, moving by special trains across the country and performing a miniature version of the stadium productions in hockey arenas in forty large and small communities across the country.

Close to a million Canadians flocked to see the 1967 Tattoo, which became one of the jewels in the crown of Canada's Centennial.

The 1967 production itself was not an isolated event, and the planning team for that show drew heavily on lessons learned a few years earlier. The genesis of Canadian Tattoos was "Soldiers of the Queen," a small historic pageant conceived in 1959 by Brigadier Robert Moncel, when he commanded the brigade in Base Gagetown, New Brunswick, a few miles from Fredericton.

Moncel, who as a lieutenant-general later quietly resigned over the unification of the Canadian Forces, was an immensely intelligent visionary. "Soldiers of the Queen" featured the usual elements found in a traditional tattoo — bands, pipes and drums, military displays, Highland dancers, and pageantry — but this one was a little different. Moncel focused on working within a theme — in this case, one with a historical component, the early French settlement in New Brunswick.

Ian Fraser, at the time an officer in the Black Watch who had been freelancing as a dramatist with the CBC, was dragooned onto the brigadier's team. Working under Moncel, he wrote the script for the show, then found himself directing the production, which was staged in a small arena in Fredericton.

"Soldiers of the Queen" would not be Fraser's last venture into military show business. In 1962, he was summoned from the Infantry School at Camp Borden, Ontario, to organize "The Canadian Tattoo" at the Seattle World's Fair. Drawing on his experience in Fredericton, he applied Moncel's vision to that show, which turned out to be a highlight of the fair.

Canadian Armed Forces Tattoo brochure, 1967

Three years later, while attending Staff College in India, Fraser was called back to Ottawa to produce the ''Canadian Armed Forces Tattoo.'' His experiences from the Fredericton and Seattle shows would help take the production of the Centennial Tattoo and later the Nova Scotia Tattoo to a higher level. Besides Fraser, of those who worked on the 1967 show, only Doug Bell — who also worked on the Seattle show — would become part of the Nova Scotia team, as an assistant director and announcer. Fraser and Bell had learned their trade well, and the lessons from Fredericton, Seattle, and 1967 were applied to the Halifax production.

Above all, however, it was the vision of Brigadier Bob Moncel that formed the basis of the Royal Nova Scotia International Tattoo. As Fraser readily acknowledges, ''Sadly, before the general died, I never took the time to thank him for his vision and foresight that made the Nova Scotia show possible. Every time I watch the Tattoo, I can't help but think it was the tiny show in Fredericton forty years ago, created by General Moncel, that did so much to make this one such a great success.''

Canadian Armed Forces Tattoo, 1967

An Unusual Relationship

The relationship between the military and those from the theatre on the production team is an unusual one, and not without its problems.

The military system of giving orders within a chain of command, to be implemented without question or discussion, was something the theatrical team could not accept. For their part, soldiers on the staff found it hard to understand that theatre people move in a free, generally unrestrained manner and consider it their professional duty to question direction or to improve on every suggestion, even so-called orders from on high.

The military staff slowly began to realize, however, that there is also a great sense of discipline in the theatre, but of a different kind. It is based on strong self-discipline drawn from the ancient tradition that "the show must go on." As part of that discipline, everything moves to opening night and, once the show opens, it is locked in without much room to make changes. To the soldiers, who saw it like a military operation, that strategy made sense.

Before long, the strict military approach was watered down and input from all members of the team led to a degree of consensus before any final decisions were taken. Slowly, the theatrical team and the military staff grew closer and, more important, began to respect each other's contributions.

The theatrical element acknowledged the ability of the military staff to plan and implement operations effectively and efficiently. With some surprise, they also discovered that the soldiers, especially those who had chosen to "follow the drum" out of an old-fashioned sense of adventure, were the source of much imagination and creativity. The Canadian Forces staff, in turn, saw how quickly and efficiently the theatrical staff got things done without bureaucratic rules or even, in some cases, direction. The soldiers were awed and astounded by the skill and creative contribution of the theatre side of the team.

There was another problem.

Theatre people are trained to think within the framework of a proscenium stage with a limited number of performers

and are skilled in working in that context. Working on the canvas of an arena floor nearly two hundred feet long and almost eighty feet wide meant a major readjustment for them. The military, however, thinks in large numbers. Huge bands, marching troops, and hundreds of performers could be moved exactly the way soldiers had been moved and drilled for thousands of years. Before long, the two elements were learning from each other, and the team began to come together. The saying "the only bad idea is the one you don't mention" began to drive everyone in the same direction. During the early years, the alternative lifestyles of some team members from the theatre side raised a few military eyebrows. The soldiers were not used to it and some had difficulty accepting it. But times change.

Don Acaster, the lighting designer, was openly gay and had been in a strong, devoted relationship with his partner for many years. He felt that, if it was a problem, it was the military's, not his. Canadian Forces staff might have been reluctant at first to acknowledge his being gay, but Acaster talked openly about his relationship with his partner, even joked about it, and made certain that everyone knew exactly where he stood.

After a short time, even the hardened old soldiers accepted Don's lifestyle and began to develop great respect both for his creativity and skill and for his frankness and openness. Before long, they would tease him about it, and he would respond cheerfully in kind. Many years later, when Don fell critically ill, partly as a result of his penchant for cigarettes, the old soldiers on the team watched in awe as his partner cared for him and nursed him until the end. There was great sadness among the military staff that had worked with him and admired the relationship Don and his partner had enjoyed for so long.

Upon his death in 2002, Don Acaster left two significant legacies to the Tattoo. One was the show's immensely high standard of lighting design. The other, much more important, legacy was a spirit of tolerance and understanding that, as much as anything else, pulled the production team from the Canadian Forces and the theatre closer together.

Once the jetty parties have laid out the equipment on the arena floor, both teams will assume the starting position. At the sound of the starter's signal each of the 17 man teams must take its gun and equipment over the wall (1).

After disassembly, the equipment is carried across the chasm (2). First across on the traveller will be the 180 lb wheels carried by one man each. The carriage is next - its 450 lbs being handled with apparent ease. Following quickly are the 250 lb cannon and the 175 lb limber each carried by 2 men.

START/FINISH

Once on the other side, the equipment is passed through the hole in the wall (3), reassembled and the cannon fired (4) at the predetermined aiming mark. The procedure is then reversed and the equipment is passed over the wall, across the chasm, and fired again (5). After the second firing, the equipment is passed under the wall, reassembled and the teams race for the finish line.

The first team across the finish line is the winner - subject to penalty seconds which may be added. Penalty seconds are given for offenses such as dropping equipment, unsafe practices and improper drill and dress.

The team with the shortest accumulated time during all races is declared the Champion Team of the Canadian Naval Gun Run Competition and will be awarded the William Hall V.C. Memorial Trophy emblematic of the Canadian Naval Gun Run Championship which has been presented by the Province of Nova Scotia.

▲ A diagram explaining The Gun Run ▼ Sea Cadets and a saluting gun

The GROWING YEARS

During the summer of 1979 Nova Scotians continued to bask in the fallout from the International Gathering of the Clans as thousands of tourists from Canada and abroad attended the various events throughout the province. The Tattoo remained the centrepiece of the Gathering, and by September the province was awash with rumours that the show might be mounted again in 1980, fuelled by a comment by Development Minister Roland Thornhill to the *Chronicle Herald* that the provincial government was looking at the possibility of making the Tattoo a permanent tourism attraction.

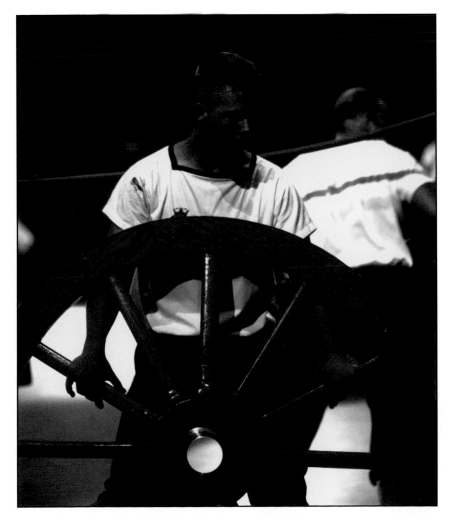

The Gun Run

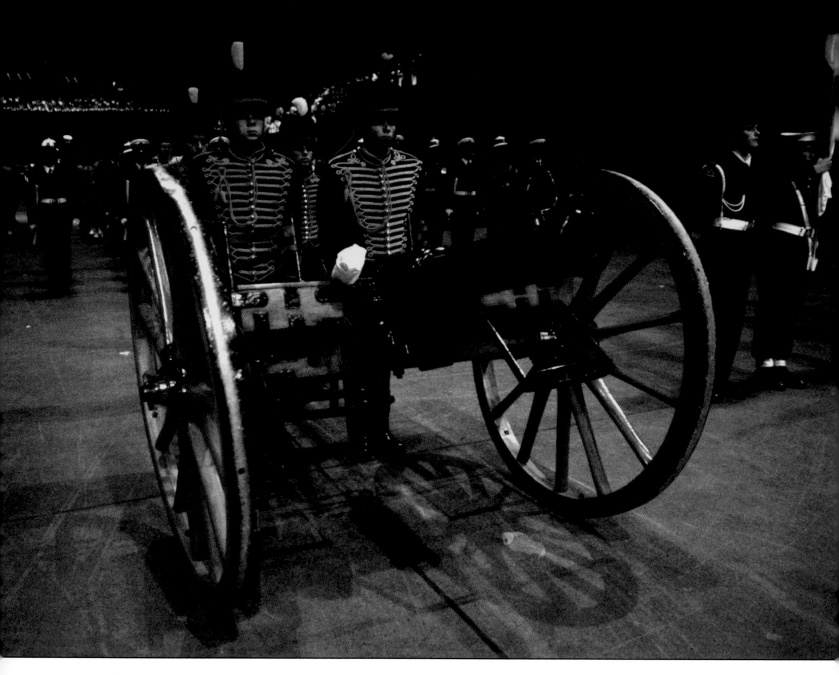

The 2nd Regiment of the Royal Canadian Horse Artillery during the Finale

That summer, Vice-Admiral Collier retired and was replaced by Vice-Admiral John "Jock" Allen. Allen shared Collier's view that continuing the show would greatly strengthen the relationship between the Navy and the province. From the point of view of Premier Buchanan, with the Navy on side, the only potential obstacle was removed and the decision was taken early that autumn to continue the show for another year. The province made no commitment, however, beyond the 1980 production — that would be up to the cabinet.

The 1979 team from the Navy's Regional Operations staff was given the task of organizing the 1980 Tattoo. A few faces had changed as the Canadian Forces had

posted some of the 1979 team elsewhere, but most of the group was still there along with the key civilian staff that had helped with the International Gathering of the Clans show.

The theme for the show would be the seventieth anniversary of the Royal Canadian Navy, which was founded in 1910 in Halifax. But more would be required to stimulate local interest and draw tourists to the province the following summer. The solution was provided by the marketing staff of the Department of Tourism, with the help of Theta Marketing, the province's designated advertising agency.

Two key people surfaced: Dan Brennan, the marketing guru in the department, and Charlie McGuire, the owner of Theta Marketing. They came up with an idea. Why not create a summer festival focusing on the Canadian Navy, with a fleet review, the Tattoo, and a revival of "Meet the Navy," the enormously successful World War 2 Navy Show that had played across Canada and the United Kingdom during the war? Other provincial items could be included, thus creating a full summer program. The festival would be named "Super Summer Eighty," and the virtually endless energy of both McGuire and Brennan added zest to the concept.

Fraser and Brennan, being somewhat similar in terms of imagination and drive, clashed on occasion, but they had great respect for each other. Thirty years later,

Fraser is still convinced that Dan Brennan, who had come from the private sector to join the provincial public service, was easily the best marketer the Nova Scotia Department of Tourism ever had.

The staff of Theta Marketing, under the direction of Charlie McGuire, took on the promotion and advertising. The result was a campaign that was original, colourful, and broad reaching. Derek Sarty's poster and brochure material was a light-hearted departure from the somewhat staid and traditional work that had tended to be the hallmark of earlier tourism campaigns.

While Brennan and McGuire set about promoting "Super Summer Eighty," the Tattoo staff began to plan the show.

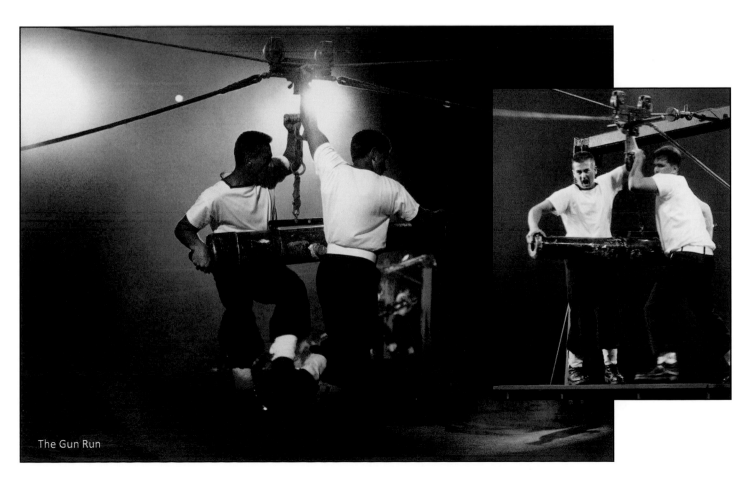

The Gun Run

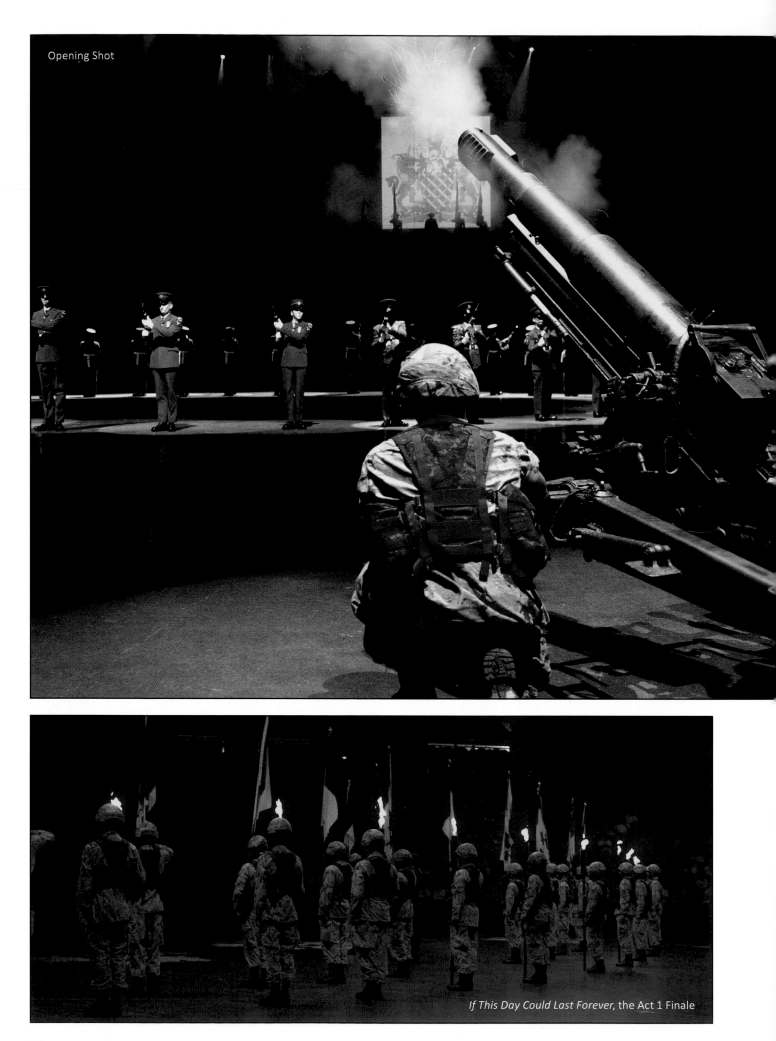

If This Day Could Last Forever, the Act 1 Finale

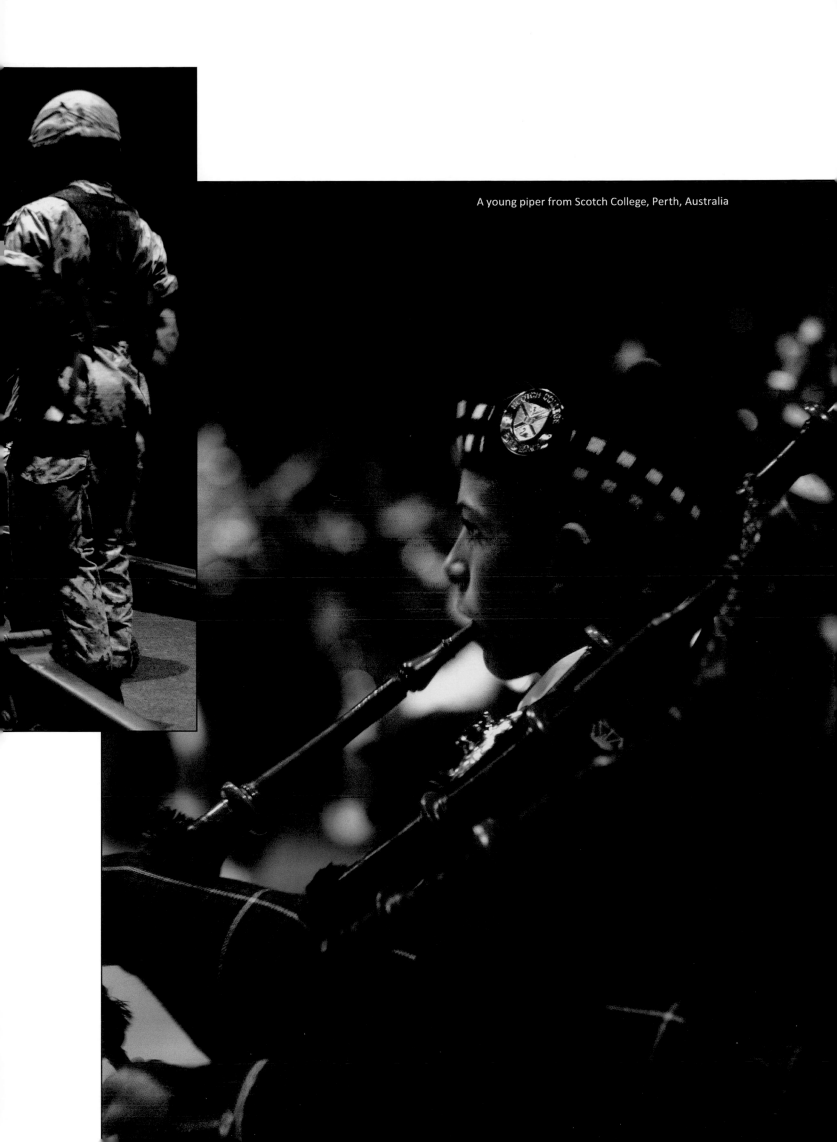

A young piper from Scotch College, Perth, Australia

One key element, especially since the Navy had thrown its weight behind the project, would be the revival of the Naval Gun Run that had been part of the Centennial Tattoo in 1967. In this challenging exhibition, sailors carried naval field guns over a gruelling obstacle course. It was patterned loosely on the famous Royal Naval Gun Run, but, unlike the British system, which was somewhat labour intensive, the Canadian event would be based on obstacles that could be erected and removed quickly. The field guns and carriages that had been constructed for the 1967 show also were lighter than the equipment used by the Royal Navy, making the Canadian Gun Run much faster, but no less exciting, than the Royal Navy version. What gave an unusual twist to the event, however, was that the 1967 guns were accurate replicas of the field guns carried on board Royal Navy vessels in 1812. But there was a problem: no one knew where the equipment was.

Enter Chief Petty Officer Ray Lawrence. First, he sought the help of retired Lieutenant Jack Hannam and retired Chief Petty Officer Ray Ellison, both of whom had been Gun Run officers during the 1967 tour and were now living in British Columbia. Then Lawrence scoured the country. He found the obstacles, four sets of them, in a warehouse in Ottawa, then tracked down three of the four field guns. The fourth seemed to have vanished. Then, much to everyone's amazement, it surfaced in the Nova Scotia Museum storage facility in Mount Uniacke. No one had the faintest idea how it ever got there.

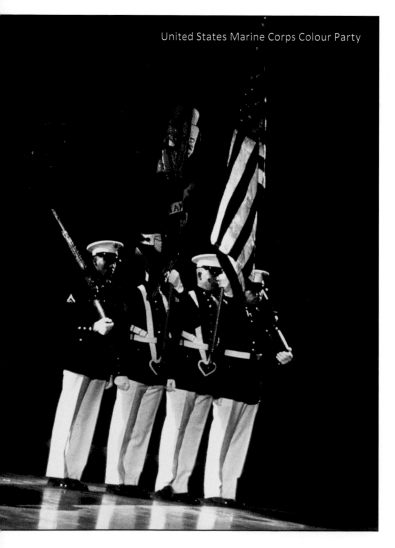

United States Marine Corps Colour Party

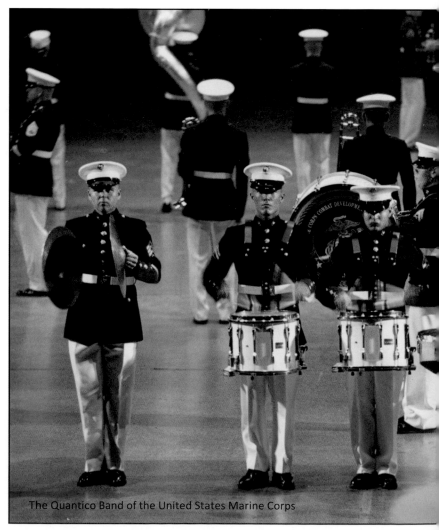

The Quantico Band of the United States Marine Corps

With the equipment now in place, Lawrence sought out two more retired chief petty officers from the 1967 show, George Boardman and Jerry Lavery. They would work with the designated naval instructor, Chief Petty Officer Doug Wright, a Naval Reservist in Halifax, to train the teams that would compete in the 1980 Tattoo. The teams were drawn from the Regular Navy and the Naval Reserve and included a number of young officer cadets awaiting training. One of those was Darrell Dexter, who, in 2009, would become the first New Democratic premier of Nova Scotia. Thanks to Lawrence's work, the Canadian Naval Gun Run became the centrepiece of the Tattoo for the best part of the next twenty years — after 1980 staged as a competition between the east and west coasts.

The Gun Run wasn't the only highlight of the 1980 Tattoo.

In an effort to create an international flavour and to help acknowledge the Canadian Navy's seventieth anniversary, the United States Marine Corps was invited to participate in the Tattoo. The Marines accordingly sent a band from Quantico, Virginia, under the leadership of Major Sid Snellings.

Snellings was a unique character. A garrulous leader who chewed on cigars he hid in the side of his boot and never smoked, Snellings considered himself and his musicians as Marines first and musicians second. He was unique for many reasons, not the least of

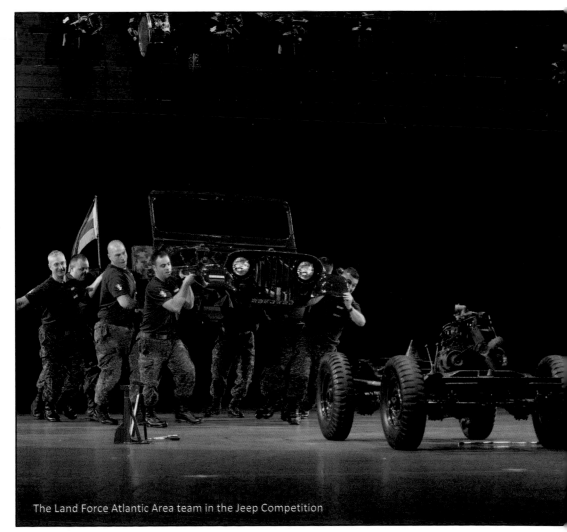

The Land Force Atlantic Area team in the Jeep Competition

▲ Queen's Colour Squadron of the Royal Air Force from the United Kingdom

which was that, as a band leader, he had won a Bronze Star for gallantry during the Vietnam War. Snellings claimed he came to Nova Scotia because of the people, the freshness of the air, and the local beer. Those who got to know him concluded that the beer was probably top of the list.

The band immediately established a rapport and a mutual love affair with Nova Scotians that continues to this day. The Quantico musicians were even declared honorary Nova Scotians by Premier Buchanan, and their music and marching routines set a standard for the Tattoo that holds to this day.

The Marine band's last appearance was in 1996. The next year a U.S. Navy Band came instead, followed by an Army band in 1998. Then U.S. military bands suddenly stopped coming after the Public Affairs Branch of the U.S. Defense Department decreed that

they could not be out of the United States on their national holiday, July 4, which, unfortunately, was in the middle of the Nova Scotia Tattoo's run. No one is quite sure if the Defense Department's rule was really new or a long-standing regulation that simply had been ignored with impunity by the bands over the years. It was a blow to the Tattoo, but the end of U.S. military participation did not end the affection of the Quantico musicians for the province, which many have visited regularly over the years.

The 1980 Tattoo was a great success. The mix of civilian and military performers continued to give the show an unusual and effective balance. New elements were added, based on the experience of the year before. New lessons were learned, new mistakes made, new ideas thought of—and with more rehearsal time the show had come together relatively smoothly.

Paris Police Gymnastics Display Team

Even with the success of "Super Summer Eighty," however, the province was not yet prepared to make a firm commitment to continue the Tattoo on an annual basis. That was to change under the leadership of Premier Buchanan. With the support of cabinet ministers Rollie Thornhill and Jack MacIsaac, Buchanan set about breaking down the resistance of other members of the cabinet. Some argued that the Tattoo should not be given preferential treatment when other cultural events were cash starved. MacIsaac countered that the Tattoo provided broad-based entertainment and had universal appeal, unlike some other events that, although they warranted support, appealed only to a small segment of the community.

That was a strong argument, but it didn't quite carry the day.

Another minister took the position that the Tattoo should be presented only every other year. MacIsaac pointed out that, for a variety of reasons, the concept would not work — indeed, if applied, the Tattoo would wither and die within a few years.

Buchanan, MacIsaac, and Thornhill also saw something else that other ministers did not recognize. They realized that the Tattoo had vast potential as a generator of tourist revenue, but that its potential could be achieved only over the long term, as the

Commander Jack McGuire, Principal Director of Music

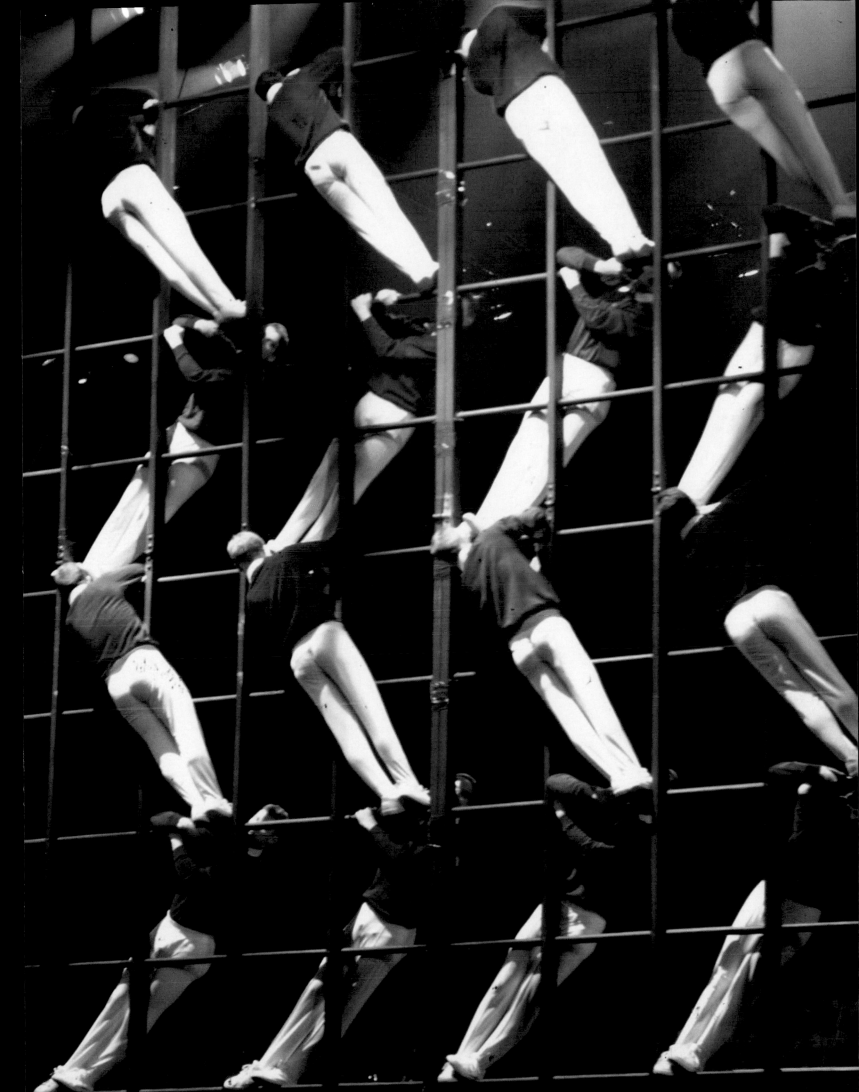

Canadian Naval Displays

◄ Ladder Routines

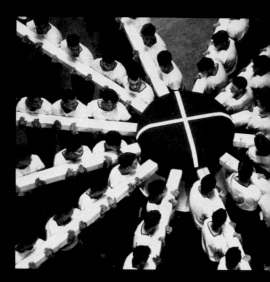

▲ Capstan Routine

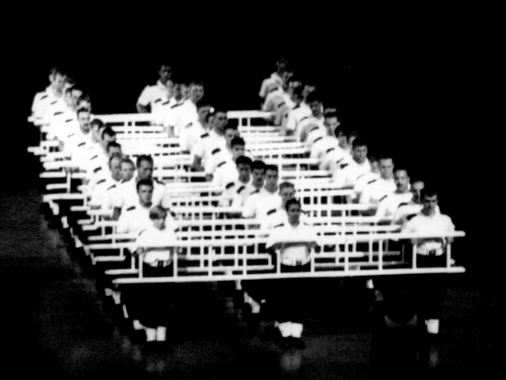

production gained an international reputation and began to draw tourists to the province. Once in Nova Scotia, they concluded, visitors drawn by the Tattoo would be exposed to other events and be enticed to return, perhaps even on a regular basis. Foresight is unusual in politicians, but Buchanan, Thornhill, and MacIsaac eventually carried the day. The Tattoo would become an annual event supported by the province and marketed by the Department of Tourism.

In summer 1980 Vice-Admiral Allen was posted to Ottawa and Vice-Admiral J.A. (Andy) Fulton took over command of the Navy. Of all the admirals involved with the Tattoo over the years, Fulton had the greatest impact on the production. He supported the Tattoo wholeheartedly and made certain the Navy followed his example. Largely because of Fulton's interest and support, the next two decades really became the golden years of the Navy's participation in the Tattoo.

The Band of the Canadian Naval Reserve under Lieutenant-Commander (later Commander) Jack McGuire, with as many as eighty musicians, along with the Stadacona Band and the Atlantic Area Army Band became the central musical components of the Tattoo. But more was needed from the Canadian Forces, and especially the Navy.

▼ Canadian Naval Display, Capstan Routine

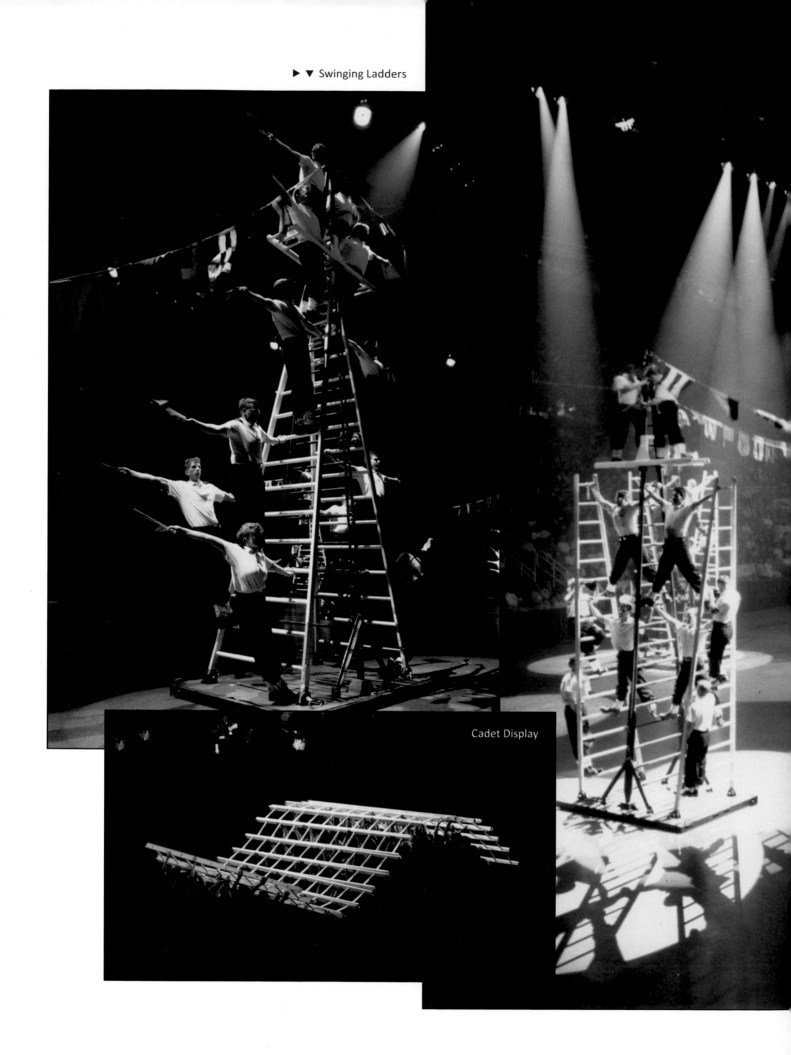

▶ ▼ Swinging Ladders

Cadet Display

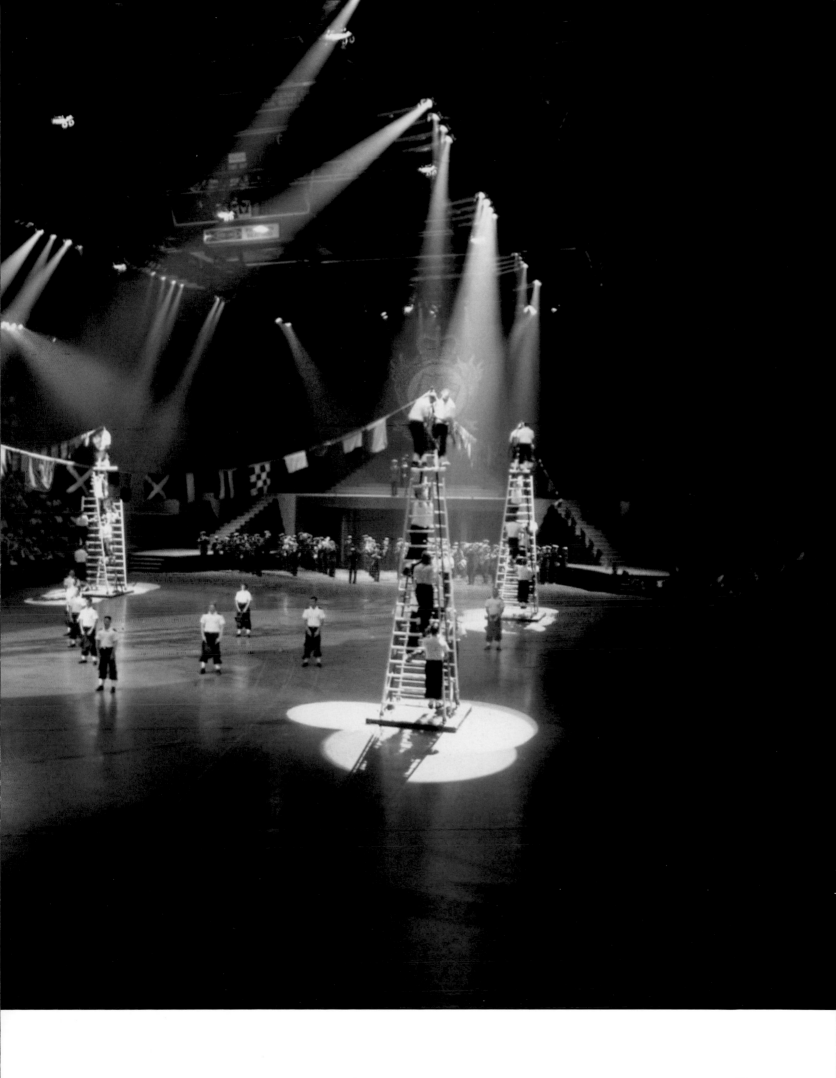

Enter the Fleet School of the Navy, which produced innovative and unique displays that captured the hearts of the thousands of Nova Scotians and visitors to the province who attended the Tattoo every year. One unusual and entertaining routine, created with ordinary painters' ladders, was drawn from Japan's "Renaissance For Peace" and adapted by the Fleet School for an arena production with young sailors under training. The School also designed a display based on the capstan used on the old windjammers, with sailors singing sea shanties to the spontaneous applause of a delighted audience.

A team from the Tattoo staff and the Fleet School visited Whale Island, the Royal Navy Training Centre in England to review the displays the Royal Navy had been performing over the years. The Canadians took a look at cutlass routines, were briefed on the Royal

Navy's famous window ladder display, and given drawings of the equipment and instructions on how to use it. When the Canadians got home, they adapted the window ladder routine, traditionally presented outdoors, to an indoor arena. With the help of the dockyard, they constructed large window ladder frames that folded out of the rafters of the Metro Centre and then disappeared at the end of the routine.

These and other routines from the Fleet School, along with the Naval Gun Run, became the centrepieces of every Tattoo during the 1980s and 1990s. With the encouragement of the various commanders of the Fleet School, a team of highly skilled and imaginative petty officers—Lemieux, Dumas, Muldoon, and Flynn—with a bit of help from the Army's John MacNeil, broke new ground every year with the naval displays.

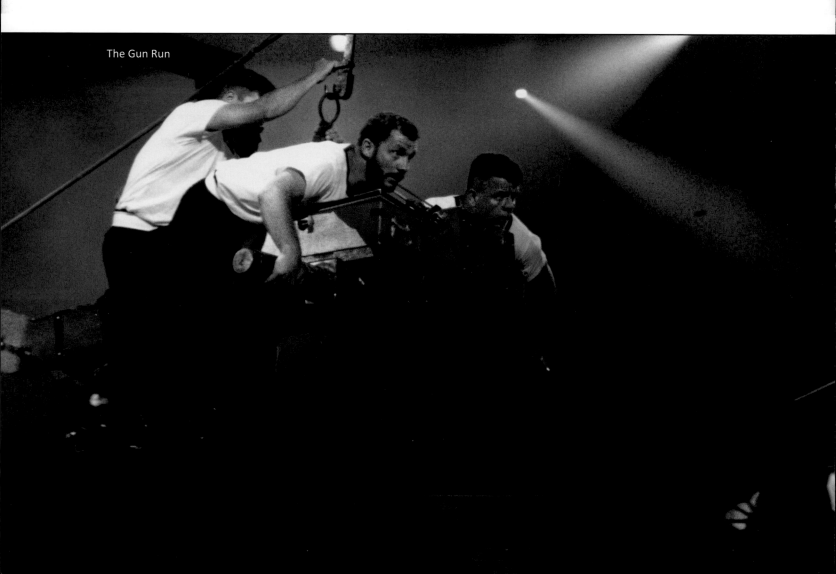

The Gun Run

The Tri-Service Obstacle Race

The Army Gun Race

The Army was there, too: pipes and drums, display acts, bands from the Royal Canadian Regiment, the Canadian Artillery, and Atlantic Militia, joined later by the Band of Ottawa's Ceremonial Guard. The Army Obstacle Race eventually became a tri-service contest featuring militia and regular force competitors, participation in which became a matter of great pride for the soldiers who took part. The Royal Canadian Regiment, the Regimental Band, and the Pipes and Drums even performed an abbreviated Trooping of the Colour on the floor of the Metro Centre as part of the Tattoo. Years later, a local Army commander, when asked why the soldiers took part, summed it up: "It's good for the Army, it's good for the public, and it's fun for the soldiers."

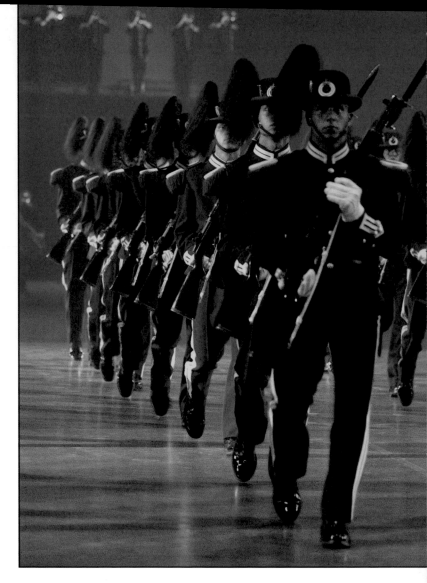

▲ His Majesty The King's Guards from Norway

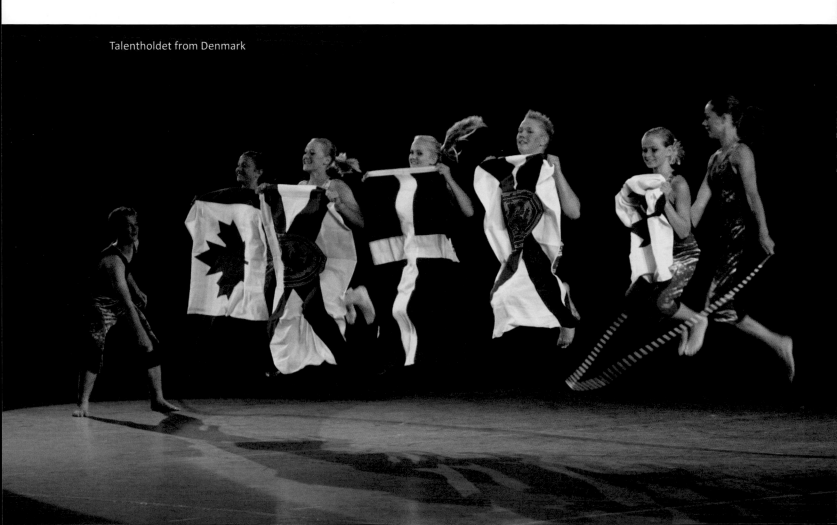

Talentholdet from Denmark

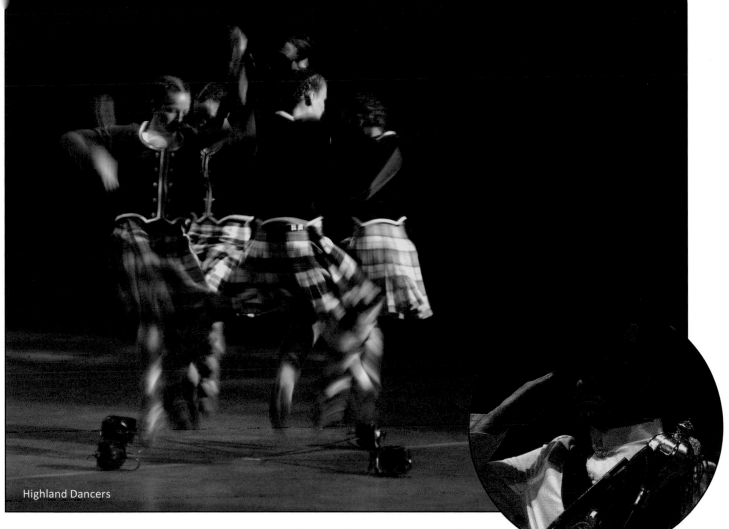

Highland Dancers

▶ Cadet Pipes and Drums Drum Major

A couple of Tattoo Extras

The list of international performers began to grow from the first appearance of the Quantico Marine Band in 1980. A German band first took part in 1983 — over the years, Germany has been represented more often in the Tattoo than any other nation. During the next two decades, the Tattoo's growing international reputation attracted participants from the United Kingdom, The Netherlands, France, Belgium, Denmark, Norway, Sweden, Estonia, Switzerland, Bermuda, Australia, New Zealand, Japan, Portugal, and Russia. By the turn of the century, eighteen countries had taken part in the Tattoo, and new nations — among them Ireland, South Korea, Oman, and Trinidad and Tobago — continue to join in.

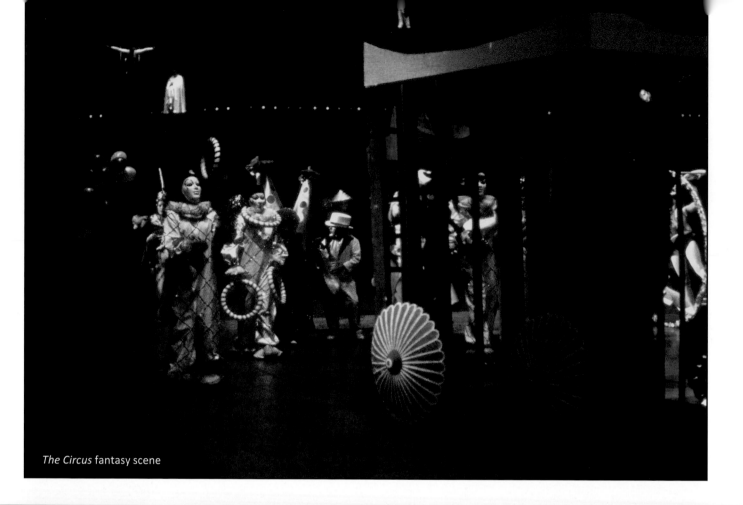

The Circus fantasy scene

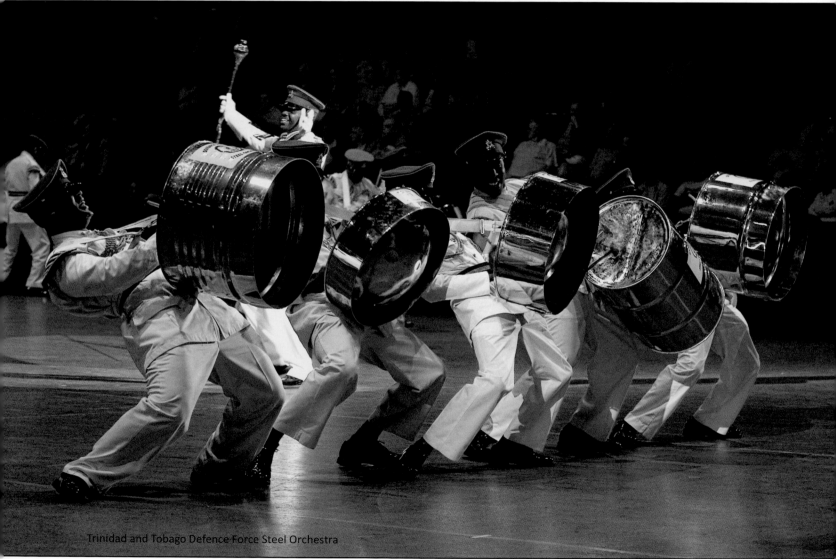

Trinidad and Tobago Defence Force Steel Orchestra

▲ Limbo Dancer from the Trinidad and Tobago Defence Force Steel Orchestra

A large choir of barbershop singers had been formed for the 1980 production and, in keeping with the Naval theme that year, performed "A Mess Deck Medley." This innovation led in 1983 to the establishment of the Tattoo Choir, under the direction of Dr. Walter Kemp, and later a junior choir, organized by Patricia Tupper, a protégée of Kemp's. Both choirs became permanent fixtures at the Tattoo. The choir idea and many other elements of the Nova Scotia show were later copied by major Tattoos around the world.

Another popular production was the children's scene, which provided Robert Doyle and his costume and props staff limitless opportunities to illustrate their skills. Joe Wallin trained the young dancers, gymnasts, and cadets were included, and the junior choir joined in. Huge production numbers, referred to by many as the Tattoo "Fantasy scenes," involved as many as two hundred youngsters. Before long, these productions, which some of the Tattoo staff began calling "Mickey Mouse scenes," became an annual highlight of the show. One was a circus act, with marching elephants, clowns, jugglers, circus wagons, and a large flying "Dumbo."

Buffy Andrews

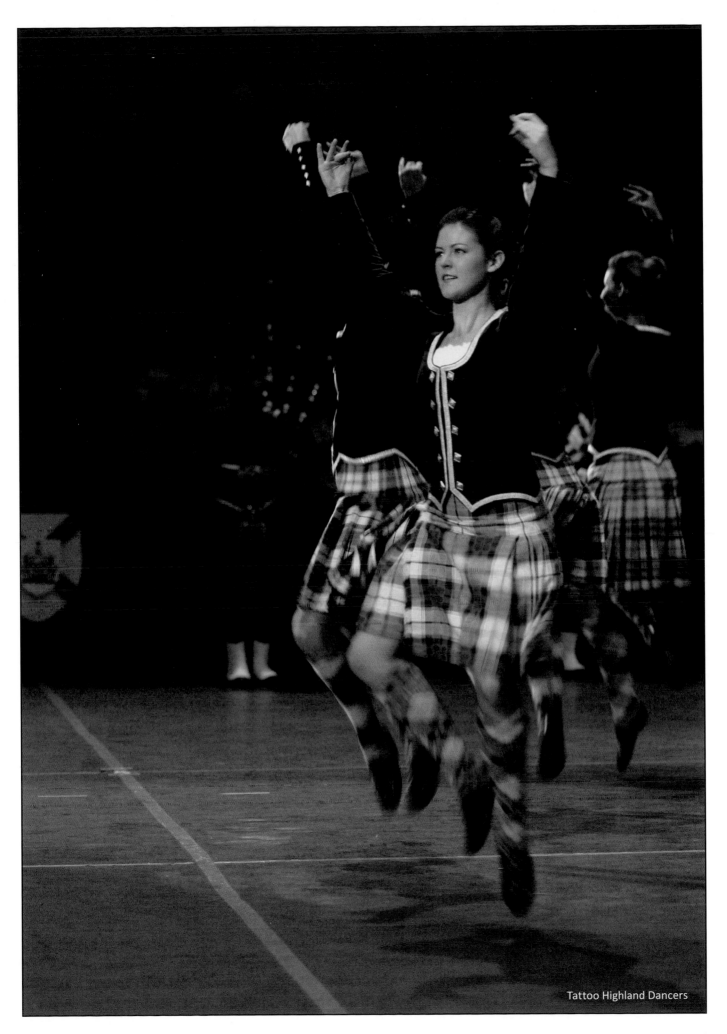

Tattoo Highland Dancers

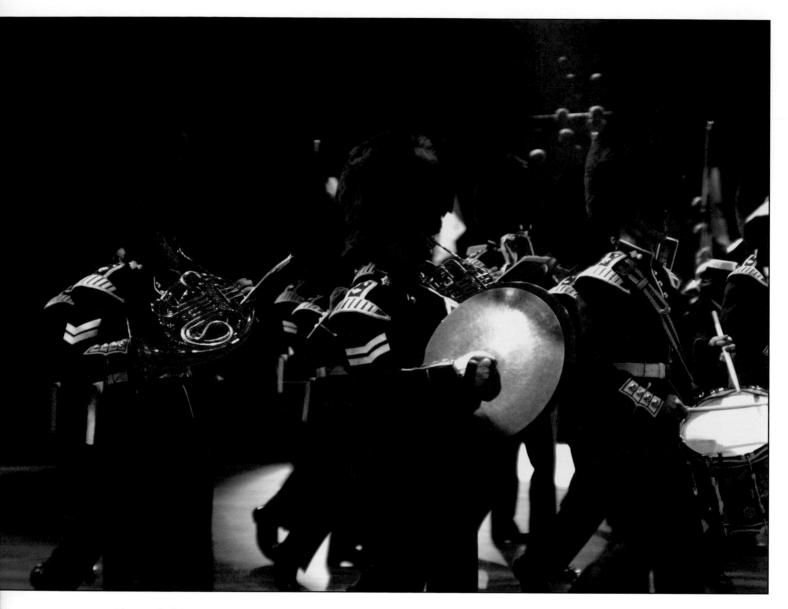

▲ The Band of the Ceremonial Guard from Ottawa

Another was an "underwater" extravaganza, with huge foam sea monsters, octopuses, flying fish, a deep-sea diver, and even a yellow submarine flying above the arena floor, which Don Acaster flooded with dark blue light to simulate the deep blue sea. There was a "wild west show" with cowboys and Mounties, a medieval tournament with knights on French ballet hobby horses, maypole dancers, and a miniature king and queen. Other productions featured a toyshop, the Oak Island mystery, and even a Loyalist wonderland. There was no limit. The young performers who took part in these scenes literally grew up with the show.

Many continued in new roles as adults, and as the years went on, their children became part of the Tattoo adventure.

Another important component of the show was dance, which brought more of the performing community to the Tattoo as local dancers under Joe Wallin's direction provided Highland and Scottish country dance, jive, and rock and roll routines. They were Pearly Kings and Queens, they danced waltzes, minuets, polkas, and square dances, and they performed in historic balls and galas.

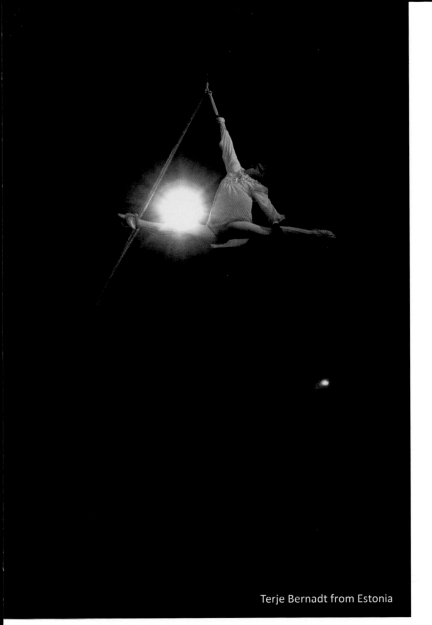

Terje Bernadt from Estonia

One of the hobbies of George Tibbetts, the Tattoo assistant producer, was radio-controlled aircraft, although he had little time to pursue that diversion. But he had an idea. He brought Arie Hakkert, an old hobbyist friend who was a civilian employee at the Halifax Dockyard, onto the team. Hakkert, with the full support of his employer, began building models for the Tattoo. His first project was a scale model of a Second World War Lancaster bomber. Then came a radio-controlled mouse for one of the children's scenes and a radio-controlled flying blimp that later was adapted to become a yellow submarine. He even built a robot that rolled around the floor and had electronic speakers inside that permitted it to "talk" to the audience. A measure of control eventually had to be applied to the robot, however, for continually upstaging the Tattoo Town Crier, who could not decide whether to give up the contest or smash the cheeky robot to pieces.

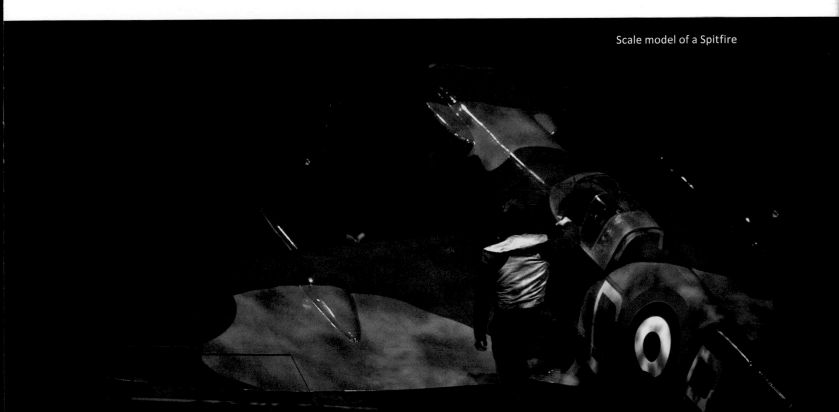

Scale model of a Spitfire

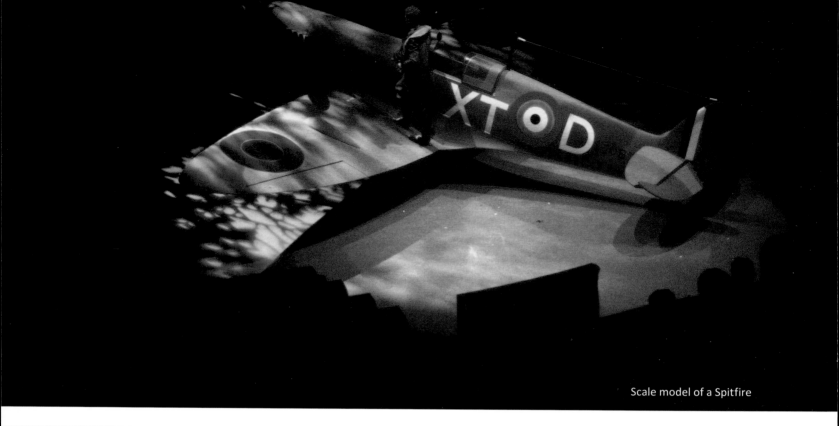

Scale model of a Spitfire

Motorcycle Display Team of the Berlin Police Force

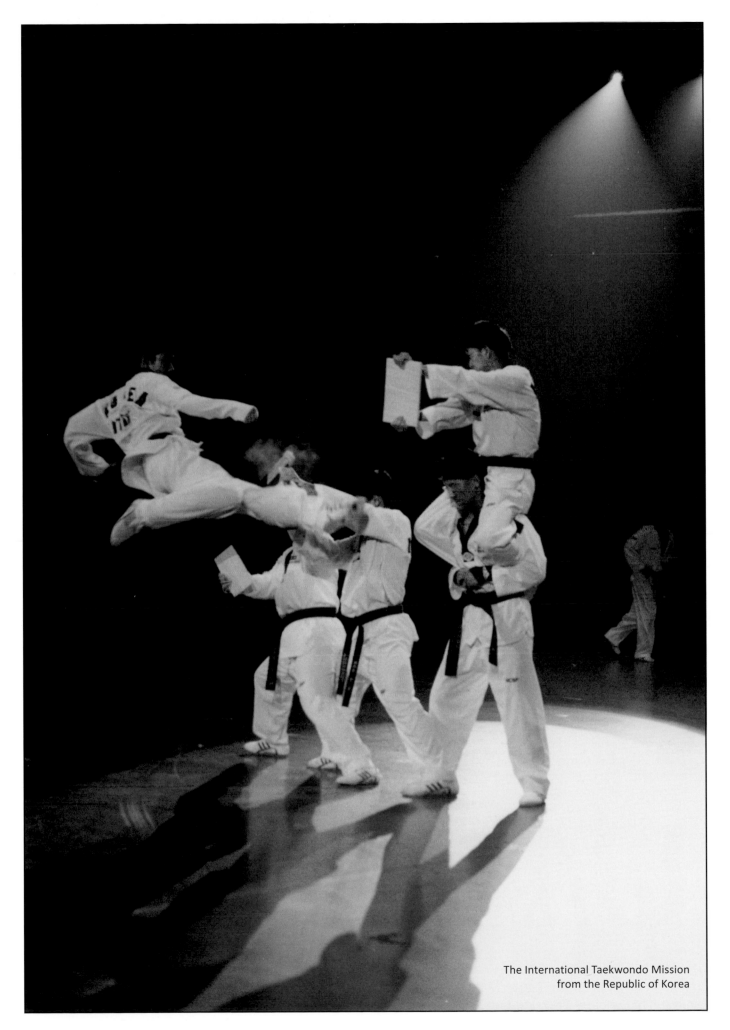

The International Taekwondo Mission
from the Republic of Korea

Another of Arie's innovations was a Sea King helicopter, lowered from the rafters of the Metro Centre with rotors turning and lights flashing. But his pièce de résistance was a three-quarter-scale Spitfire, built with such accuracy that Second World War fighter pilots had to come within a foot of it before they agreed it was a model. That Spitfire brought the Tattoo's Battle of Britain scene to life and gave the audience an astoundingly realistic look back at those years. The Spitfire was often used as the centrepiece of future Air Force scenes in the show. The staff at Canadian Forces Base Shearwater even repainted it once to make an equally accurate RCN Fleet Air Arm Sea Fury.

The use of radio-controlled models took the Tattoo to another level and gave many of the scenes during the eighties and nineties a new and innovative look.

In 1982, the RCMP helped the Tattoo celebrate the Mounties' fiftieth anniversary in Nova Scotia. From a small item that year, their participation has grown to become an annual feature of the show: the marching of a Ceremonial Troop with a standard of drill and deportment equal to the best of the Canadian Forces. As the years went on, production staff who had started as members of the Canadian Forces retired or became civilians and others were added. All staff, however, held firmly to the show's combination of the best the Canadian Forces, the RCMP, and international

▼ Central Band of the Japan Air Self-Defence Force

▲ RCMP and the Ceremonial Guard

military could offer, along with the best Canadian and international civilian performers. The mix of performers was proving successful, and it was obvious that moving away from a traditional military Tattoo had been the right decision.

The Tattoo's organizers then began to look at other shows and tournaments in Europe, to see if any could offer a model of interest, and came upon the police and sport shows presented in Germany. They visited numerous German shows over the years, but finally focused on the Hamburg Police Show, which featured a wide variety of items from Europe within a musical framework. It differed from both traditional Tattoos and the Nova Scotia show, but was designed with the same concept in mind as the Halifax show: maximum variety. Before long, a close, mutually beneficial relationship developed

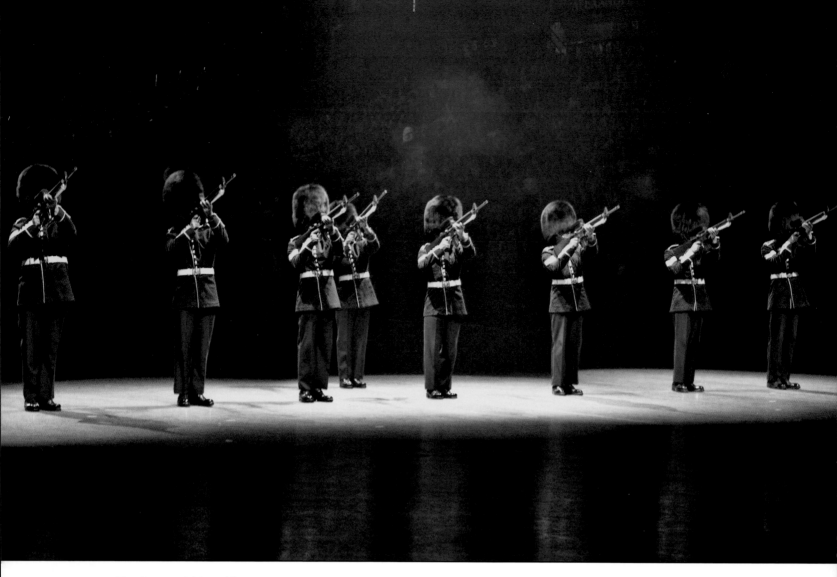

▲ The Ceremonial Guard from Ottawa

between the Hamburg show and the Nova Scotia production. Acts were identified in Hamburg, then brought to Nova Scotia, and their happy experiences led them to spread the word about the Halifax show. As a result, unique performing groups from Europe began to express interest in being part of the Nova Scotia production.

Following the example of The Queen Mother in 1979, distinguished guests have taken centre stage on the reviewing platform at every performance since, including three other members of the Royal Family, governors general, premiers, lieutenant governors, federal and provincial cabinet ministers, mayors of

Halifax, senior Canadian Forces and RCMP officers, as well as high-profile business leaders from across the country. Their presence has enhanced the production and given it an added sense of dignity and pageantry. By the mid-1980s, Ian Fraser concluded that the Tattoo could no longer be a "one-man show." With that in mind, he organized a production team, affectionately or otherwise known as the "Gang of Four" — himself, Ann Montague, Don Reekie, and Doug Bell. Jim Forde was added later and others were to follow over the years. As Fraser said, "Before long, all I had to do was guide the horses and, in truth, I didn't have to do much of that."

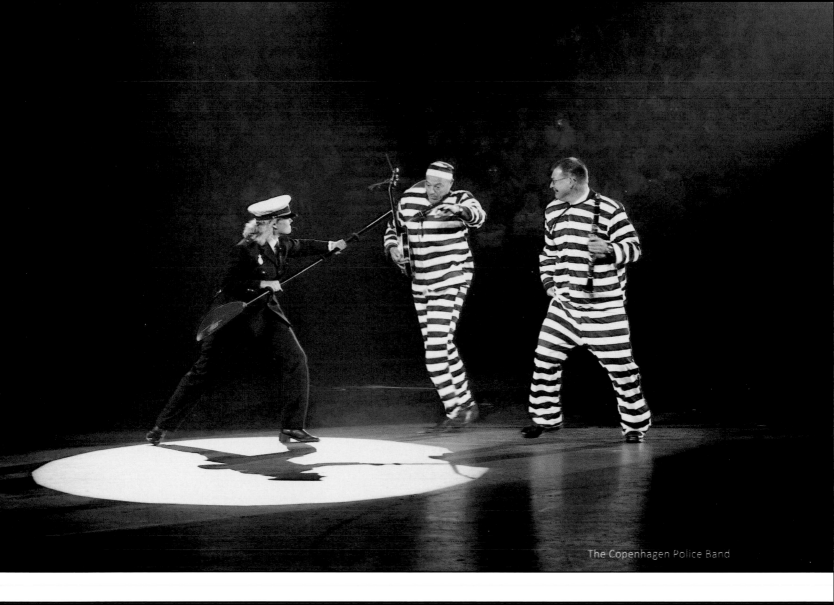

The Copenhagen Police Band

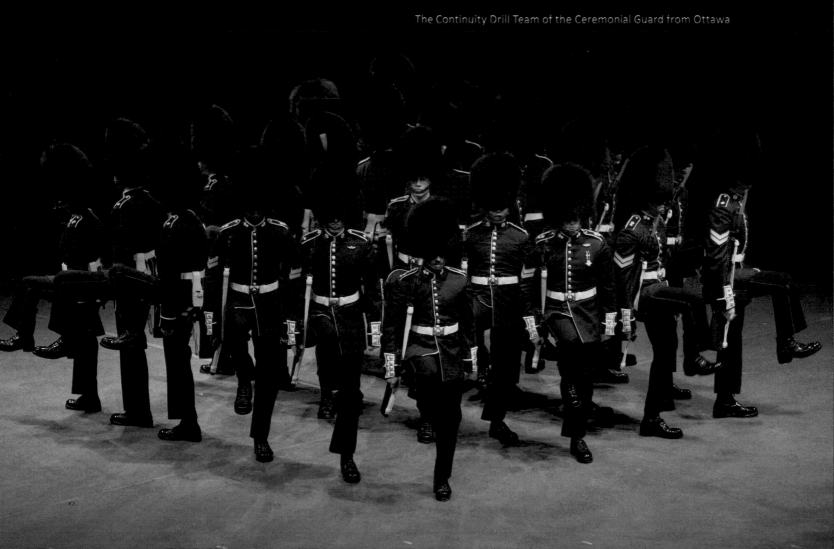

The Continuity Drill Team of the Ceremonial Guard from Ottawa

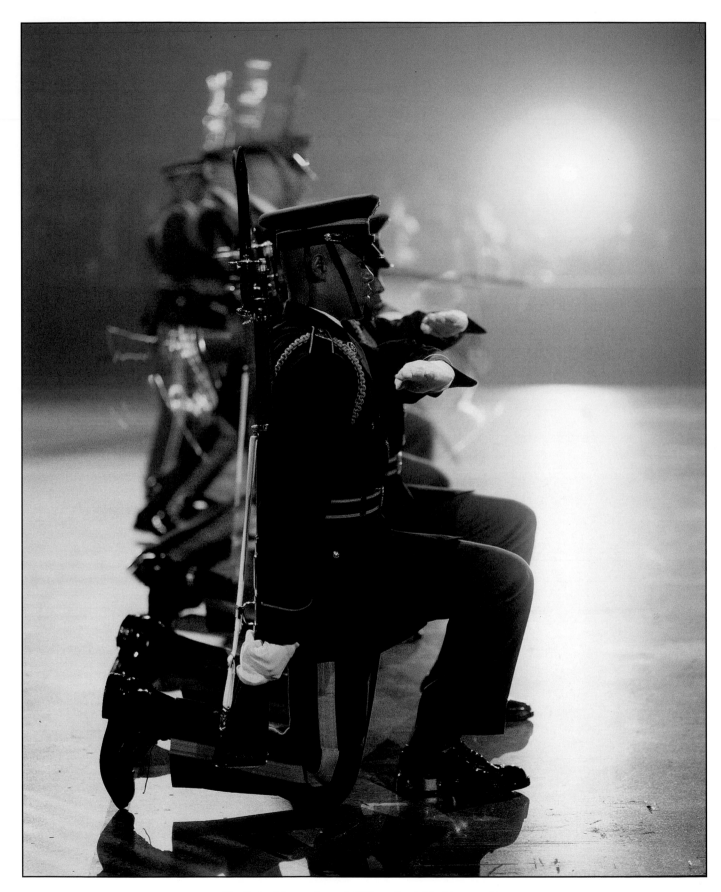

The United States Army Drill Team from Washington, DC

Toward the end of the Tattoo's second decade, two events had a profound impact on the show's future: the "Kitchen Report" and the formation of the Nova Scotia International Tattoo Society.

Midway through the 1990s, the Tattoo staff realized that it was essential to obtain advice and help on giving the show a fresh focus. To that end, consultant Heather Kitchen was asked to prepare a report to help guide the Tattoo through the next decade. Kitchen had worked at the Stratford Festival and run theatres in a number of cities, including Edmonton's Citadel Theatre,

one of Canada's foremost theatre companies. Unlike many of her contemporaries in the theatrical world, she also had a keen understanding of business and had obtained an MBA from the Richard Ivy School of Business at the University of Western Ontario. After her Tattoo project was completed, she became the executive director of the American Conservatory Theatre in San Francisco, one of the most prestigious teaching theatres in North America. Kitchen's recommendations became the basis of the plan that would carry the Tattoo into the future.

Gym Wheel Team Taunusstein from Germany

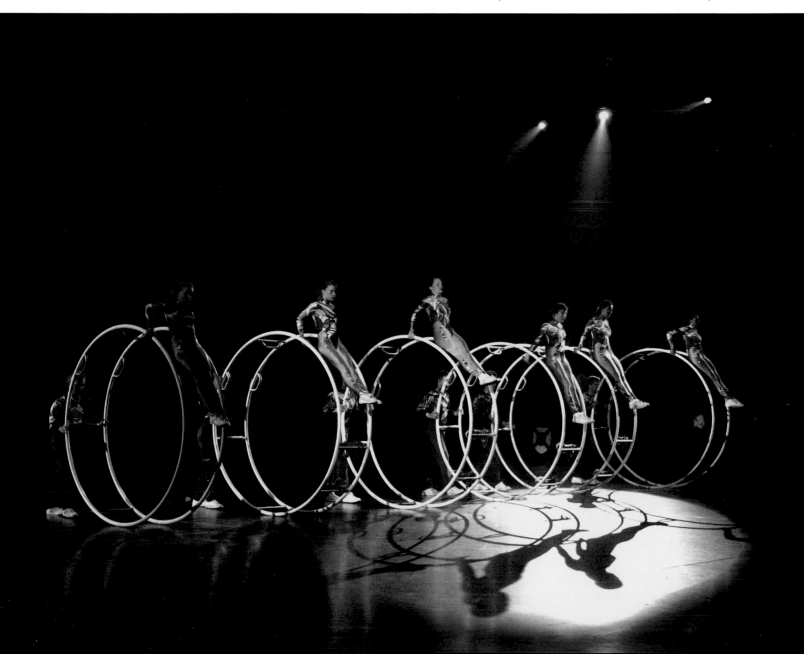

With the "Kitchen Report" in hand, the next step was to move control of the Tattoo from the province to an independent society governed by a board of directors chosen by the society. The society's organizers knew it was a step in the right direction, with many more advantages than disadvantages, but convincing the province — especially its public servants, who by nature are cautious of new developments — was not a simple matter.

For reasons that were never clear, there was some reluctance on the part of the provincial government to give up control of the Tattoo even though passing it to a society would ease the province's financial and management burden. In effect, with a society, the private sector would become responsible for the cultural and economic benefits that the province had overseen since 1979. That process took well over a year. It would have taken a good deal longer without the help of George Cooper, a well-known Halifax lawyer and former Member of Parliament, who probably understood more than anyone else how to cut through the political and bureaucratic jungle.

Finally, however, the agreement was made, the documents were signed, and in April 1994, the Nova Scotia International Tattoo Society was formed. Its board of directors henceforth would take on the responsibility of directing and managing a production that had grown from a small local show in 1979 to a Tattoo unrivalled anywhere in the world.

An era had ended.

▲ Thomas Mosher, one of the Tattoo Extras

▶ Militia soldiers pose for a photo prior to the Obstacle Race

The Black Watch Mafia

Unless you have served in an Army regiment, it is difficult, if not impossible, to understand how the regimental system works. It is a bit like a club, a bit like a society, or even a church; ultimately, it is like a family, and a close one at that.

To organize staff for the first Tattoo, Ian Fraser, the show's producer, turned to his old regiment, The Black Watch (Royal Highland Regiment) of Canada. In the early years, most of his recruits were still serving in the Canadian Forces, but as time went on, retired members of the Regiment surfaced to join the Tattoo staff. The "Black Watchers," as they sometimes called themselves, responded enthusiastically, delighted to be part of the team, exactly as Fraser knew they would be. He knew his men. They had soldiered together for years in Canada and abroad, they had lived together, they knew one another's families, they trusted and looked out for one another, they occasionally faced danger together, but above all they loyally supported one another. From the point of view of the Tattoo's early organizers, this mix of skill, loyalty, and friendship, coupled with the rule "the Regiment comes first," were the essential ingredients that would make the show work. In a way, the Tattoo became their new regiment.

As a group, those old soldiers were known by the Tattoo staff, especially the civilians, as the "Black Watch Mafia." Some were there from the beginning, but whenever they joined they were all key players on the staff.

George Tibbetts was the first assistant producer . . . Don Carrigan and Bill Gilmour were Tattoo pipe majors . . . Dave Ellis was a Tattoo commanding officer . . . Frank Grant was the first backstage co-ordinator; he was followed by Bob Burchill, Harry Philpitt, and Eric Journeay . . . John Strong and Pete Goldie were support coordinators . . . Don Reekie,

a famed regimental sergeant major, became an assistant director . . . Ike Kennedy designed the Tattoo poster in 2001 . . . John MacNeil joined the staff to organize a militia competition for the first Tattoo in 1979 and went on to become the Tattoo special projects coordinator . . . Charlie Campbell, Wayne Tanner, and Nash Harb were Tattoo sergeants major . . . Mick Hanlon came on side as John MacNeil's assistant in 2009.

Then there is Charlie Johnson. Charlie's name has appeared in the souvenir program at the end of the acknowledgements section every year since 1979. But no one connected with the Tattoo, outside the "Black Watch Mafia," has the faintest idea what he does.

And finally, there is the Regiment's most distinguished member, the colonel-in-chief, Her Majesty Queen Elizabeth The Queen Mother, who opened the first Tattoo in 1979. She was revered by the old Black Watch hands, who referred to her simply as "The Mother of the Regiment."

Nemo Me Impune Lacessit.

The Grandfather Clock

Some strange situations are etched in the memories of Tattoo staff. One of the most bizarre occurred during the early years of the show between Ian Fraser, the producer/ director at the time, and Don Acaster, the lighting designer/ director. It can best be recounted in Fraser's words.

It was opening night in the early 1980s. Just before the show that evening, I discovered that Don's credit as lighting designer/director had been left off the free playbill that was to be given to the audience attending the Tattoo.

In the theatre world, that was serious stuff.

I was considering how to resolve the problem and, as I walked into the Metro Centre, about a half-hour before the show, I noticed that the place was filling up nicely with al- most half the audience settled into the seats. But I sensed there was a problem.

After a moment or two, I realized there was no pre-set stage lighting.

In something of a panic, I rushed up the stairs to the catwalk above the arena floor and discovered Don peering down at the darkened stage with his arms folded across his chest.

"The pre-set Don," I said, trying to control my anger, "you forgot the bloody pre-set."

He didn't look at me as he replied. "I didn't forget. I'm not calling the show."

Lighting on the Metro Centre floor

"You're not what?"

He didn't reply for a moment or two, then turned slowly and looked at me. "You left my credit off the playbill so I'm not calling the show."

This was not good.

I tried to explain that I had just found out myself and agreed it was a terrible oversight. I assured him the guilty would be punished, it would never happen again. And then I went on expressing great regret about the omission.

My apology was greeted with cold silence and show time was rapidly approaching.

I considered what I could do to convince him to call the show — an announcement to the audience, an expensive dinner, a bottle of gin, or perhaps a few cartons of ciga- rettes. The options made sense to me. I would offer the announcement first, but Don was a serious smoker and a drinker of gin, so, as I upped my incentives, I would finish off with the big one — the gin and cigarettes. With the options fixed in my mind, I opened the negotiations. "Okay, what do you want to put it right?"

"A grandfather clock," he replied, without any hesitation whatever.

"A what?"

"You heard me," he said, "no grandfather clock, no lights."

I began to protest.

Then I looked over the catwalk railing at the eight thousand or so people who had now filled every seat in the Halifax Metro Centre and were waiting for the show to begin in a matter of minutes.

We stared at each other for a very long moment as each of us considered the consequences.

"What kind?" I said, swallowing my pride, "oak or mahogany?"

Don smiled, and the lights came on.

Lighting effects on the floor of the Metro Centre

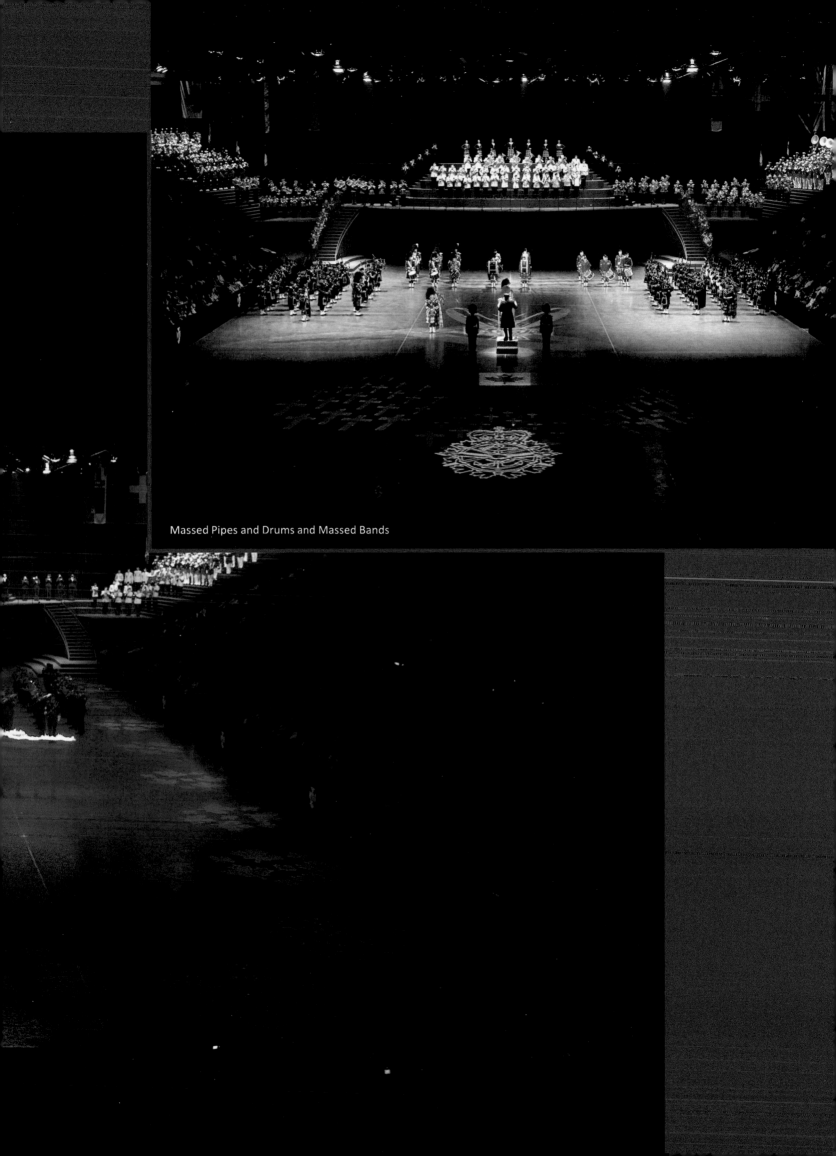

Massed Pipes and Drums and Massed Bands

The Royal Family and the Tattoo

More than thirty years on, the people of Nova Scotia still recall with great affection the visit of Her Majesty Queen Elizabeth The Queen Mother, who opened the first Nova Scotia Tattoo in 1979. Her visit that year was to be her last to the province. But it was not to be the last visit of members of the Royal Family.

HRH Prince Andrew, Duke of York, opened the Tattoo in 1985. As colonel-in-chief of the Princess Louise Fusiliers, however, he regularly returns without fanfare to visit his Regiment in Halifax. His brother, HRH Prince Edward, Earl of Wessex, opened the Tattoo in 1987 as the principal guest of honour.

HRH Princess Anne The Princess Royal came in 1991. She captured hearts by standing on a rough makeshift platform backstage and speaking warmly to the performers, crew, and staff of the Tattoo. Then, in an enormously kind gesture, she presented souvenir cast T-shirts to the youngest cast member, a shy eight-year-old, and then to an eighty-year-old performer.

The one thing all of the four Royal visitors who have attended the Tattoo have in common is their deep interest in Nova Scotia, the Canadian Forces, and the RCMP. More important is their pleasure in meeting, talking to, and being seen by as many of the people of the province as possible during their all-too-brief visits.

One memorable Royal event was not a Royal Visit to the Tattoo, but in some respects it is the Tattoo's most significant connection to the Royal Family. It occurred in spring, 2006, when Her Majesty Queen Elizabeth, on the occasion of her eightieth birthday, granted "Royal" designation to the Nova Scotia International Tattoo, the only one so honoured at that time, thereby greatly strengthening the link between the Tattoo and the Royal Family that had been established by her mother in June 1979.

▲ HRH Princess Anne The Princess Royal, with Tattoo Producer/Director Ian Fraser, 1991.

▼ Her Majesty Queen Elizabeth The Queen Mother opens the first Nova Scotia Tattoo, 1979.

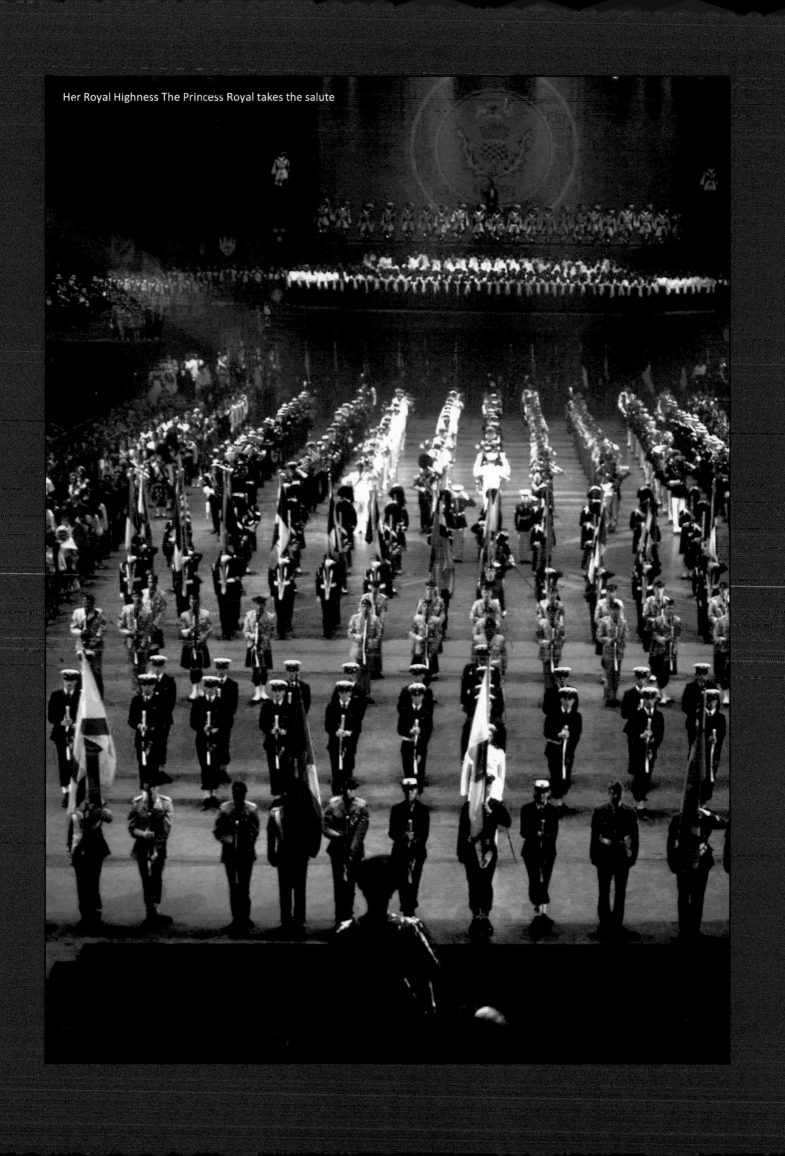

Her Royal Highness The Princess Royal takes the salute

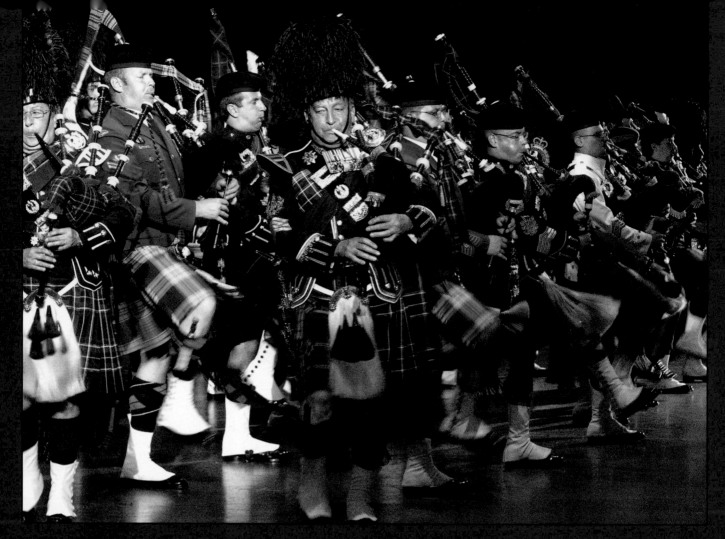

▲ The Massed Pipes and Drums

▼ The Tattoo Choir and Children's Chorus sing the British National Anthem — Finale

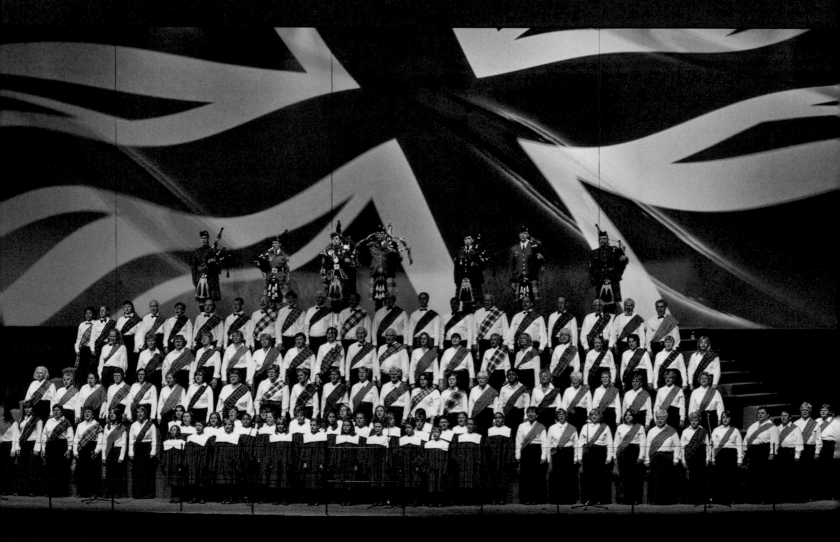

The New
MILLENNIUM

During the Tattoo's first two decades, after each show everyone involved in the production contributed the lessons they had learned, which were then applied to the next show. But as the Tattoo drew into the millennium, the texture of the production began to change dramatically, although the format remained essentially the same.

The change was driven to a large extent by recognition of the influence of television and of the audience's expectations based on that medium. The tempo of the show began to pick up, and the philosophy of short and dynamic scenes began to drive the production. The mantra was simple: keep things moving quickly, get input from as many staff and participants as possible, apply the lessons everyone has learned, but above all, don't make the same mistake twice.

As one of the leaders from a prestigious European display said, "When we were approached and told the ten- or twelve-minute act we have done for years had to be shortened to four minutes for the Nova Scotia show, we were not happy. Although we agreed, we made the point that we really couldn't afford to travel from Europe to present an act that short. Once we saw the Tattoo, we realized we couldn't afford not to."

In addition to keeping the acts short and the show moving quickly, the other key lesson learned was never to compromise on rehearsing. The Tattoo's approach to rehearsals became dominated by the observation of an old theatre producer that "there are lots of shows that are under rehearsed but very few are over rehearsed." Or, as British director Joan Littlewood has put it, "rehearsal is the work — performance is the pleasure." The rehearsal period got longer, the tempo increased, the performers got into it, and the production improved immeasurably as a result.

As one member of the audience pointed out, "The great thing about the Nova Scotia International Tattoo is that in the unlikely event there is something you don't like, you only have to wait a couple of minutes for something you will like."

Staff changes took place. After the 2000 Tattoo, Don Tremaine, the venerable host since 1979, retired; his place was taken by George Jordan — like Tremaine, a well-known veteran announcer with the Canadian Broadcasting Corporation (CBC). Doug Bell, a long-time assistant director, passed away quietly a short two hours after the final 2000 show.

Jim Forde, the support coordinator with the Canadian Forces, moved across to the civilian side to become the Tattoo production coordinator, with a wide variety of responsibilities, including music coordination, band liaison, and television and video recording. The Canadian Forces Tattoo staff also continued to change every couple of years in accordance with the normal Canadian Forces system, but Connie Matheson, who had worked on the Tattoo since the early 1980s and was the repository of the Canadian Forces corporate Tattoo memory, remained in her position as the Canadian Forces administrative coordinator.

Barbara MacLeod, who began as the Tattoo's office clerk, became the business manager, taking on an immense variety of responsibilities within the organization.

In 2007, Artistic Director Ian Fraser, satisfying the final recommendation of the "Kitchen Report," handed producer responsibilities over to Ann Montague, who became the CEO and executive producer. In 2009, choreographer Joe Wallin, who had been with the show since the International Gathering of the Clans, retired, leaving Ian Fraser and Earl Fralick as the last two originals from 1979.

Since the Tattoo's local market was somewhat limited, given Nova Scotia's small population, the show's marketing emphasis began to shift toward attracting tour groups from outside the province, particularly from the U.S. eastern seaboard. The show's organizers were also pleased to see increasing numbers of European visitors and even a few from as far away as Japan and Australia.

Although the Tattoo had functioned well for more than two decades without a clearly articulated mission statement, the board of directors of the Tattoo Society decided this was an omission that had to be filled. After much discussion, the Mission of the Tattoo was adopted in 2004:

◀ The Lieutenant-Governor of Nova Scotia,
The Hon. Myra Freeman, announces the Tattoo's
Royal Designation, 2006

▲ Royal Nova Scotia International Tattoo Coat of Arms

To produce and present a world-class international, cultural event that will stimulate Canadian patriotism, educate youth, recognize our country's debt to the Canadian Forces and the Royal Canadian Mounted Police, attract tourists to Nova Scotia, strengthen international relations and enhance the commercial position of Tattoo sponsors.

The Tattoo logo also needed attention, since the basic design had been prepared by Charlie McGuire's Theta Marketing for the first Tattoo in 1979. Elements had been changed or added from time to time over the years, but the image clearly had become dated. The

Tattoo staff took the position that any new logo, like the original, eventually would become outdated and that what was needed was something timeless.

With that in mind, an application was made to Robert Watt, Chief Herald of Canada, for an official and recorded Tattoo Society Coat of Arms. The process took more than a year, but in June 2003 the governor general approved a coat of arms that, reflecting the nature of the Tattoo, includes the Gaelic motto "We stir the heart and call you home." In 2006 the coat of arms was augmented with the inclusion of the Royal Crown after the Tattoo was granted "Royal" status by Her Majesty The Queen on her eightieth birthday in April.

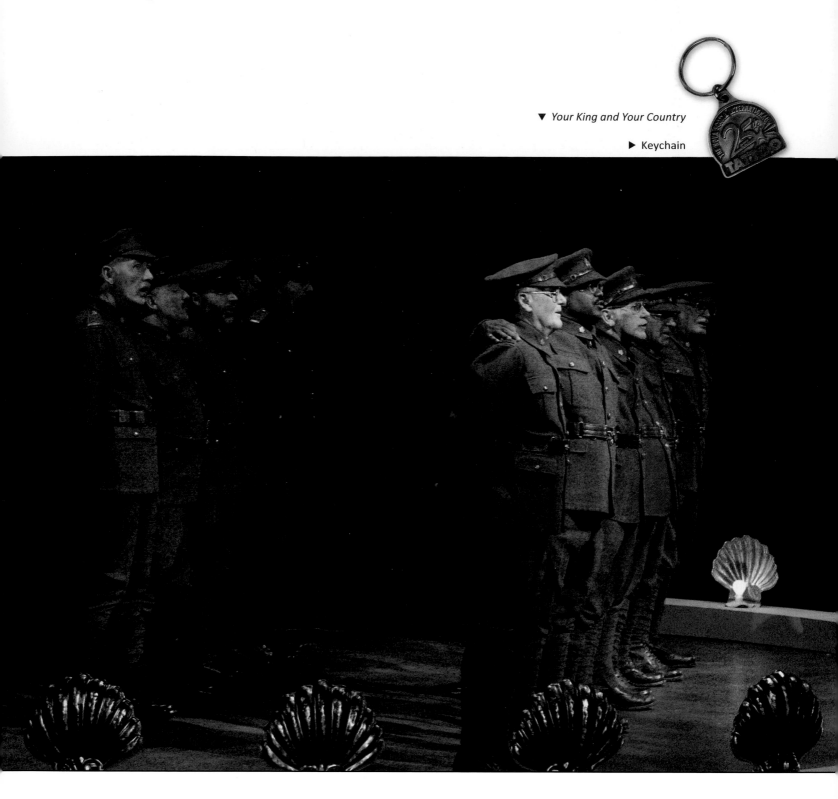

▲ Evolution of the Tattoo crest 1979-1989

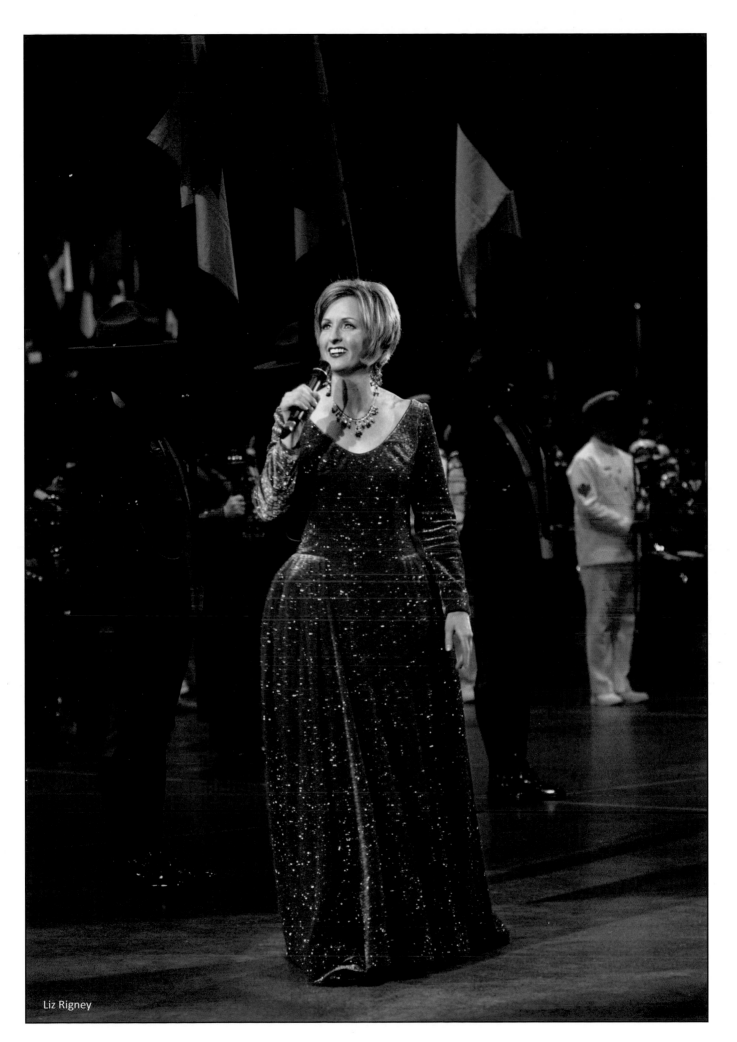

Liz Rigney

ROYAL NOVA SCOTIA
INTERNATIONAL TATTOO

No Exchange or Refund

No Cameras, Video or Recording Permitted

Halifax Metro Centre
Tuesday July 1, 2008

SECT 19 L
ROW 5
SEAT

ROYAL NOVA SCOTIA
INTERNATIONAL TATTOO

No Exchange or Refund

No Cameras, Video or Recording Permitted

Halifax Metro Centre
Wednesday July 1, 2009 2:30pm

SECT 14 H 7
ROW SEAT

11/27/2009
LINLOU

ROYAL NOVA SCOTIA
INTERNATIONAL TATTOO

No Exchange or Refund

No Cameras, Video or Recording Permitted

Halifax Metro Centre
Sunday July 1, 2007 6:

SECT 17 R 1
ROW

ROYAL NS TATTOO

Halifax Metro Centre

Saturday July 1/06 6:30pm

SECT 19 ROW R SEAT 8 11/27/2009
LINLOU

As the new century's first decade passed, it became
obvious that other changes had to be made. The
stage, for example, although updated periodically
since 1979, was essentially "jerry-built." A new,
more functional set, one that would also give the
show a new look, had to be designed and built.
Then there was the rented sound system, which
was badly out of date and of doubtful quality at
best, and the rented lighting system, which was also
no longer current. It seemed technology had left the
Tattoo standing still.

The Massed Bands and Choir

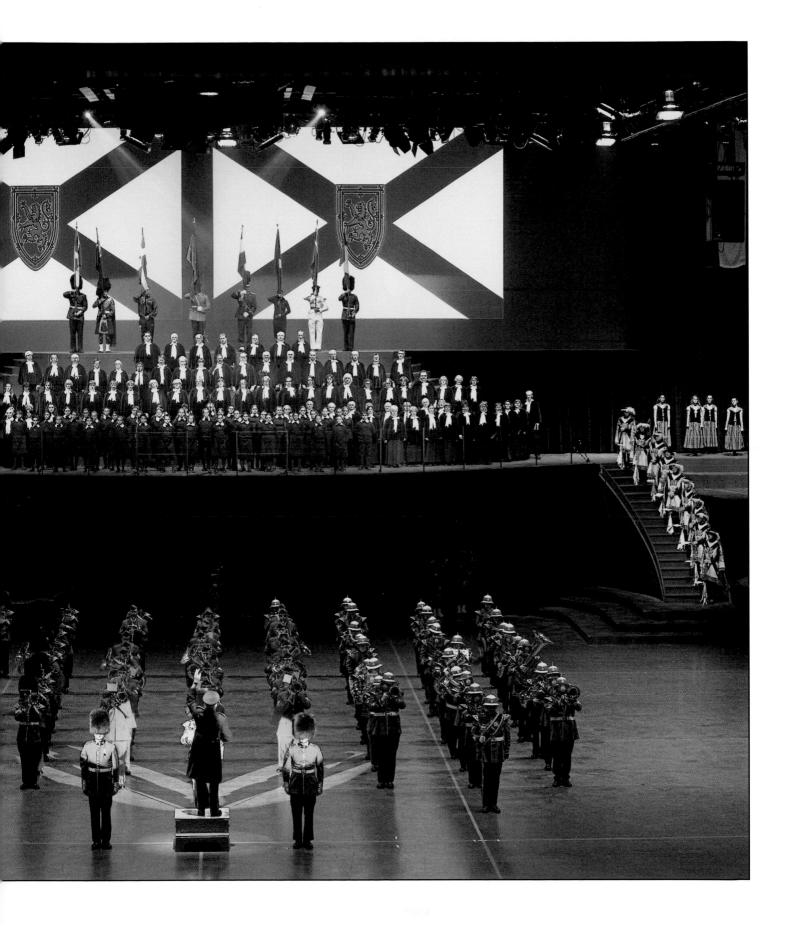

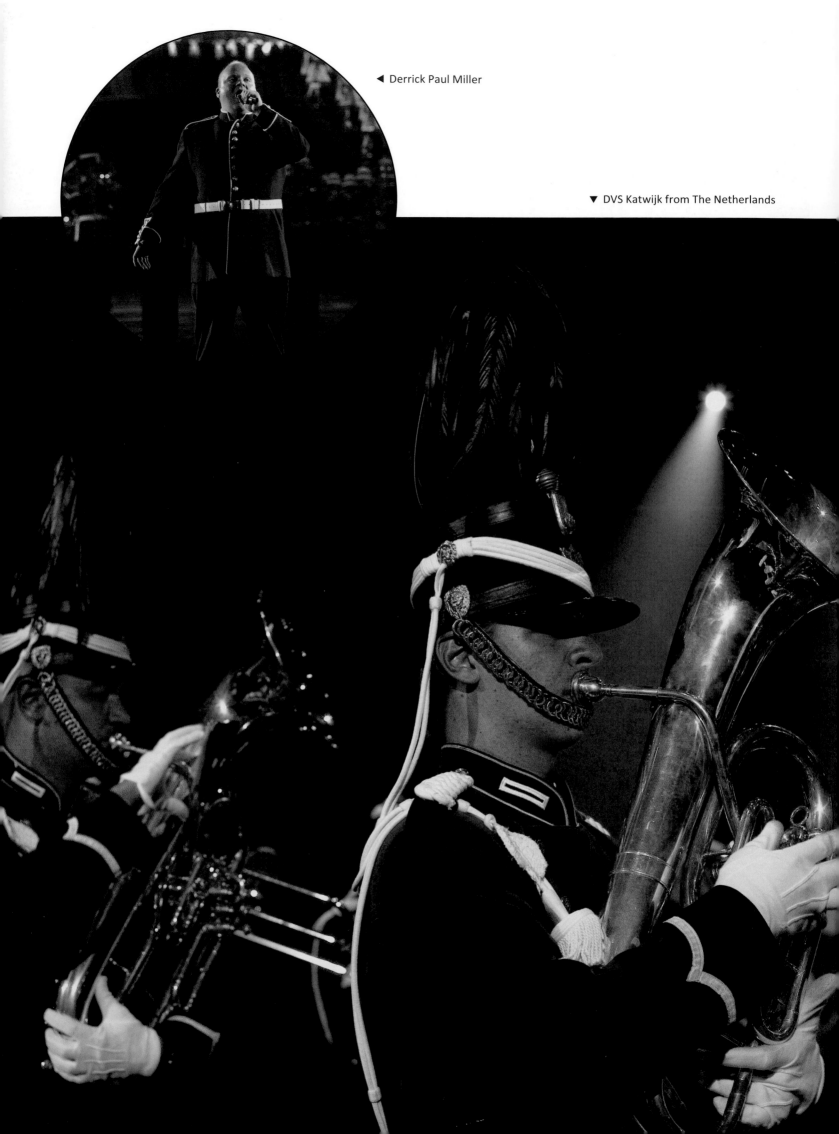

◄ Derrick Paul Miller

▼ DVS Katwijk from The Netherlands

The Torch, the Historic Scene

▶ Middlesex County Volunteers Fifes
and Drums from Massachusetts, USA

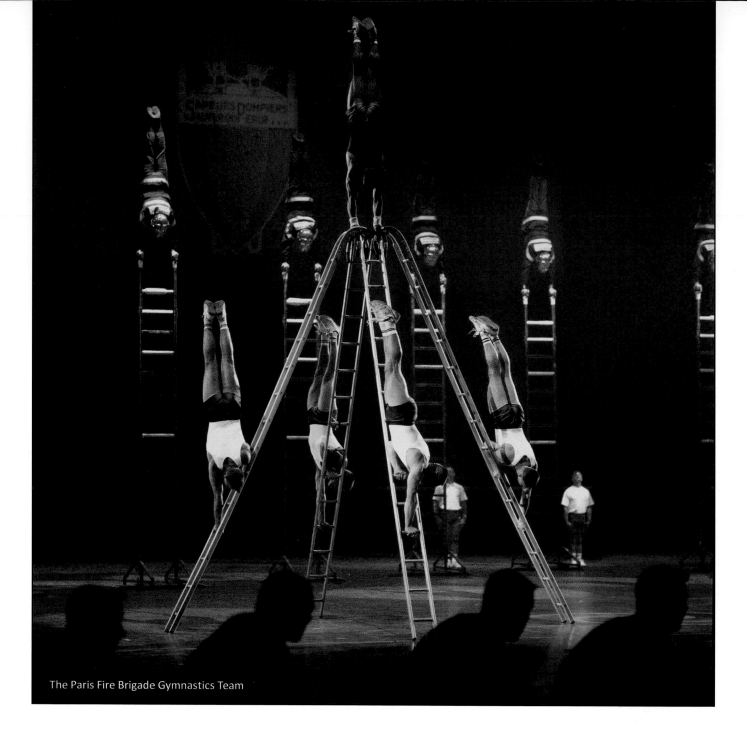

The Paris Fire Brigade Gymnastics Team

The first priority was the stage, but the cost of the solution was well beyond the resources of the Tattoo Society. Then Joe Shannon from Cape Breton, a member of the board of directors of the Tattoo Society, Ann Montague, the Tattoo's relentless CEO and executive producer, and stage architect Mike Harvey led a team that approached the Atlantic Canada Opportunities Agency (ACOA) to help with the necessary funding.

ACOA probably didn't need a great deal of convincing — the agency knew the value of the Tattoo to the regional economy and that a new stage would enhance the quality of the show, which, in turn, would draw more tourists from outside the region to the annual production. ACOA, in fact, provided

a significant degree of financial assistance. With additional investments by the province of Nova Scotia and the Tattoo Society, the new stage — with its state-of-the-art projectors as electronic components of the unit — was built and installed in the Metro Centre for the 2008 production.

The next task was to upgrade the sound system. After looking at the problem, the Tattoo staff and ACOA came up with a reasonable solution. ACOA had been assisting the Tattoo with out-of-region marketing and, as a result, the number of tourists — especially groups attending the Tattoo from outside the Atlantic region — had increased significantly. In view of that success, the Tattoo staff suggested that if some help could be provided by way of purchasing a new sound

system, the annual rental cost could then be diverted to drawing tourists. That meant no further marketing assistance would be required from ACOA and the momentum established by the ACOA marketing program would continue to be maintained. In the end, through the cooperation of ACOA, the Nova Scotia Department of Economic Development, and the Tattoo Society, a new state-of-the-art sound system was purchased in time for the 2009 show.

The lighting problem, too, was being sorted out. Tour Tech East, a Halifax lighting company, came forward with a proposal to provide a completely new, high-tech lighting rig for the show. The Tattoo accepted, a contract was signed, and a new lighting rig was installed for the 2009 production. In a short span of two years, new stage, state-of-the-art projectors, new sound system, and, now, new lighting rig — the Tattoo firmly established itself as one of the most progressive productions of any type in North America.

It was a classic case of the public and private sectors in combination with a not-for-profit society coming together to solve a major problem and, in the process, greatly strengthening the economic and cultural impact of the Tattoo. There was little doubt in anyone's mind, however, that what had enabled the Tattoo to move in a new direction was the value ACOA placed on its investment.

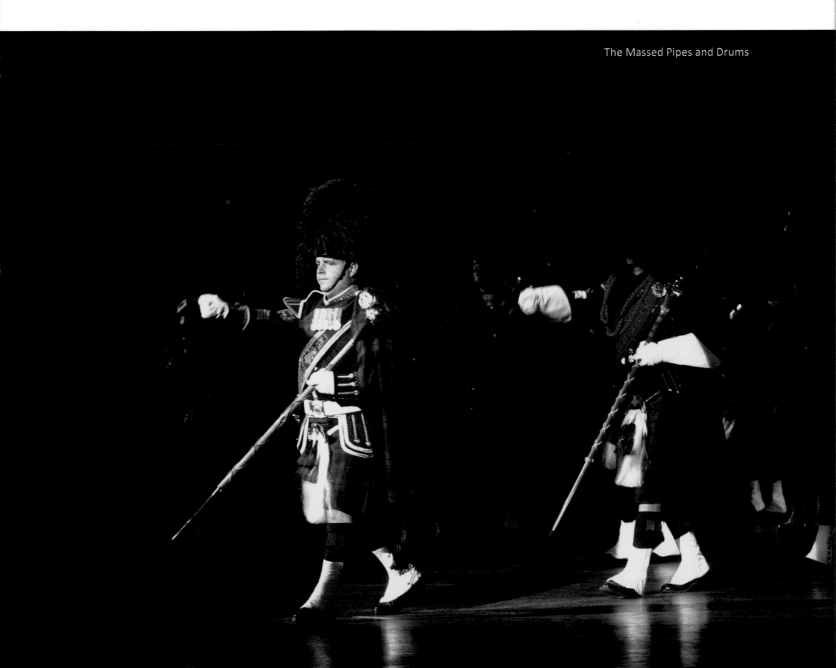

The Massed Pipes and Drums

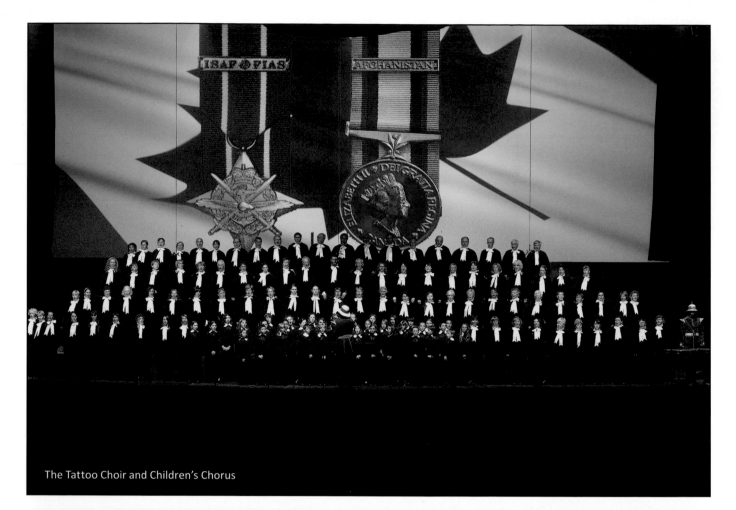

The Tattoo Choir and Children's Chorus

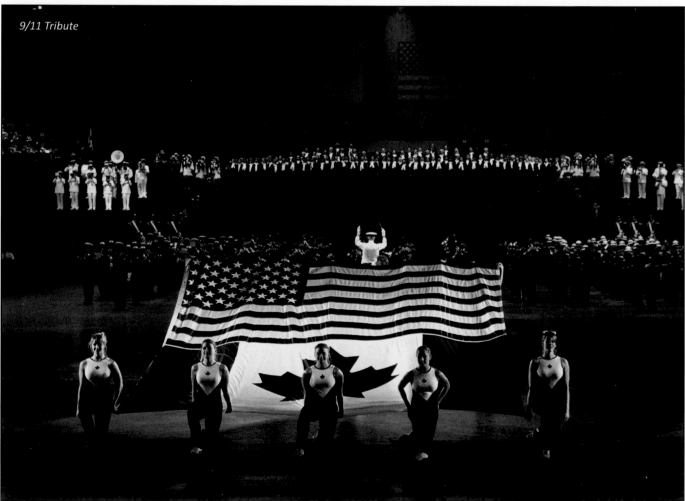

9/11 Tribute

Tattoo Extras

Nova Scotia's La Baie En Joie Acadian Dancers

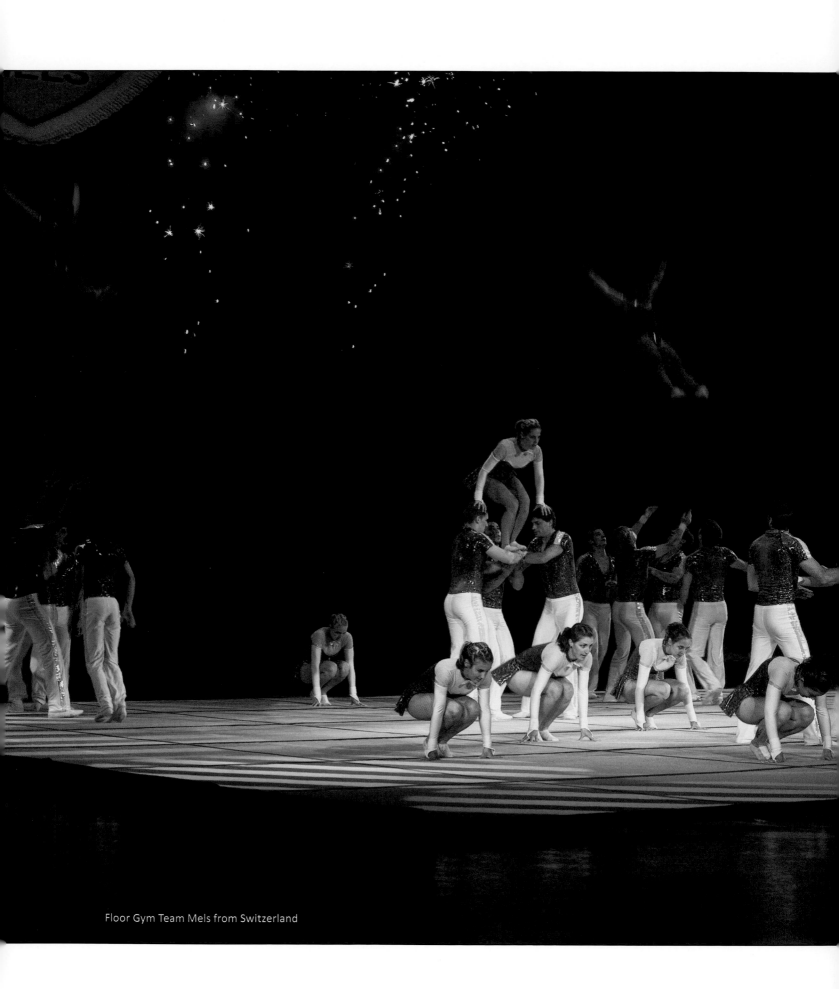

Floor Gym Team Mels from Switzerland

Over the years, indeed, the Tattoo's financial relationships with all levels of government — the Halifax Regional Municipality, the province of Nova Scotia, the federal government through ACOA, Industry Canada, and Heritage Canada — have had an enormously positive impact on the production. It is interesting, however, that the Tattoo staff steadfastly refuses to refer to any financial support from a government agency as a "grant." From the point of view of the Tattoo, that financial support is an investment; from the point of view of government, that investment has paid off handsomely. The Tattoo has greatly stimulated the provincial economy, had an enormously positive impact on Nova Scotian and Canadian culture, and strengthened international relations through the participation of twenty-three countries since the show began in 1979.

The corporate community has also become part of the mix. Led by Sobeys, the national grocery chain, a number of companies became Tattoo Sponsors, pleased to associate their images with that of the Tattoo and to support an event that has become something of a national icon. The three levels of government, the corporate community, the Canadian Forces, the RCMP, and the Royal Nova Scotia International Tattoo Society have joined together in a partnership that is probably unique in the world. The results they have achieved have been greatly enhanced by the participation of the international community in celebrating an annual event that has charmed and thrilled well over a million and a half Canadians and visitors to Nova Scotia over the past three decades.

Drummers from the
Massed Pipes and Drums

▲ The Band, Pipes, and Dancers
of the Royal Air Force of Oman

In 2007, a Tattoo Foundation was formed to
reach out to the community and to develop
projects of mutual benefit to the Tattoo and
the province. The first undertaking was the
organization of a youth and adult pipe band, to
provide a pool of pipers and drummers for the
Tattoo and generally to enhance the important
Nova Scotia cultural tradition of piping and
drumming.

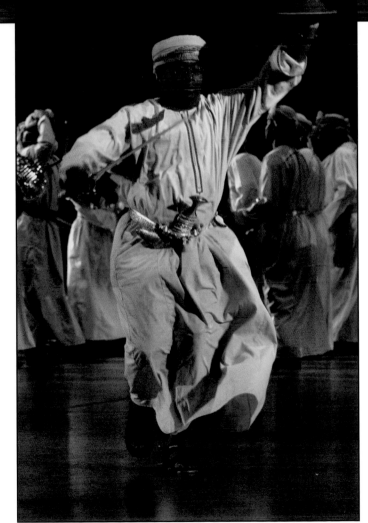

▶ A dancer from the Royal Air Force of Oman

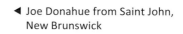
◄ Joe Donahue from Saint John,
New Brunswick

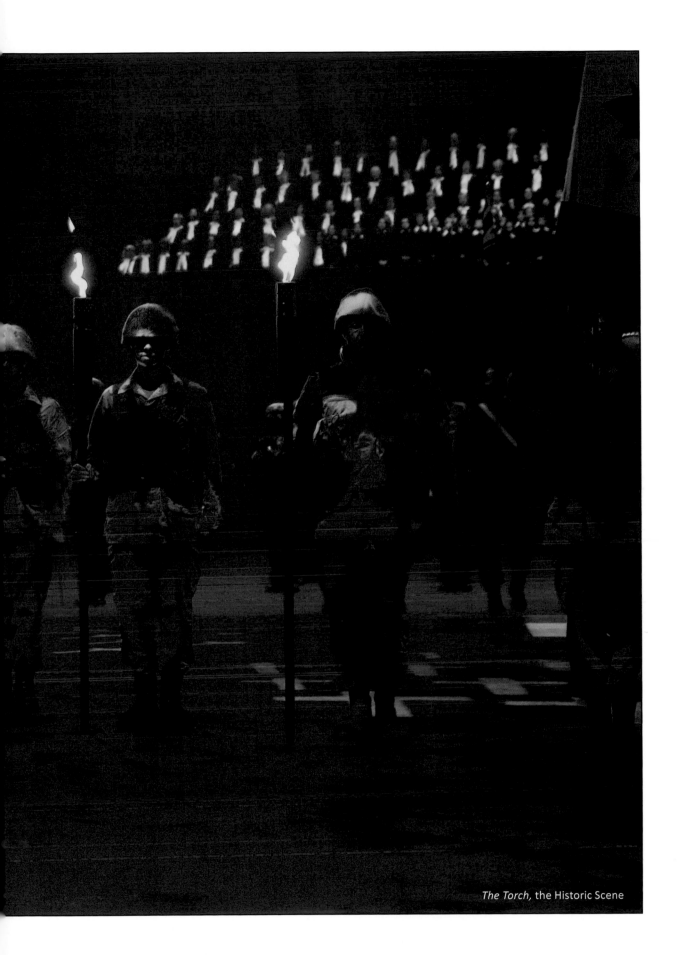

The Torch, the Historic Scene

As the third decade drew to a close in 2009, the staff of the Tattoo looked back over the past thirty years and marvelled at the changes. New faces appeared as the old guard slipped away, new ideas surfaced, new techniques were developed, new mistakes were made, and new lessons learned. The team from 1979 had all but vanished, but its legacy continued to fuel the Tattoo—everyone with the show acknowledges how

much has been learned since the early days, but, more important, how much there is still to learn.

No matter what the future holds for the Royal Nova Scotia International Tattoo, the achievement of the past three decades is a monument to the skill and tenacity of thousands of people and to the interest and support of all levels of government, the corporate community, the Canadian Forces, and the Royal Canadian Mounted Police.

If the past is any indication, the future of the Royal Nova Scotia International Tattoo is going to be very bright indeed. 🌱

▼ His Majesty The King's Guards' Band and Drill Team from Norway

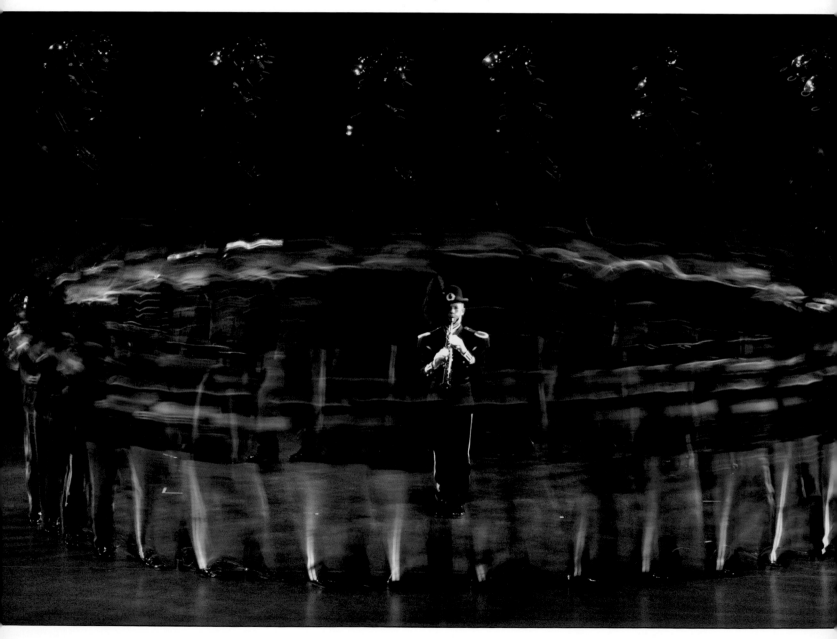

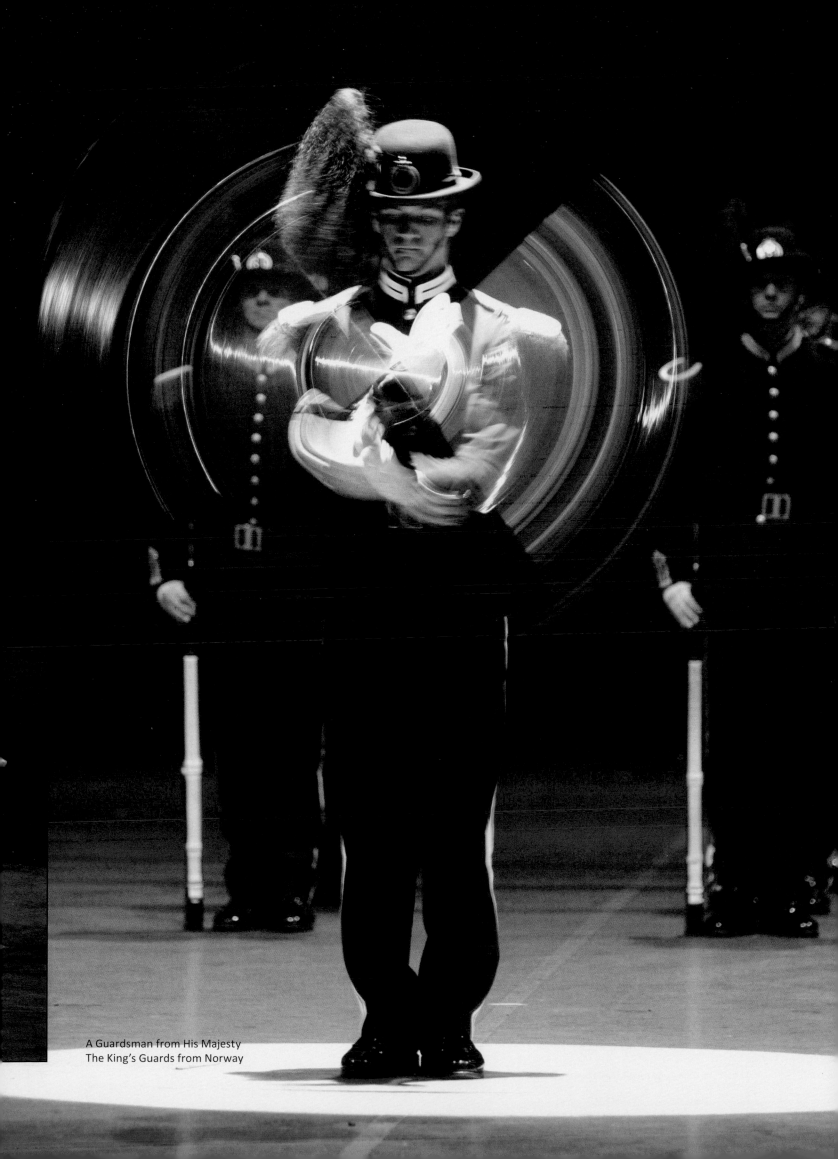

A Guardsman from His Majesty
The King's Guards from Norway

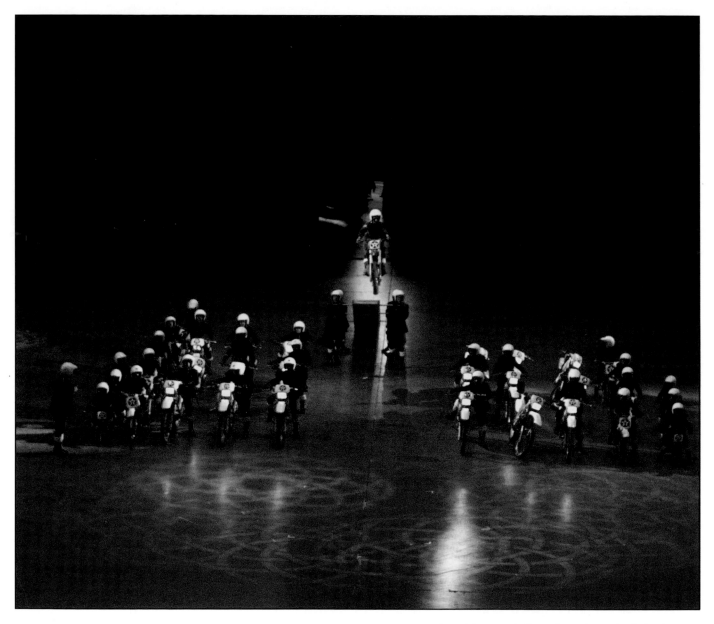

▲ Imps Motorcycle Team from the United Kingdom

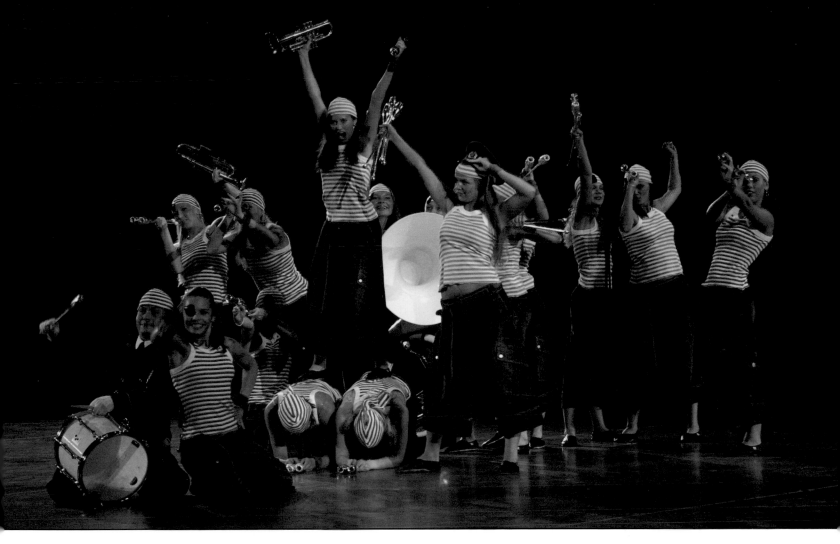

▲ Club Piruett and the Estonian Defence Force Orchestra combine in a piratical display

▼ The Langley Ukulele Ensemble from British Columbia

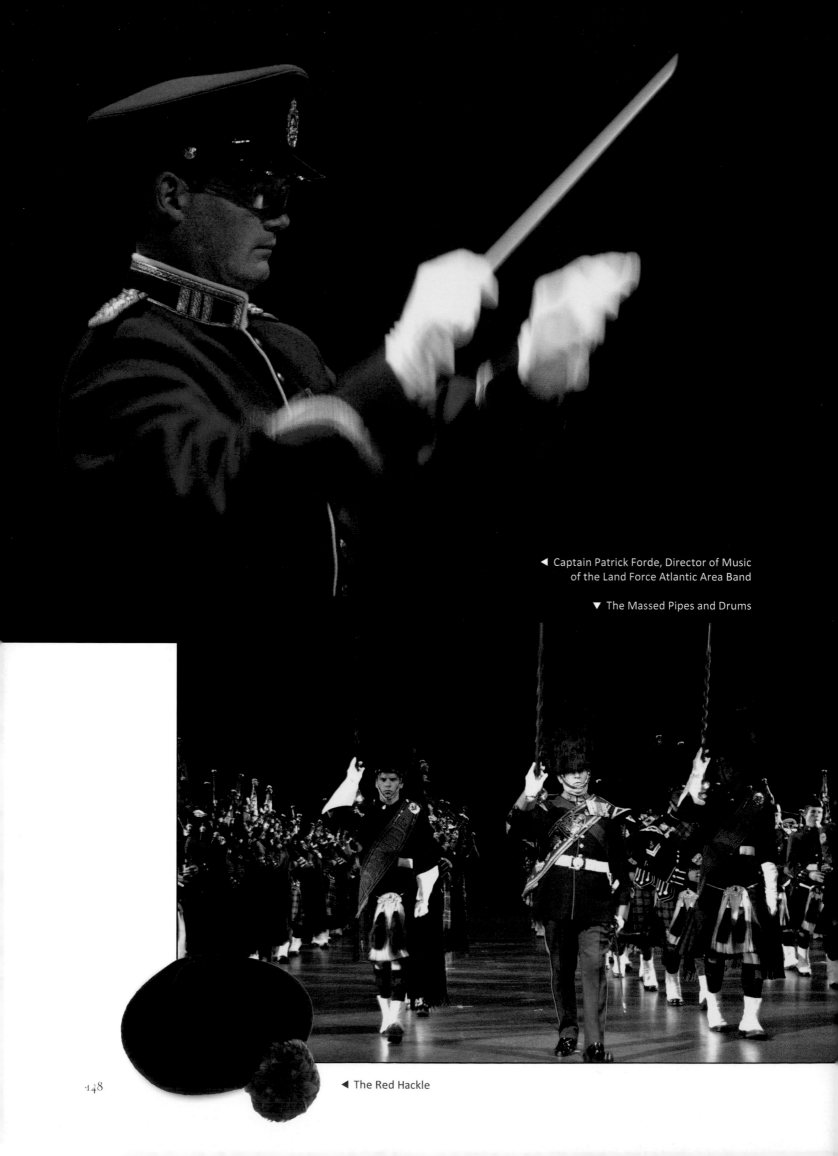

◄ Captain Patrick Forde, Director of Music
of the Land Force Atlantic Area Band

▼ The Massed Pipes and Drums

◄ The Red Hackle

The Souvenir Programs

Frequently, things move ahead without any specific plan, then grow into something quite remarkable.

The annual Tattoo souvenir program is a case in point. For the past decade, the program has been designed by Ken Webb, who manages each year to give it a new and unique look. Webb's programs are in effect miniature "coffee-table" books, flooded with photographs and unusual design elements. Like the Tattoo posters, many of which Webb has also designed, they have become collectors' items.

A unique element of the souvenir program is best described as a gift from Halifax writer Jim Lotz. Since 1993, Jim has donated his talent to the Tattoo by way of articles on Canada's military history for the souvenir program. His subjects cover an amazing spectrum: the Battle of the North Atlantic, Vimy, Dieppe, D-Day, the RCMP at War, Nova Scotia's Black Battalion, Canadian Military Engineers, Canada's Afghan Mission, Reconciliation, the Merchant Marine, the First World War — the list goes on and on. The articles have become a stand-alone series of readable stories about the Canadians who have served their country in war and in peacekeeping operations for nearly a century and a half. The combined contributions of Jim Lotz and all the other creative people involved have given the Tattoo a remarkable trove of posters and programs.

"We Are Listening"

The Tattoo has been conducting an annual survey of its audience since 1981. Collecting demographic data is not unusual in any business, but it is not all that common in the theatrical industry.

Productions that do survey their audience tend to focus on aspects that will enhance marketing and, in the process, increase ticket sales. The Nova Scotia Tattoo, however, moved its survey in a completely different direction, not just collecting all the usual demographic information but also asking the audience to critique the show. In the theatrical world, that is not only unusual, it is somewhat astounding.

The survey form lists and describes the show's scenes to refresh the memory, and asks those who complete the survey to rate each scene numerically — in other words, to tell the Tattoo's organizers what they liked and what they didn't like. Families frequently discuss the show and rate the scenes on a consensus basis, which, in the view of the Tattoo staff, makes the critique all the more valuable.

The ratings, which are not made available beyond the production staff, are examined in great detail, and if, over the years, some groups have been curious as to why they were never invited back, it is simply because the audience has spoken and the Tattoo has listened.

ROYAL
NOVA SCOTIA INTERNATIONAL
TATTOO

HALIFAX METRO CENTRE JULY 1 – 8 2007

NOVA SCOTIA'S GREATEST ENTERTAINMENT EXTRAVAGANZA

HALIFAX METRO CENTRE JULY 6, 7, 8 & 9

The Posters

Three decades of annual Tattoo posters are hung on the walls in the Tattoo office. Each poster has become a stand-alone work of graphic art by immensely talented, though virtually unknown and unrecognized artists.

One who surfaced in the 1980s was Pekka Kauppi. Without putting too fine a line on it, Pekka was an unusual character.

Pekka immigrated to the United States from Finland at the age of twenty and studied in New York before moving to California. Along the way, he was drafted into the U.S. Army, but his talent as an artist kept him out of Vietnam, which,

needless to say, delighted him. Once in California, he gravitated to Hollywood and the film industry, where he became a scenic artist and cameraman, working with stars such as John Wayne, Cary Grant, and John Travolta.

He never explained why he surfaced in Halifax. But once there, he taught at the Nova Scotia College of Art and Design (NSCAD) and worked with a number of advertising agencies in the city. Kauppi used photographs as his basic design element, which he then turned into dynamic artistic illustrations, creating unique poster designs that have more than stood the test of time.

Kauppi eventually vanished from Halifax, returning to Finland and, rumour has it, on to Russia. Given his penchant for mobility, where he is now is anyone's guess.

Dave Leonard took a different approach to designing Tattoo

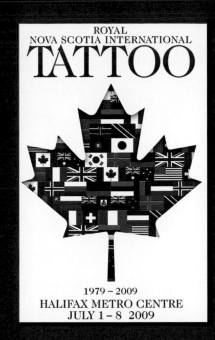

posters. Like Kauppi, he had lived and studied in the United States before settling with his family in Halifax and taught at NSCAD. His Tattoo posters were developed from his oil paintings, some of which are now in private collections. One is also in the hallway of National Defence Headquarters in Ottawa and another, of Don Carrigan, the Tattoo pipe major, is on display in Army Headquarters in Halifax.

Following Dave Leonard as a poster designer in the 1990s was Ken Webb, a NSCAD graduate who had worked in advertising in Halifax. Webb, in contrast to Kauppi and Leonard, focused on combining photographs, computer-generated images, and drawn images. In the process, he gave the Tattoo posters a completely different and creative spin that captured the essence of the show and set his work apart from the other designers.

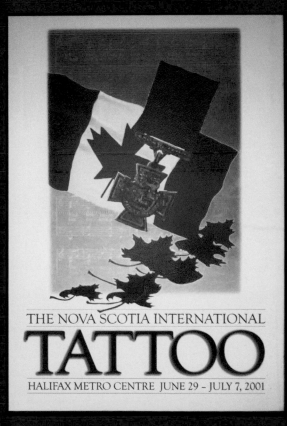

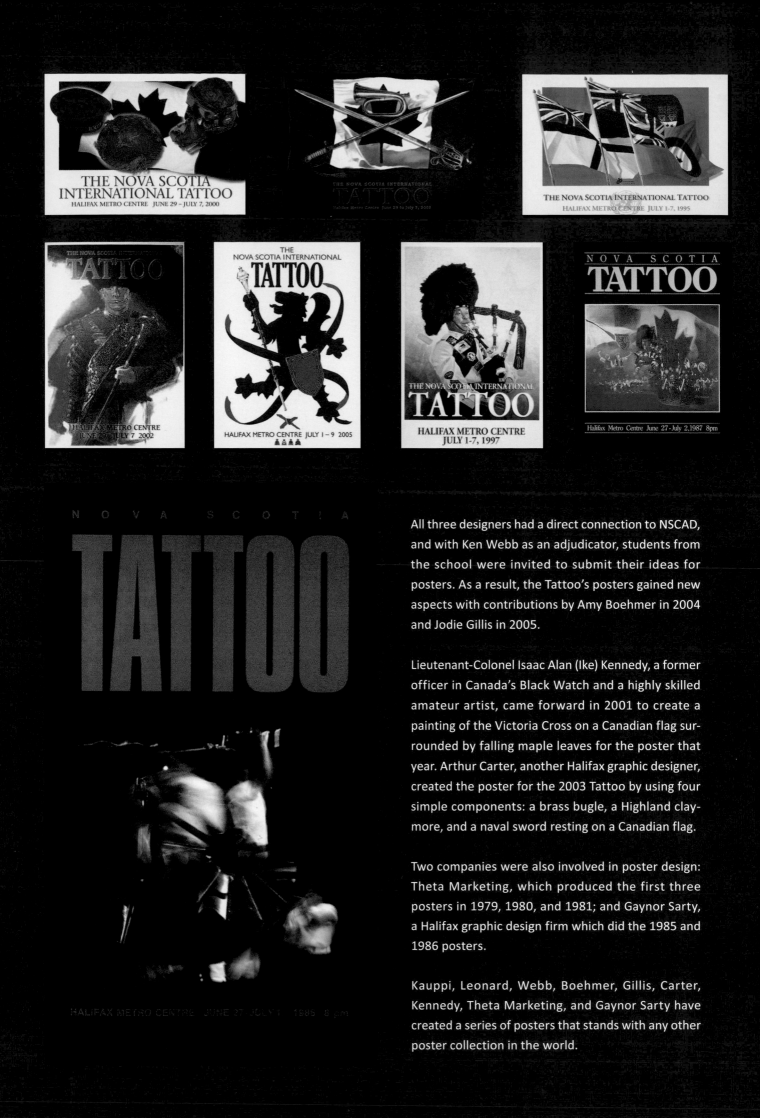

THE NOVA SCOTIA
INTERNATIONAL TATTOO
HALIFAX METRO CENTRE JUNE 29 – JULY 7, 2000

THE NOVA SCOTIA INTERNATIONAL
TATTOO
Halifax Metro Centre June 29 to July 7, 2008

THE NOVA SCOTIA INTERNATIONAL TATTOO
HALIFAX METRO CENTRE JULY 1-7, 1995

THE NOVA SCOTIA INTERNATIONAL
TATTOO
HALIFAX METRO CENTRE
JUNE 29, JULY 7 2002

THE
NOVA SCOTIA INTERNATIONAL
TATTOO
HALIFAX METRO CENTRE JULY 1 – 9 2005

THE NOVA SCOTIA INTERNATIONAL
TATTOO
HALIFAX METRO CENTRE
JULY 1-7, 1997

NOVA SCOTIA
TATTOO
Halifax Metro Centre June 27-July 2,1987 8pm

NOVA SCOTIA
TATTOO

HALIFAX METRO CENTRE JUNE 27 JULY 1 1985 8 pm

All three designers had a direct connection to NSCAD, and with Ken Webb as an adjudicator, students from the school were invited to submit their ideas for posters. As a result, the Tattoo's posters gained new aspects with contributions by Amy Boehmer in 2004 and Jodie Gillis in 2005.

Lieutenant-Colonel Isaac Alan (Ike) Kennedy, a former officer in Canada's Black Watch and a highly skilled amateur artist, came forward in 2001 to create a painting of the Victoria Cross on a Canadian flag surrounded by falling maple leaves for the poster that year. Arthur Carter, another Halifax graphic designer, created the poster for the 2003 Tattoo by using four simple components: a brass bugle, a Highland claymore, and a naval sword resting on a Canadian flag.

Two companies were also involved in poster design: Theta Marketing, which produced the first three posters in 1979, 1980, and 1981; and Gaynor Sarty, a Halifax graphic design firm which did the 1985 and 1986 posters.

Kauppi, Leonard, Webb, Boehmer, Gillis, Carter, Kennedy, Theta Marketing, and Gaynor Sarty have created a series of posters that stands with any other poster collection in the world.

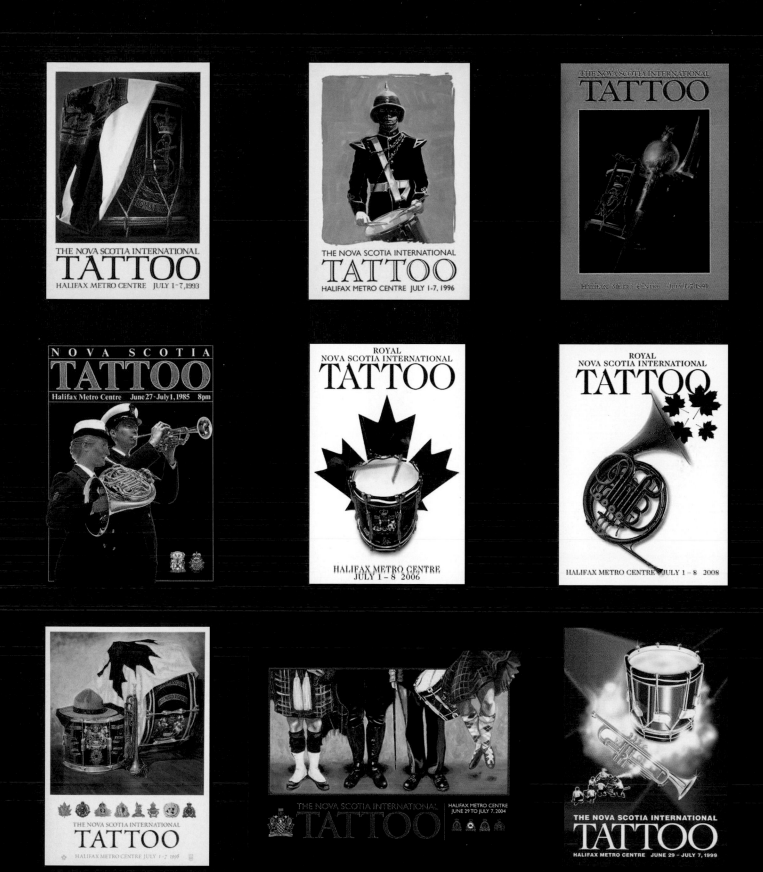

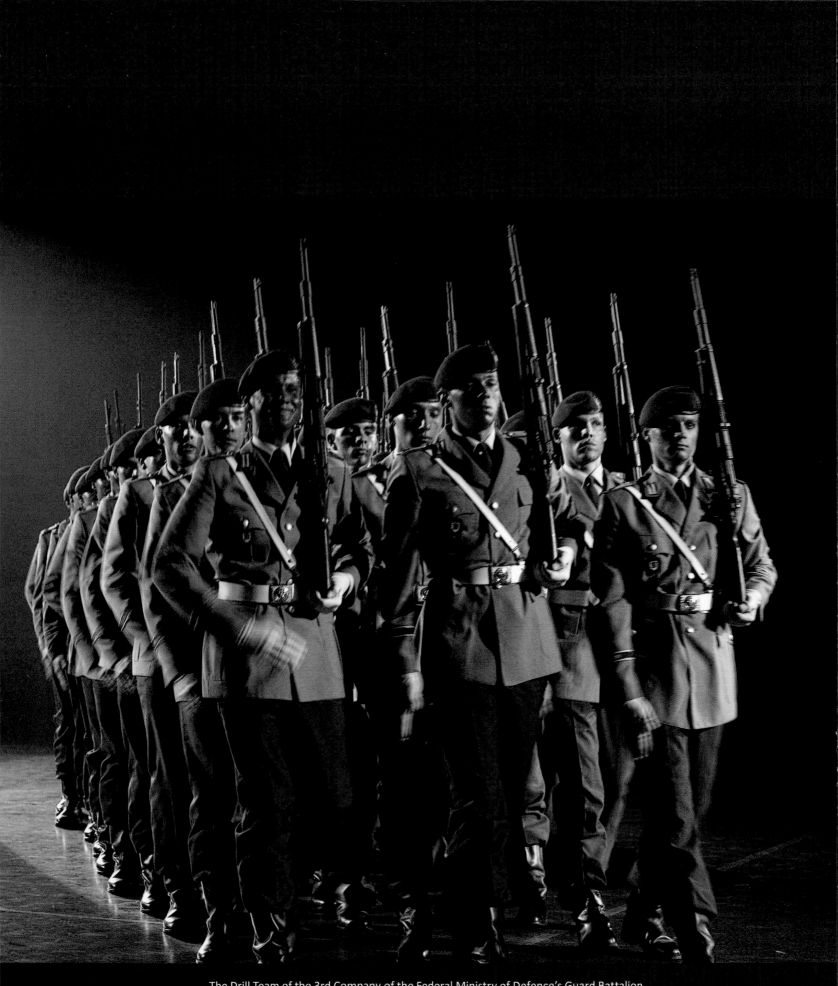

The Drill Team of the 3rd Company of the Federal Ministry of Defence's Guard Battalion
from Siegburg, Germany

The Bond of
FRIENDSHIP

At a reception in spring 1983, quite by accident, the first person to be told that a German band was going to be in the Tattoo that year was one of the most influential businessmen in Atlantic Canada. He was not impressed.

"German participation in that show is not a good idea," he said very seriously, with a touch of genuine anger in his voice. "There are far too many people in Nova Scotia who still remember the Second World War. I, for one, certainly do not agree that a German band should take part in the Tattoo."

That the man was still imbued with a suspicion of Germans nearly forty years after the end of the war astounded us. No one on the Tattoo staff had even remotely considered the possibility that someone might object to German participation in the show. Even more surprising, however, was that the businessman was too young to have served in the war.

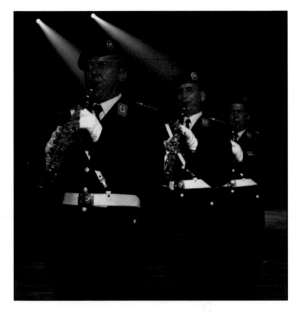

▲ German Air Force Band Musicians

◄ On parade in the Finale

The Tattoo staff's support of German participation was probably due to their long experience serving in the Canadian NATO brigade side by side with the German army. They knew the Germans well—many had lived among them in the villages and small towns surrounding the Canadian bases—and had formed long-lasting and firm friendships with the German people.

▲ ◀ The Flying Grandpas of the
Hamburg Police from Germany

German Air Force Band

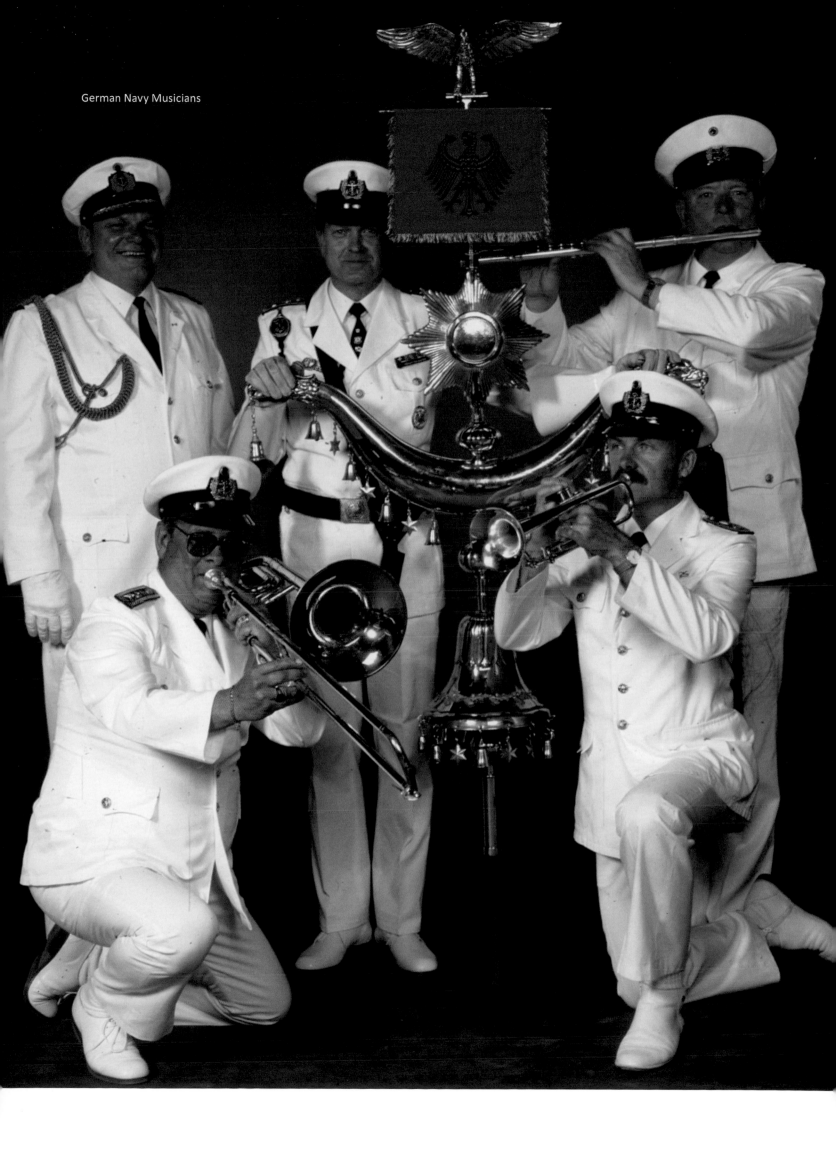

German Navy Musicians

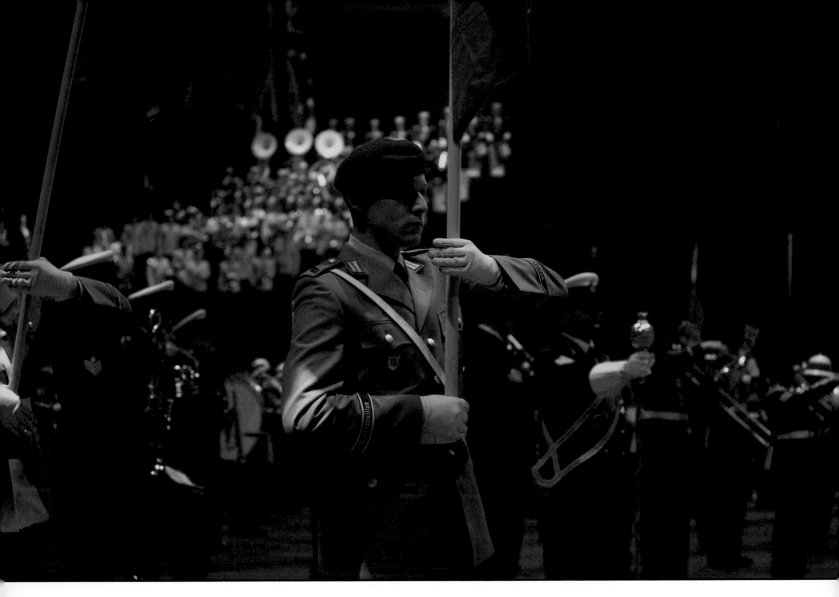

On parade in the Finale

"If a German band appears in the Nova Scotia Tattoo," the businessman went on ominously, "that decision will be greatly regretted by everyone on the Tattoo staff, and I personally will see to it." He turned on his heel and walked away.

The businessman was an influential opinion leader not only in Atlantic Canada, but across the country, so his warning could not be ignored. Still, the Tattoo staff agreed that, as far as they were concerned, a German band was going to be in the show.

The Germans arrived as scheduled and immediately entered into the spirit of the Tattoo. On opening night, Lieutenant-Colonel Herbert Russek, director of music of the German Air Force Band from Karlsruhe,

put to rest any concerns anyone in the Metro Centre might have had. From the moment the band entered the arena, Russek had the audience eating out of the palm of his hand. What followed was a stunning performance of German and Canadian music. It was a triumph.

At the reception following the show that first evening, the businessman who had strenuously objected to the presence of the Germans joined a group of the Tattoo staff gathered about the bar. He stared at them for a moment and said nothing. Then, much to everyone's amazement, all of whom expected the worst, he smiled and said, "I was wrong. I was totally wrong—that band was tremendous, absolutely tremendous."

With the unexpected apology, the businessman perhaps unwittingly had made an important point: when all is said and done, music is a universal language that can work wonders! As a result of the German band's performance, the businessman — along with a few others, including some veterans — left the Second World War behind and went on to become one of the Tattoo's greatest supporters.

The next year, in 1984, Commander Horst Wenzel led the Baltic Sea Band to Halifax, and a year later Lieutenant-Colonel Wolfgang Rödiger's Airborne Band from Stuttgart, with a hilarious "off the wall" display, received the Tattoo's first standing ovation.

German military bands have been a highlight of the Tattoo ever since, with a repertoire so varied and so well performed that they stand apart from every other musical group that has participated. Each presentation is different, extremely creative, and highly entertaining, with an approach that includes humour, fun, and always great music.

But the most important aspect of the participation of German bands in the Tattoo has not been the music but something else. Simply put, it is the friendship the bands have brought to Halifax and the friendship they have taken back to Germany. Many of the Germans have struck up strong personal relationships with Nova Scotians, some marriages have taken place, and some musicians have even established second homes in the province.

The Drill Team of the 3rd Company of the Federal Ministry of Defence Battalion from Germany

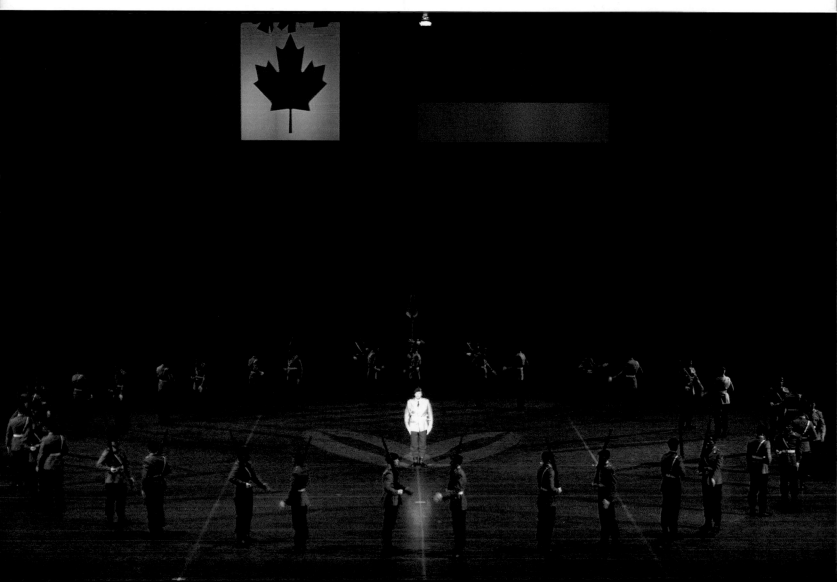

The Flying Saxons from Germany

The National Ceremonial Troop of the
Royal Canadian Mounted Police

One year, after the Tattoo ended, the German
director of music, in an enormously generous
gesture, gave the Tattoo's producer/director Ian
Fraser the baton with which he had conducted
his band in the show. As Fraser said, "That baton
will always remind me of the professionalism of
the bands of the Federal Republic of Germany
and the amazing friendship that has been forged
between Germans and Canadians because of the
participation of those bands in the Tattoo."

German Air Force Band 2 from Karlsruhe

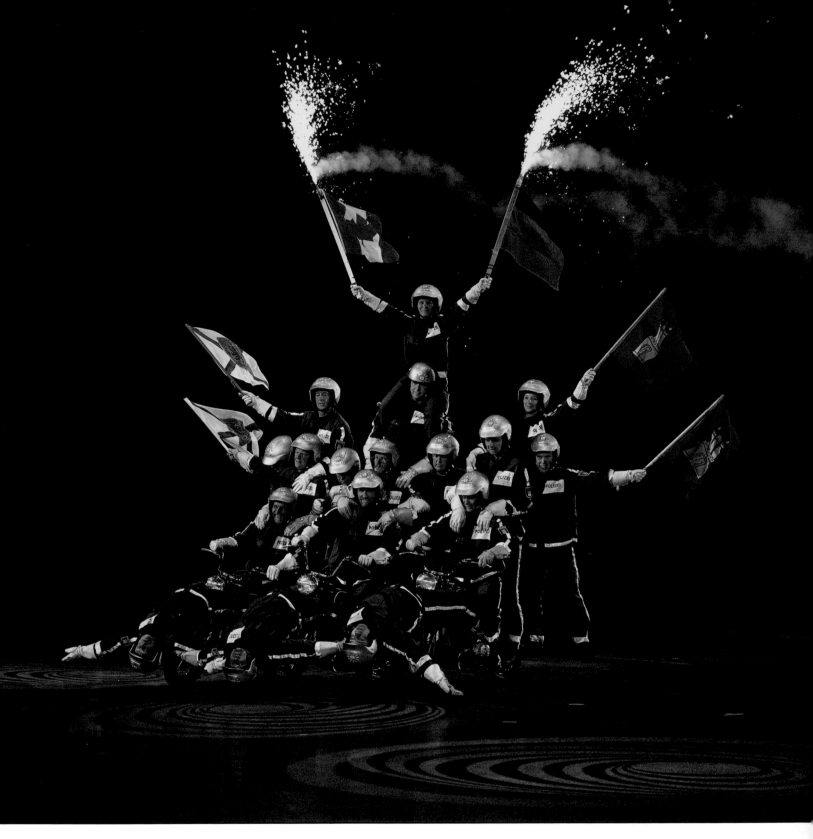

The Hamburg Police Motorcycle Display Team from Germany

Lieutenant-Colonel Russek and his German Air Force musicians captured the hearts of Nova Scotians in 1983 and, in the process, led the Tattoo to establish the "Bond of Friendship" as the annual theme of the production. It is without question one of the best decisions the Tattoo staff has ever made. 🌿

The Motorcyclist

A few items in the Tattoo haven't worked all that well. Jürgen Baumgarten is a case in point.

Ian Fraser still can't recall how he happened to connect with Baumgarten, but it was probably during a trip to Hamburg. Baumgarten was the "Evel Knievel" of Germany, a reputation he got partly by driving a motorcycle off the Innsbruck ski jump in Austria. How he did that without killing himself was a source of wonder to the spectators and, in truth, probably to Baumgarten.

The idea was that, at the Tattoo, Baumgarten would launch himself through fire, then crash through a huge pane of glass. As an additional event he agreed, if arrangements could be made with the city, to drive his motorcycle from Brunswick Street, in front of the historic old town clock on Citadel Hill, down the hill adjacent to the Metro Centre, and then, assuming he had got up to a speed of something in the range of a hundred and fifty kilometres per hour or so, he would leap over the Grand Parade. No problem as far as Jurgen was concerned: just another event in his already dangerous occupation.

Baumgarten arrived on schedule, unpacked his machine, climbed on, and decided to get a feel for the Metro Centre — in a rather unusual fashion. He simply drove the motorcycle up the aisle steps leading to the seats, up to the concourse, and on to the top of the arena. Then he came bouncing back down the stairs and drove up and down the aisles, the cast now streaming out from backstage to watch the performance.

The Metro Centre staff was horrified — if Baumgarten did that with thousands of people in the stands, there could be an interesting lawsuit. In no uncertain terms, an arena representative told Fraser, who was watching the performance with Ann Montague, the production coordinator, that there was no way that would happen during the show. It was frightening enough to watch it without an audience, but with the stands full there was the potential for a major disaster.

Meanwhile, Jurgen finished driving through the stands, then turned his attention to the Tattoo stage. He revved up the bike, drove down the arena floor, turned, and drove up the stairs to the first level of the stage. That in itself was impressive. Then, to add a little zest to the performance, he drove across the stage, planning to go down the stairs on the other side and back up the Metro Centre floor. But it didn't really work out that way. Instead, halfway across, Baumgarten promptly drove over the edge of the stage, dropped fifteen feet onto the terrazzo tile floor of the Metro Centre, landed in a heap with his motorcycle on top of him, and broke his leg.

Fraser immediately assured the arena representative that she no longer needed to worry about Baumgarten's driving through the audience.

Stage Manager Bob Burchill was also somewhat relieved — he had not been looking forward to dealing with the fire marshal about Baumgarten's plan to drive through fire. And he was happy he wouldn't have to figure out how to clear broken glass off the Metro Centre floor.

Baumgarten accepted his fate as a fact of life. He spent the rest of the show, his leg in a full cast, in a wheelchair in the foyer of the Metro Centre with his motorcycle beside him, signing autographs for the curious, who had been exposed to a significant amount of media coverage about the incident. Baumgarten never did jump over the Grand Parade — but, as Fraser was quick to point out, his misfortune sold more than enough tickets to cover the cost of bringing him to Canada.

A poster advertising the infamous Jurgen Baumgarten

The Royal Nova Scotia International Tattoo, as Seen by a Friend from Germany

Since my first visit in 1989 as president of the Hamburg Police Force with the "Flying Grandpas," I have visited the Tattoo in Halifax with my family every year. Even on the homebound flight, I start looking forward to the next show and to meeting our Canadian friends again.

Every year I enjoy the great Canadian hospitality and helpfulness, the calmness and composure of the people in the Maritimes and, in particular, their outstanding friendliness, which is exceptional, even by Canadian standards. Where else in Canada, or in the rest of the world for that matter, do you find cars stopping everywhere to allow pedestrians to cross the road?

And then there's the Royal Nova Scotia International Tattoo, the biggest and, for many reasons, the best show in the world. Nowhere else is perfect entertainment so skilfully and casually bound up with the values of a nation and the institutions that protect and defend it.

Organized with military precision, the show acquires a very special atmosphere of merry enthusiasm, thanks to its hundreds of volunteers. Backstage one senses how the show allows international friendship to develop. In the arena the sound, colours, and performances of first-class participants from throughout the world blend into a breathtaking experience that again and again inspires enthusiastic audiences of all ages to express their pleasure.

The program reflects the very different interests of these audiences, with a broad spectrum of contributions ranging from scenes of sheer exuberance to contemplative, tentative moments.

The presentation shows not only that the police and the military can make music and can march — something everyone knows. With the help of historical scenes, it also explains to those in the audience who otherwise have little contact with these institutions why there is a need in the first place for Canadian soldiers and the police force, why they are proud of their tradition, and what sacrifices and casualties they have borne. It also shows that, inside each uniform, there is an individual like anyone else.

The march-in of the rows of RCMP — the Mounties — with their Canadian flags and banners is a powerful demonstration of Canadian identity. The military history scenes demonstrate the madness of war and the victims it claims, though at the same time underlining a continuing readiness to defend and protect shared values. And if, before the break, the public applauds those who have served their country in uniform, it is a patriotic sense of community that makes itself felt that has little to do with militarism or nationalism.

The impressive case for trust in the police and the military forces is made in a wise and cautious manner. This is not a show that encourages superficial or blind patriotism. Instead it addresses itself to responsible-minded democrats around the world and demonstrates friendship towards all other nations.

This is something that impresses all visitors, the Germans among them in particular. In the Germany of 1933 to 1945, all community-related terms, such as "nation" and "patriotism," were so thoroughly misused and with such dreadful consequences that for a very long time we had great difficulty allowing ourselves to consider using them again. In Halifax some of us became aware of just what our country had lost in this process. Thanks to the Canadian example, we have also won encouragement.

When, in 1995, for example, the rest of the world was commemorating the fiftieth anniversary of the victory over Hitler's Germany, in the Metro Centre in Halifax, Nova Scotia, a Canadian veteran and a German veteran, together with an active Canadian soldier and an active German soldier, celebrated the friendly ties both nations now enjoy despite the oppressive history.

This expression of reconciliation and forward orientation was a moving gesture for us all. We Germans who grew up in the post-war period recorded it with deep gratitude.

We will never forget it.

Dirk Reimers
President of the Hamburg Police Association
Managing Director of the German National Foundation

Das Royal Nova Scotia International Tattoo
aus der Sicht eines Freundes aus Deutschland

Seit meinem ersten Besuch 1989 als Präsident der Polizei Hamburg mit den „Flying Grandpas" besuche ich jedes Jahr das Tattoo in Halifax mit meiner Familie und freue mich beim Rückflug immer schon auf die nächste Show und auf das Wiedersehen mit unseren kanadischen Freunden.

In jedem Jahr genieße ich die großzügige kanadische Gastfreundschaft und Hilfsbereitschaft, die ruhige Gelassenheit der Menschen in den Maritimes und vor allem ihre, selbst für kanadische Verhältnisse, außergewöhnliche Freundlichkeit. Wo sonst in Kanada oder dem Rest der Welt halten Autos überall für Fußgänger an, die die Straße überqueren wollen?

Und dann das Royal Nova Scotia International Tattoo: die größte und aus vielen Gründen auch die beste Show der Welt, denn nirgendwo sonst wird perfekte Unterhaltung so gekonnt und locker mit den Werten einer Nation verbunden und mit den Institutionen, die sie schützen.

Geleitet von einer militärisch exakten Organisation gehen Hunderte von Ehrenamtlichen der Show eine besondere Atmosphäre von fröhlicher Begeisterung. Backstage spürt man, wie die Show internationale Freundschaft entstehen lässt und in der Arena verschmelzen Klänge, Farben und Aktionen erstklassiger Gruppen aus aller Welt zu einer atemberaubenden Gesamtkomposition, die das nach Alter breit gestreute Publikum immer wieder begeistert.

Das Programm nimmt die unterschiedlichen Interessen des Publikums auf und spannt den Bogen von ausgelassener Freude bis zu nachdenklichen Szenen.

Dabei wird nicht nur gezeigt, dass Polizei und Militär Musik machen und marschieren können, was jeder weiß. Menschen, die mit diesen Institutionen sonst oft keinerlei Berührung haben, wird durch historische Szenen vor Augen geführt, warum es überhaupt kanadische Soldaten und Polizisten gibt, warum sie auf ihre Tradition stolz sind, welche Opfer sie gebracht haben und dass in den Uniformen individuelle Menschen stecken.

Der Einmarsch der Reihe von RCMP-„Mounties" mit kanadischen Fahnen ist eine kraftvolle Demonstration kanadischer Identität. Die militärgeschichtlichen Szenen demonstrieren den Wahnsinn des Krieges und die Opfer, die er fordert, und gleichzeitig die Bereitschaft, die gemeinsamen Werte auch künftig zu schützen. Wenn das Publikum vor der Pause denen applaudiert, die ihrem Land in Uniform gedient haben, dann wird ein patriotisches Gemeinschaftsgefühl deutlich, das mit Militarismus oder Nationalismus nichts zu tun hat. Die eindrucksvolle Vertrauenswerbung für Polizei und Militär geschieht weise und behutsam. Diese Show fördert keinen oberflächlichen Hurra-Patriotismus. Diese Show spricht weltoffene Patrioten und verantwortungsbewusste Demokraten an und sie demonstriert eine herzliche Freundschaft zu allen anderen Nationen.

Das beeindruckt alle Besucher, Deutsche aber ganz besonders stark. In Deutschland wurden in der Zeit von 1933 bis 1945 alle gemeinschaftsbezogenen Begriffe wie Nation und Patriotismus so gründlich und mit so furchtbaren Folgen missbraucht, dass wir lange Zeit Mühe hatten, uns diesen Gedanken überhaupt wieder zu nähern. In Halifax wurde manchem von uns erst bewusst, was unser Land verloren hatte. Durch das kanadische Beispiel haben wir hier aber auch Ermutigung erfahren.

Als 1995 zum Beispiel überall in der Welt in 50-Jahr-Feiern auf den Sieg über Hitler-Deutschland zurückgeblickt wurde, symbolisierten im Metro Centre von Halifax in Nova Scotia je ein kanadischer und deutscher Veteran und je ein aktiver kanadischer und deutscher Soldat die freundschaftliche Verbundenheit der beiden Nationen nach einer bedrückenden Vergangenheit. Dieser Ausdruck von Versöhnung und Zukunftsorientierung war für jedermann ergreifend. Uns Deutsche, die wir alle erst nach dem Krieg aufgewachsen sind, hat diese Geste mit tiefer Dankbarkeit erfüllt. Wir werden das nie vergessen.

Dirk Reimers
Vorsitzender des Polizeivereins Hamburg e.V.
Geschäftsführender Vorstand der Deutschen
Nationalstiftung

The Reconciliation — Warrant Officer M.R. Hennig of the German Armed Forces, Second World War soldier Dennis LeBlanc of the West Nova Scotia Regiment, Robert Dietz, a German soldier, and Sergeant K.R. Venus of the Royal Canadian Regiment. LeBlanc and Dietz fought against each other in the Second World War and later became close friends. Hennig and Venus served with the United Nations as peacekeepers.

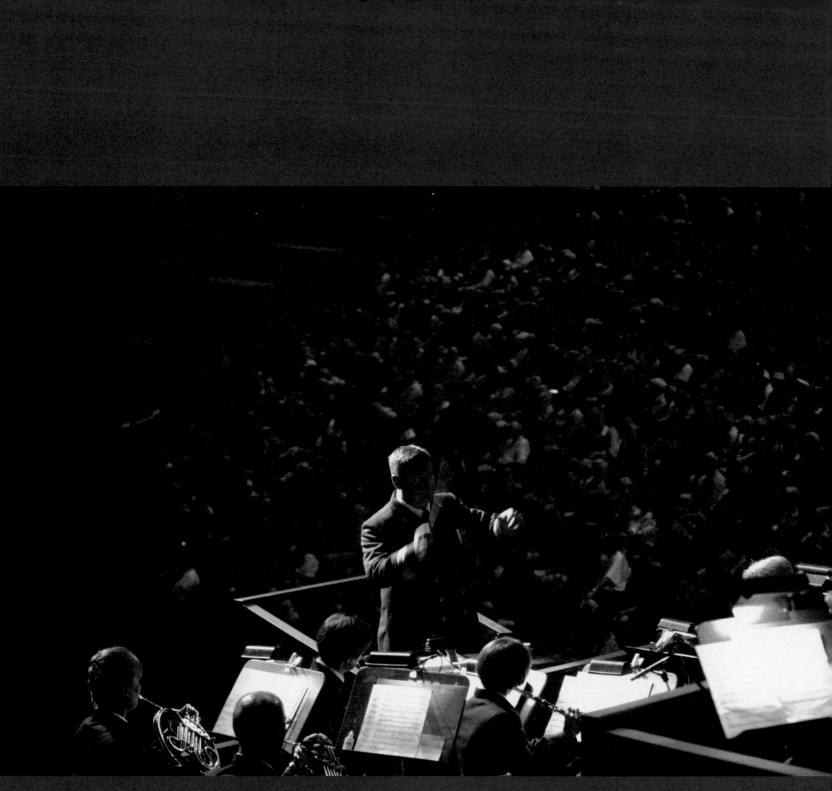

Lieutenant-Commander Ray Murray, Director of Music,
The Stadacona Band of Maritime Forces Atlantic

ACKNOWLEDGEMENTS

Even assuming a picture is worth a thousand words, a book cannot be more than a pale reflection of the Royal Nova Scotia International Tattoo. Simply put, the drama, music, excitement, colour, and pageantry of this amazing theatrical event must be experienced. That said, a great many people have been of immeasurable help.

Ann Montague, the CEO/executive producer of the Tattoo, and Barbara MacLeod, the Tattoo business manager, decided the book project was viable and set the wheels in motion. Ann was also the first to read and comment on the manuscript, and she was ever ready to offer advice and assistance.

Leah Whitehead, who displayed great efficiency in coordinating the project for the Tattoo and liaising with the publisher, deserves much credit, as do Sue Dickie and Jim Forde of the Tattoo staff, both of whom helped in a wide variety of ways.

Many thanks to Barry Norris, who edited the manuscript and, in the process, greatly improved my occasionally shoddy work, and to Edward Young, the Deputy Private Secretary to The Queen, who obtained a message from Her Majesty. Dirk Reimers, the managing director of the German National Foundation and a long-standing friend of the Tattoo, deserves much appreciation for his splendid overview of the Tattoo from the perspective of a European.

Beth Brooks, Thomas Grotrian, Philip Hartling of the Nova Scotia Archives, Laura MacDonald, Margaret MacDonald, Diane Tibbetts, and Ken Webb helped with the photo collection. Thanks to Angela Williams of Goose Lane Editions, who was tolerant of my cavalier attitude toward her deadlines, and to Ike Kennedy, who was ever ready to provide a link to the publisher. Many others who contributed to the end product chose to remain anonymous.

The photographers, more than anyone else, provided the foundation for the book: the late George Tibbetts, who started the Tattoo photo collection thirty years ago, and the late Bob Brooks, one of Nova Scotia's most famous photographers, were the first to be involved; Dave Stewart, who created a great artistic void when he left the photography profession a decade or so ago; Doug O'Neill, long-standing Tattoo photographer; Jean-Pierre Lafleur, a Canadian Air Force officer and sometime musician, who generously shared his passion for photography; James Whitehead, Nora Blansett, and Master Corporal Albert and Corporal Dugay of the Canadian Forces — all deserve special thanks. Then there is François Deschacht, a highly talented Belgian photographer who travels to Nova Scotia every year at his own expense specifically to photograph the Tattoo and asks for nothing in return.

The Tattoo production and administrative staff have been immensely helpful. They talked openly about the show but modestly refused to take any credit — in many cases identifying others who they felt had made a greater contribution. Sadly, many who gave so much are no longer with us, but their legacy lives on. Great appreciation is due those who put the show on each year and to whom Aubrey Jackman, the British dean of Tattoo producers, refers simply as a "team of friends."

For anyone who has seen the Royal Nova Scotia International Tattoo, one can only hope that this book will bring back a few memories. For those who haven't, perhaps it will encourage them to travel to Nova Scotia and discover what is essentially Canada's best-kept secret.

As always, any errors or omissions that a vigilant reader might pick up are my responsibility.

Simon Falconer

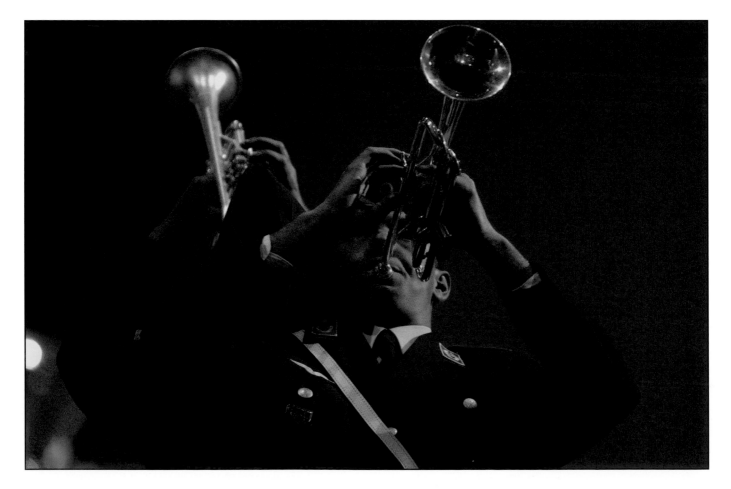

Royal Nova Scotia International TATTOO

SOCIETY

Patrons
The Hon. Myra A. Freeman,
Lieutenant-Governor of Nova Scotia,
2003-2006
The Hon. Mayann E. Francis,
Lieutenant-Governor of Nova Scotia,
2007-

Board of Directors
David Sobey, *Honorary Chairman*
LCol The Hon. Alan R. Abraham,
Chairman
Tina V. Battcock
Col (Ret'd) J.B. Boileau
Col A.D. Blair
David J. Bright
Cmdre (Ret'd) David Cogdon
Steinar Engeset
D/Commr Steve Graham
Dana Hatfield
VAdm James King (Ret'd)
M. Patricia Lynch
James M. MacConnell
RAdm P.A. Maddison
Ann Montague
Harvey Morrison
Deborah R. Mountenay
BGen D.G. Neasmith
Col (Ret'd) John Orr
D/Commr (Ret'd) J. Terry Ryan
Joseph P. Shannon
Frank Cameron Sobey
Donald G. Tremaine
John Young

Advisors
Larry Doane
Col (Ret'd) Ian S. Fraser
George W. MacDonald, *Past Chairman*

Members
VAdm (Ret'd) J. Allan
Margaret Amour
Adm (Ret'd) J.R. Anderson
Col (Ret'd) A.D. Blair
D/Comm J.G. Harper Boucher
J. Bernard Boudreau
Senator The Hon. John M. Buchanan
VAdm (Ret'd) P.W. Cairns
The Hon. Donald W. Cameron
Col (Ret'd) John M. Cody
George Cooper
BGen (Ret'd) C. Curleigh
Brian Cuthbertson
Capt (N) (Ret'd) H. Davies
Premier The Hon. Darrell Dexter
Lois Dyer Mann
Capt (N) (Ret'd) Bryan Elson
Brian Flemming
The Hon. Myra Freeman
VAdm (Ret'd) J.A. Fulton, *Past Chairman*
VAdm (Ret'd) G.L. Garnett
VAdm (Ret'd) R.E. George
Col (Ret'd) B.C. Gilchrist
Ruth M. Goldbloom
The Hon. John F. Hamm
Bernie Hum
Maj Aubrey Jackman
Jack Keith
Mayor Peter Kelly
Michael A. Kontak
Jim Lotz
A/Commr Gerry Lynch
The Hon. Rodney MacDonald
Jack MacIsaac
VAdm Bruce MacLean
The Hon. Russell MacLellan
Annette Marshall
VAdm (Ret'd) L.G. Mason,
Past Chairman

Bill McEwan
VAdm P.D. McFadden
Cdr (Ret'd) Jack McGuire
Douglas C. McNeil
RAdm (Ret'd) D.G. McNeil
VAdm (Ret'd) D.E. Miller
John A. Morash
Kenneth M. Mounce
Deborah R. Mountenay
Col D.A. Neill
BGen Rick G. Parsons
Dirk Reimers
BGen R.R. Romses
Insp (Ret'd) Keith Sherwood
John R. Sobey
VAdm (Ret'd) C.M. Thomas
Barbara Watt
VAdm (Ret'd) J. C. Wood
Michele Wood-Tweel

To differentiate from ex officio members and in recognition of their exceptional support over many years, those names in italics were elected to the Royal Nova Scotia International Tattoo Society.

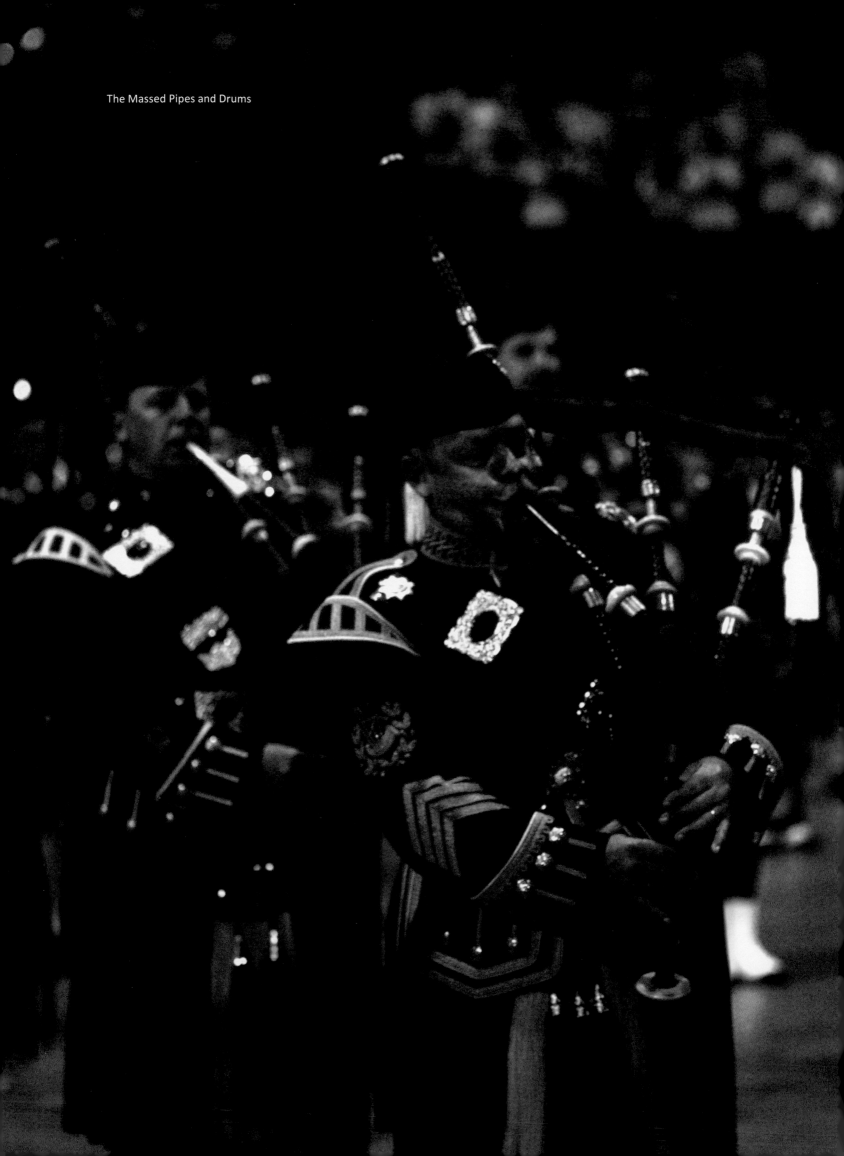

The Massed Pipes and Drums

FOUNDATION

Board of Directors
D/Comm (Ret'd) J. Terry Ryan,
Chairman
LCol The Hon. Alan R. Abraham
Cmdre (Ret'd) David Cogdon
Lt (N) (Ret'd) Jim Forde
Trevor Hughes
John Jay
VAdm James King (Ret'd)
George W. MacDonald
Jack MacIsaac
Ann Montague
Kenneth Mounce
Harry Munro
Susan Parker
Insp (Ret'd) Keith Sherwood

Advisors
Larry Doane
Col (Ret'd) Ian S. Fraser
The Hon. Myra A. Freeman

Premiers of Nova Scotia
John M. Buchanan, 1979-1990
Donald W. Cameron, 1991-1992
John P. Savage, 1993-1997
Russell MacLellan, 1998-1999
John F. Hamm, 2000-2005
Rodney MacDonald, 2006-2008
Darrell Dexter, 2009-

Commanders Maritime Command
VAdm A.L. Collier, 1979
VAdm J. Allan, 1980
VAdm J.A. Fulton, 1981-1983
VAdm J.C. Wood, 1984-1987
VAdm C.M. Thomas, 1988-1989
VAdm R.E. George, 1990-1991
VAdm J.R. Anderson, 1992

VAdm P.W. Cairns, 1993-1994
VAdm L.G. Mason, 1995-1996

Commanders Maritime Forces Atlantic
RAdm G.L. Garnett, 1996
RAdm G.R. Maddison, 1997
RAdm D.E. Miller, 1998-2000
RAdm Bruce MacLean, 2000-2002
RAdm G.V. Davidson, 2002-2004
RAdm D.G. MacNeil, 2005-2006

Joint Task Force Atlantic
RAdm Dan MacNeil, 2006-2007
RAdm Dean McFadden, 2007-2008
RAdm Paul Maddison 2008-

Commanders Land Force Atlantic Area
MGen R.R. Crabbe, 1996-1997
BGen H.C. Ross, 1998
BGen D.W. Foster, 1999
BGen G.B. Mitchell, 2000-2003
BGen R.R. Romses, 2003-2005
BGen Richard Parsons, 2006-2007
BGen David Neasmith, 2008-2009

Commander Land Force Central Area
BGen J Collin, 2009

Commanders Maritime Air Component (Atlantic)
BGen B.N. Cameron, 1996-1997
Col J.L. Orr, 1998-1999
Col M.W. Haché, 2000-2002
Col M.H. Arndt, 2003-2004
Col D.A. Neill, 2005-2006
Col Alan Blair, 2007-2009

Royal Canadian Mounted Police
C/Supt H.A. Fagan, 1979-1980

C/Supt C.J. Reid, 1981-1988
C/Supt G.G. Leahy, 1989-1990
A/Comm A.D.F. Burchill, 1991-1995
A/Comm R.F. Falkingham, 1996-1997
A/Comm D.L. Bishop, 1998-2003
A/Comm Ian Atkins, 2004-2007
A/Comm Steve Graham, 2008
D/Comm Steve Graham 2009-

Mayors of Halifax and Halifax Regional Municipality
Edmund Morris, 1979-1980
Ronald J. Hanson, 1980
Ron Wallace, 1981-1991
Moira Ducharme, 1991-1994
Walter Fitzgerald, 1994-2000
Peter Kelly, 2001-

Chairman, The Nova Scotia Tattoo Committee
VAdm (Ret'd) J.A. Fulton, 1986-1987

Chairman, The Nova Scotia International Tattoo Committee
VAdm (Ret'd) J.A. Fulton, 1988-1994

Chairmen, Nova Scotia International Tattoo Society
VAdm (Ret'd) J.A. Fulton, 1995-1998
VAdm (Ret'd) L.G. Mason, 1999-2001
George W. MacDonald, QC, 2002-2005

Chairmen, Royal Nova Scotia International Tattoo Society
George W. MacDonald, QC, 2006-2007
LCol The Hon. Alan R. Abraham, 2008-

Chairman, Nova Scotia International Tattoo Foundation
D/Comm (Ret'd) J. Terry Ryan, 2007-

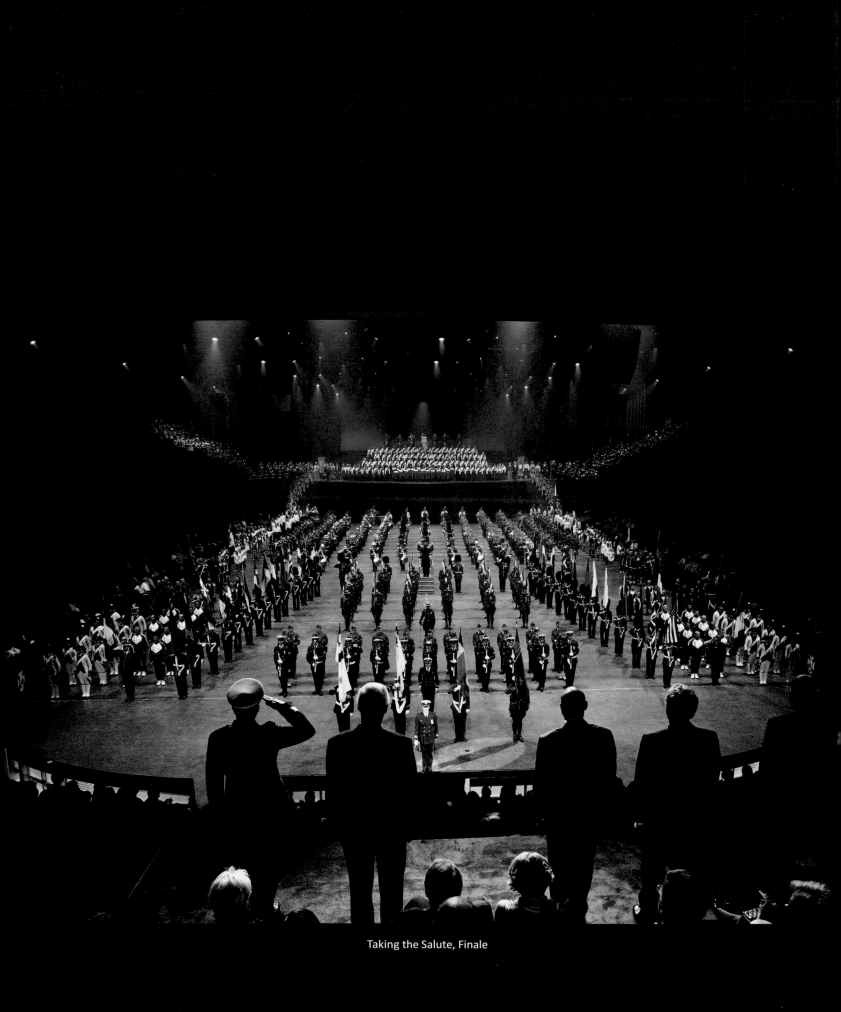

Taking the Salute, Finale

TATTOO STAFF AND CREW
1979-2009

Producer/Director
Ian S. Fraser

CEO/Executive Producer
Ann Montague

Artistic Director
Ian S. Fraser

Production Designers
Fred Allen (Set and Props)
Lin Chapman (Costumes)
Robert Doyle
Rosemarie Gwilliam (Costumes)
Marilyn T.F. McLaren (Costumes)
D'Arcy Poultney
Lesley Preston (Set and Props)

Lighting Designers
Donald Acaster
David Hignell
Brian S. Pincott

Assistant Producers
Ann Montague
Maj George Tibbetts

Choreographer/Dance Director
Joseph Wallin

Assistant Directors
Doug Bell
CWO Tom Peet
Don Reekie

Principal Directors of Music
Capt W.F. Eberts
Cdr Jack McGuire

Tattoo Director of Music Emeritus
Cdr Jack McGuire

Tattoo Choral Director/Arranger
Dr. Walter Kemp

Production Coordinator
Jim Forde

Business Managers
Shelley Arsenault
Barbara MacLeod

Accountant
Brenda Keith

**Assistant Principal Director
 of Music**
Capt W.F. Eberts

Children's Chorus Director
Patricia L. (Guy) Tupper

Directors of Pipes & Drums
Capt Ian Ferguson
Capt Andrew Kerr

Tattoo Drum Majors
Norman MacKenzie
MWO Arthur McKenzie
CWO Tom Peet

**Tattoo Pipe Majors/Pipes and
 Drums Coordinators**
Capt Fred Alderman
Capt Donald M. Carrigan
CWO A.L. Dewar
CWO W. Gilmour
PM James A. Patterson
WO Dan Smith

Drum Majors (Pipes and Drums)
John Cody
Sgt Duane Johnson
Bob Marr
WO Colin Smith

Drum Majors (Military Bands)
Jack Fisher
CPO2 Mike Morling

CWO Tom Peet

**Additional Music Composers
 and Arrangers**
Graeme Abernethy
Capt Peter Archibald
Ben Bogisch
Heather Davis
Earl Fralick
Leo Harinen
Cdr Jack McGuire
PM James A. Patterson
Graham Rhodes
Craig Roberts
Jamie Thomas

**Tattoo Fanfare Trumpet
 Coordinators**
LCdr (Ret'd) Gaetan Bouchard
CPO2 Frank Ridgeway

**Tattoo Drumming Coordinators
 (Pipes and Drums)**
Sgt Eugene Heather
CWO Mike Steele

Tattoo Pipe Major Emeritus
PM James A .Patterson

**Tattoo Drumming Coordinators
 (Military Bands)**
CPO2 Bill Brousseau
PO1 Al MacDonald

**Massed Band Choreographer/
 Trainers**
PO2 Dennis Collier
Capt F.S. Gannon
PO1 Bob Gaudreau

Performer Liaisons
François Deschacht — Belgium
Rudy Eneman — Belgium

Maj Aubrey Jackman — United
 Kingdom
Wilhelm Jaenike — Germany
Col (Ret'd) Anthony
 McGee — Australia
Vitaly Mironov — Russia
Felix Park — France
Jacqueline Park — France
Craig Roberts — United Kingdom

Ensemble Directors
Hugh Dickie
Ian Flemming
Peter Luongo

Associate/Assistant Lighting
 Designers
Eric Céré
Brian Dawe
James McDowell
Michael Patton

Marketing Coordinators
Alexandra (Weedon) Bryan
P.J. Dunning
Brent Feser (Assistant)
Thomas Grotrian
Katherine Handin
Angela Landry
Katherine MacDougall
Robyn McIsaac
Don Shiner

Advertising
Bobbie Harrington
Anita Lathigee
Carole McDougall
Scott Tremaine

Backstage Coordinators
Eric Journeay
Mike Muldoon
Harry Philpitt

Tattoo Narrators
Geoff Ball
Doug Bell
John Fulton
Costas Halavrezos
George W. Jordan
John Nowlan
Donald G. Tremaine

Production Manager
MWO Robert Burchell

Assistant Production Manager/
 Comptroller
Maj Al Brown

Production Assistant
Maj Grant MacLean

Production Consultants
Richard W. Aldhelm-White
Robert Dietz
John Grenville
Pedro Guinard
LCol (Ret'd) W.E.J. Hutchinson
Maj Aubrey Jackman
Maj Rick Mader
Hamilton McClymont
Wayne Moug

Training Coordinator
CPO1 D.B. Wright

Arena Masters, Assistant Arena
 Masters, and Stage Crew
 Supervisors
PO2 M. Archambault
PO1 P.A.J. Beauvais
PO2 T.K. Beazley
Brian Bennett
MS M. Blanchette
WO J. Brackley
Sgt Michaela Brister
MWO Bruce Campbell
MS A. Collier
PO1 Bill Delaney
PO D.R. Deschene
CPO1 Gary Dumas
MS Gordon Dumas
PO2 C.R. Ehler
PO2 M.L. Eng
Doug Ewing
PO2 J.Y. Gaudet
Rebecca Hanson
MS M.J. Hebert
Ms C.E. Hilchey
LS Daniel Jacques
Dave Jellicoe
MS L. Jesso
Michael Johner
STGC Gregory King (U.S. Navy)
Capt Teresa King
OS Patricia Kruger
Nicolas Kunz
LS Martin Lallier
CPO1 Pat Laming-Russell
MS A.S. Lavergne
CPO2 Keith Lawson
PO1 John Letour
PO1 Larry Marshall
Melinda McKenzie
PO2 A. Scott McKenzie
Chris Mitchell
Lt (N) J.M.E. Monette
LS W.J. Munro
LS Michael Myles
MS Andrew Pirie
Donald Reibin

LS Stefane Sabourin
Matthew Smith
PO1 M. St-Hilaire
PO1 B.D. Ubsdell
Maj Bill Weagle
PO2 D.K. Wilton
Lauren Westhaver
Jake Wttewaall
SLt Chris Young
PO2 C. Young

Stage Crew/Set Construction
14 Airfield Engineering Squad
3ESR
CF Fleet School (Halifax)
CFNES CSE
CFNES PAT
CF Recruiting, Education and
 Training System
PO2 Michel Fabre
Bernard Gagnon
MWO B.L. Gallant
Capt Jessie Grondines
Her Majesty's Canadian Ships
 (East Coast)
HMCS *Athabaskan*
HMCS *Halifax*
HMCS *Ville de Québec*
HMCS *St. John's*
HMCS *Windsor*
Mary Jane MacLeod
Maritime Command
Maritime Forces Atlantic
MUG5
Naval Construction Troop
Naval Reserve Headquarters
Andy Nicholson (Steel Carpenter)
Darrell Shupe (Steel Carpenter)
Mike Smith (Steel Carpenter)

Technical Directors/Coordinators
PO Jack Drake
Maj Frank E. Grant
Andre Langevin
David Mardon
Mike Maskell
William Pyke
Colin Richardson
Dave Stevenson

Set Coordinators
Mary Jane MacLeod
Phil Sorge

Head Carpenters
Robert M. Backen
Patrick Beauchamp
Marcel Boulet (Assistant)
Derek Bruce (Assistant)
Robin Creelman (Assistant)
Brian Dawe
Robert A. Elliot

Jake Danson-Faraday (Assistant)
Mike Davis (Assistant)
Rick Gillis (Assistant)
Derek Lemire
Terry MacKay
Steve Mahoney (Assistant)
Paul Majcan (Assistant)
Corey Mullins (Assistant)
Don Nicholson
John O'Neil (Assistant)
Andrew Rafuse (Assistant)
Terry Reid (Assistant)
Joseph Unrau (Assistant)
Larry Walker (Assistant)

Sound Director
Alan Strickland

Audio/Sound Engineers
Russell Brannon
Bill Girdwood
Robb Hall
Stéphane Lemay
Guy LeMire
William MacEwan
Al Merson
Alan Strickland
Bruce Thomsen

**Assistant Sound Engineers/
Technicians**
Michael Arnold (Assistant)
Marc Beauchamps (Assistant)
David Brazeau (Assistant)
Christopher Coote (Technician)
Dave Corkum (Coordinator)
Eleanor Creelman (Deck Crew)
Randy Daniels (Technician)
Brian Farr
Bill Girdwood (Assistant)
Ron Gorveatt (Assistant)
Robb Hall
Marc Laliberte (Technician)
Andy Robichaud (Assistant)
Randy Smayda (Assistant)
Frederic St-Onge (Assistant)
Harold Tsistinas (Assistant)

Sound Crew Chief
Barry (Scrapper) Stevenson

Visuals
Ron Doucette
Amanda Murphy

Technical Crew Chief
Deborah Richardson

Lighting
Maxim Archambault (Board Operator)
David Bergeron
Robert Brassard

Eric Céré (Moving Light Designer)
Gary K. Clarke
Tim Crack
Pablo Cruz
Brian Dawe (Board Operator)
Benoit De Carufel (Crew Chief)
Borys Demchynshyn
Blair Dykeman (Crew Chief)
Marie-Claude Gaboury
Gaétan J. Jalbert
Richard Lafortune
Martin Laurendeau
Mathieu Lavallee (Moving Light
 Opertaor)
Woehral Loïc
Jean Francois Mallette
William McDermott
Meric Messahli (Crew Chief)
Ray Myles
Shawn Organ (Board Operator)
Sylvan Paquet (Solotech Project Mgr.)
Serge Poupart
Dave Reilly (Crew Chief)
Matt Richman (Crew Chief)
Francois Roupignant
Pierre St-Mars
Michael Still
Valy Tremblay

Riggers
Mike Davis
Dan Grady
Evan MacDougall (Head Rigger)
Roy Mombourquette
LS Troy Queen
MS J.P. Rondhuis
PO2 B.L. Stanick

Head Electricians
Neil Andrews
Luc Bourget
Jean-François Canuel
Normand Chasse
Doug Kiddell
Steve O'Connor
Gaétan St-Onge

Costume/Wardrobe Supervisors
Christine Bray
Lin Chapman
Bonnie Deakin
Rosemarie Gwilliam
Jean Kimber
Nancy Leary
Helena Marriot
Marilyn McLaren

Costume Construction
Dawn Marie Alexander
Abby Anderson
Denise Barrett
Dawn Marie Bayer

Gail Beaton
Nancy Bell
Kathryn Belzer
Carl Bezanson
Tracy Biggs
Stephanie Blackford
Shirley A. Blakley
Tracy Bouchard
Maria Caissie
Marlene Charest
Susan Chase
Betty Chow
Rhonda Coates
Jennifer Coe
Angela Colburne
Rachel Cole
Brenda Louise Conrad
Stacey Cornelius
Holly Crooks
Shayne Cunningham
Martha Curry
Helene Dahl-Diggins
Stefan Dean
Mark DeCoste
Laurie Delany
Elizabeth Delorey
Rachel Denkers
Hilary Doda
Karen Donaldson
Bernice Dooley
Sara Driscoll
Pat Duggan
Jacqueline Ann Falle
Monica M. Farrell
Victoria Fenwick
Robin Fisher
Nadine Fletcher
Deborah Fraser
Katie Fraser
Shirley Fuchs
Anne Gavel
Patty Givogue-Reid
Ian Gough
Brad Gould
Rachael Grant
Anna Gudelewicz
Joanna Haney
Josie Harries
Louise Harrington
Julie Horrocks
Sandra Hum
Stephen Hupman
Amé Hutchinson
Catherine Jean Inkpen
Cynthia Jimenez
Minetta Jollimore
Karla Kasdan
Alexandra Kavanagh
Paula Kayouette
Julie Kennedy
Genevieve Killin
Jessy Lacourciere

Clarinda Leach
Dawn LeBlanc
Rhonda LeBlanc
Krista Levy
Sarah Linley
Laura Lee MacKay
Nicole Maquis
Sarah L. Marchant
Meghan Marentette
Iris Y. Mariott
Christina McCaffrey
Carla F. McGrath
Carol L. McNutt
Sandra McNutt
Karen McVey
Patricia Melville
Catherine Mertens
Alfonsina Metcalf
Jim Michieli
Jen Mills
Lynette Muise
Roseanne Reeve-Newson
Anita O'Toole
Roberta Ann Palmer
Michelle Pelletier
Carmen Perrier
Joan-Kathleen Peterson
Susan Pheiffer
Cara Porter
Melanie Putt
Roseanne Reeve-Newson
Brigitte U. Rehwagen
Annie Rempel
Sharon Reynolds
Katherine M. Richmond
Rachael Robatait
Elaine Sanford
Tanya Ann Shaw
Danny Shepard
Elise Sinclair
Beata Slesnski
Brenda Small
Tamara Smith
Martha W. Snetsinger
Alix Speirs
Julia St. Germain
Joan Stewart
Rebekah Streeter
Karen Tarum
Stella Adenike Tobun
Yesim Tosuner
Patrick Vallée
Pat Walton
Glennys Ward-Eversley
Janet Waters
Janice Weatherby
Deanna Webber
Jay Wells
Deborah White
Shirley Wile
Meredith Wilson
James Worthen

Hairdressers
Shannon Beardsmore
Tom Hart
Lisa Hobeck
Siobhain Horne
Nicole Jarrett
Joanne Mercer
Stephanie Sack
Jonathan Sells
Ashley Taylor

Tattoo Costume Stores
John McLaren
MCpl James A. Rogers

Military Historic Uniforms
Maj D.J. Feltmate
Marilyn Gurney
Capt Yves Laplante
Maj G. Melville
Capt M. O'Leary
Barry Rich
2Lt Stephen Ritchie

Properties Coordinators/ Supervisors
Sara (Hollett) Çelik (Pyrotechnics)
Ken Garant (Radio Controlled Props)
Arie Hakkert (Models)
Patricia Martinsen
Jim Morrow (Special Props)
Mary Sadoway
Jennifer Wyatt

Properties Assistants
MCpl Murielle Arsenault
Sandy Battcock
Cathy Bezanson
Tony Bezanson
Krista Blackwood
Allen Boden
Mark Church
Denise Dolliver
Dorothy Edwards
Lavina Fallows
Nadine Fletcher
Edith Hicks
Sara Hollett
Jennifer Hunt
Heather Jamieson
Ruth Leggett
Charlii Lohnes
Lois Loignon
OS Dwayne Mackie
Vickie Marston
Jane Muldoon
Cynthia O'Brien
Jessica Squires
Thelma Phillips
Zenovia Sadoway
Darlene Shiels
Dan St. Pierre

Peter West

Scene Artists/Painters
John Allen
Hal B. Forbes
Pamela Langille
Richard Marion
Anne Murphy
Thomas P. Paisley
Gary H. Tefler
Lorinda C. Thomas
Wendy Trethewey
Dixie White

Tattoo Logo
Paul Brunelle

Public Affairs and Media Relations
Kathleen Beaton
Katharine Berrington
Pamela Boutilier
Michelle Boylan
Margaret Brill
Capt Ross Brown
LCdr Len Canfield
LCdr Glen Chamberlain
Deborah Chatterton
Anne Marie Coolen
Suzanne Copan
Colin Craig
Maj Tim Dunne
2nd Lt PJ Dunning
Helene Gauthier
Shannon Guidry
Elizabeth Hagen (Assistant)
Charlotte Hansen
Capt John Helle
Nicola Hubbard (Assistant)
Michelle Irwin
Joanne M. Kerrigan
Akiko Lovett
Lt A. B. MacPherson
SLt Peter Magwood
Katherine Pederson
Menna Riley
Paula Romanow
SLt Penne Ryall
Lt (N) Sue Stefko
Amy Thurlow
Carolyn Townsend
Laurel Walker
James Wentzell
Maj William Whitehead

Administrative Assistants
Iona Allen
Susan Dickie
Anne MacLean
Jennifer Noel

Backstage Marshals
Retired Members of Chiefs and Petty
 Officers Association

**Program Copy and Additional
 Script Material**
Col (Ret'd) John Boileau
George Borden
Brian Cuthbertson
Harry Flemming
LCol (Ret'd) Duncan G.L. Fraser
Jane Greening
Sqn Ldr (Ret'd) Glen Hancock
Jim Lotz
Guy Simser
John Soosaar
Dr. Ronald Stewart
Donald G. Tremaine
William Weagle

Tattoo Graphic Designer
Ken Webb Design

**Tattoo Poster & Program
 Designers**
Amy Boehmer
Arthur Carter, Paragon Design Group
Cuvilier Communications
Gaynor Sarty Graphic Design
Jordie Gillis
Pekka Kauppi
LCol (Ret'd) I.A. Kennedy
Dave Leonard
Theta Marketing Ltd.
Ken Webb Design

Souvenir Program
Margaret Cassidy

Laura Clement
Heather M. Cochrane
Catherine Eyre
Julie Giles
Anne Graham
Cpl L.D. Hamilton
J. Brian Hannington
Cynthia Henry
Marie Hill
Heather Hueston
Steve Jennex
Ramona Lewis
Nicole A. McGillivary
Ellen E. Overy
Silvia Pecota
Terry Power
Cpl V.A. Riley
Karen Seaboyer
James Wentzell

Electronic Media
Clary Flemming and Associates Ltd.

Tattoo Festival Coordinators
Bill Fell
Maj J.M. MacNeil
Rebekah Streeter (Assistant)

Tattoo Volunteer Coordinators
Lynn Blake
Margaret Brill
David Church
Lynne Church
Marie Crosby
Jamie de Havilland
Theresa Feltmate

Tattoo Extras Coordinators
Larry Amirault
Lori Amirault
David Biggs
Robin Biggs
Richard Crowe
J.F. MacNeil
Al McKenzie
WO Don Smith
John C. Tupper
Lester Wood
Graham Young

Special Assistants
Sheila Andrecyk (Adult Choir)
Vera Armstrong (Adult Choir)
Barbara Birks (Dancers)
Rebecca Campbell (Ticket
 Coordinator)
Margie Colwell (Adult Choir)
Caroline Conliff (Gymnastics)
Jaquelyn Cormier (Dancers)
Paul Creaser (Adult Choir)
Thies Eisele (Pipes & Drums Parade)
Sophie Fong (Children's Chorus)
Jane Godley (Adult Choir)
Annette Graham (Gymnastics)
Anne Hayes (Children's Chorus)
Kori Inkpen (Gymnastics)
Carol Jewett (Parties & Receptions)
Paula Johnson (Gymnastics)
Carol Kemp (Adult Choir)
Valda Kemp (Adult Choir)
Pat Kent (Dancers)
Kelly Lovett (Gymnastics)
Elizabeth MacDonald (Dancers)
Kim MacLeod (Dancers)
Carol Anne MacPhee (Adult Choir)

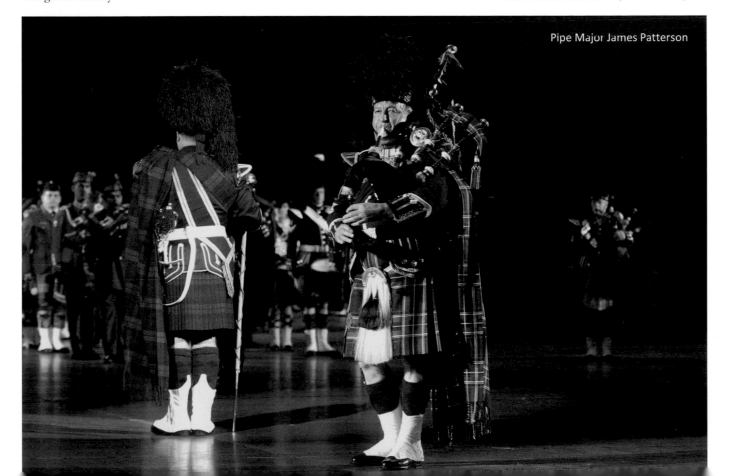

Pipe Major James Patterson

Alan Manchester (Adult Choir)
Ann Martell (Adult Choir)
Erin Maxner (Children's Chorus)
Kerry Maybee (Gymnastics)
Erica McBurney (Children's Chorus)
Coleen McJannet (Adult Choir)
Wendy Mooney (Dancers)
Colin Naulls (Children's Chorus)
Anneke Nielsen (TV Liaison)
Robyn Ovans (Dancers)
Cindy Penney (Dancers)
Jessica Roach (Children's Chorus)
Jill Simonsen (Dancers)
Capt Germaine M. Snow (Script)
Colin Stephenson (Gymnastics)
Marjorie Suddaby (Adult Choir)
Laura Thibault (Children's Chorus)
Michael Thibault (Children's Chorus)
Alexander Tilley (Adult Choir)
Jean Tremaine (Music Data Base)
Emma Tupper (Children's Chorus)
Kathryn Tupper (Children's Chorus)
Olivia Tupper (Children's Chorus)
Mary Ann Wallin (Dancers)
Bernice Williams (Parties &
 Receptions)
Laurie Young (Dancers)

Gymnastics Coordinators
Alexandra (Weedon) Bryan
Craig Budgell
Susie Gallagher
Leigh Merrill
Lynn Pascoe
Catherine Shortt

Dance Leaders
Jocelyn Clarke
Anne-Marie Comeau
Jeanne Alice Comeau
Drew Moore
Rebekah Streeter
Christiane Thériault
Lisa Thimot

Skippers Coordinator
Mary Dunn

General Duties Supervisor
—Civilian Volunteers
David Frid
Bill Rondolet

Civilian Stores Supervisor
Mike Dandurand
Randel Gray
Eric Journeay
Lynn Philpitt
Edward Scallion

Extra Voices
Steve Benton

Walter Borden
Rev. Robert Chapman
Brian Cuthbertson
Michael Fitzgerald
Costas Halavrezos
George W. Jordan
Bill Lord
Chris MacDonald
Maj Glen MacNeil
Edwin Millar
David Renton
Liz Rigney
Frank Stalley
Donald G. Tremaine

Tattoo 50/50 Draw
LCdr Al Turner

Tattoo Lounge Coordinators
John Harrison
Alec N. Simpson
Jim Trainor

Audience Survey Designers/Analysts
Dr. Helen Mallette
Dr. Norman McGuinness

Tattoo Physicians
Dr. William Acker
Dr. Graeme Bethune
Dr. Peter C. Gordon
Dr. Rex Langdon
Dr. Judy Mader
Dr. Maureen White

Tattoo Chaplain
Rev. Robert Chapman

Tattoo Veterinarian
Dr. Paul Kendall

Tattoo Mascot
A.J. Harley

Television Production
Citadel Productions Ltd.
Eastlink Community Television
Global
MITV

Photographers
Julian Beveridge
Nora Blansett
Bob Brooks
Michael Coghill
Maurice Crosby
Marc D'Entremont
François Deschacht
Warren Gordon
Bob Gourlay
Cpl Mel Hayward
Cpl Jerry Kean

Pat Keough
Rosemary Keough
J.P. Lafleur
Doug Leahy
Ken Matheson
Sgt Ed Mullin
Norman Munroe
David Nichols (Prisma)
Doug O'Neill
MCpl Pesant
David Stewart
Maj George F. Tibbetts
James Whitehead
CF Photographic Unit (Ottawa)
Formation Imaging (MARLANT)
Nova Scotia Department of Tourism

Trade Centre Limited Presidents
and CEOs
Scott Ferguson
Fred R. MacGillivray

Halifax Metro Centre
Ken Carver, Box Office Manager
Colin Craig, Promotions Manager
Anita Creaser, Promotions
 Coordinator
Peggy Dooley, Box Office Manager
Cheryl Fader, Box Office Coordinator
Scott Ferguson, General Manger
Doug Hiltz, Pyrotechnics
Randy Johnson, Event Manager
Keith D. Lewis, General Manager
Ken May, Technical Services
David Mills, Electrician
Pat Murray, Box Office Manager
Linda Poulton, Assistant Box Office
 Manager
David C. Stevenson, Operations
 Manager
Darren Watt, Event Coordinator
Ralph Williams, Operations Manager

Tattoo Commanding Officers
Cdr D.C. Beresford-Green
Cdr Mike Burke
Capt (N) L.J. Cavan
Cdr Patrick Charlton
Cdr Mark Chupick
Cdr John A. Creber
Col David B. Ells
Col Bruce Gilchrist
Cdr Barry S. Munro
Cdr Simon Page
Cdr Jamie Tennant
Cdr G. R. Tweedie
Capt (N) Arthur L. Vey

Chief Petty Officers/Sergeants Major
MWO Tom Bellefontaine
CPO1 Craig B. Calvert
MWO C.A. Campbell

CPO2 M. Feltham
MWO Nash Harb
CPO1 Ray Lawrence
CWO D.G. Lemoine
CPO1 Fred McKee
CPO2 Chris Radimer
CPO2 Percy Rasmussen
MWO B.W. Tanner

Senior Staff Officers
Maj R.R.F. Burns
SLt J.H. Chase
LCdr Graham Collins
Lt(N) Jim Forde
LCdr Greg Gillis
Lt (N) R.D. Leyte
Maj Willard MacNeil
LCdr J.B. Sparrow

Administration Coordinator
Connie A. Matheson

Support Coordinators
Maj K. Bourgeau
Capt G.F. Coady
WO E.A. Dunfield
Capt K. Gingell (Assistant)
Capt Peter Goldie
Lt H.A. Higgins (Assistant)
PO1 John Lothian
SLt A.B. Patterson
LCdr. J.B. Sparrow
Maj John R. Strong

Administration and Logistics Coordinators
Lt (N) Tracey Barlow
LCdr D.S. Chandler
Capt G.F. Coady
Maj L.G. Del Villano
A. John Lothian
Lt Kim MacNeil
Maj Willard R. MacNeil
Lt (N) Michelle McNichol
LCol D.R.B. Rogers
Maj J.H. Trethewey
Maj K. Whitehead

Chief Clerks
Cpl D.J. Alberta
CPO1 M.C. Anderson
WO K.J. Bakes
MS S.A. Butler (Assistant)
MWO B.C. Campbell
Sgt O.F. Cleary
CPO2 Stan Gilles
WO Angela Moffatt
PO2 H.M. Oake
Cpl S.L. Weatherton

Finance Coordinators
PO1 Sheila Baker-Ross

Lt (N) Tracey Barlow
MWO Jim Campbell
CPO1 Bill Levack
PO1 Roger Tymchuk (Assistant)

Production Liaison
Cdr (Ret'd) Pat Charlton

Protocol Officers
Maj Robert Burns
Capt J.E. Dunn
LCdr A.J.W. Holmes
Capt S.J. Jenkins
LCdr Rollie Leyte
Chief Supt (Ret'd) W. B. Vye
OCdt R.F. Wight
Shantell Wile

MARLANT Coordinators (Navy)
CPO2 Jack Morgan
PO Ted Mutch
LCdr Peter Townsend

LFAA Liaison Staff
Maj C. Flood
LCol D. Nauss

Army Coordinators
Capt Erica Fleck
Maj Joe Gillis
WO Kip Hannigan
Capt Rob Johnson
Maj Glen MacNeil
Capt John F. Mahon
Lt Sean Parsons
Capt W.A. Sweet
Capt John Todd

Air Force Coordinators
MWO T.E. Bellefontaine
MWO K.P. Connors
Capt Michel Desroisiers
Maj Don Feltmate
MWO Dwayne Gemmell
MWO Terry Leslie
Capt Chris Muise
Capt D.W.J. Robinson
Capt Chris Semeniuk
Maj David Wells

33 Brigade Group Commander
Col J.E. Scagnetti

Ceremonial Guard Commanding Officer
Maj B.T. Hynes

36 Brigade Group Coordinators
Capt Jim Molloy
Capt G.R. Starkey

36 Brigade Group Warrant Officers

WO D.K. Hannigan
WO Bert Hiscock
WO D. Warrington

Militia/Reserve Coordinator
Maj Tom Howland

Pit Band Directors of Music
LCdr Gaetan Bouchard (Stadacona Band)
Capt Don Embree (RCR Band)
Lt (N) Jim Forde (Stadacona Band)
Lt (N) Ron McCallum (Stadacona Band)
Lt (N) Hugh McCullough (Stadacona Band)
Lt (N) George Morrison (Stadacona Band)
LCdr Ray Murray (Stadacona Band)
Lt (N) B. Tempelaars (Stadacona Band)
LCdr Peter van der Horden (Stadacona Band)

National Band of the Naval Reserve Directors of Music
Lt (N) Francois Ferland
LCdr Alexandra Kovacs-Ada
Cdr J.F. McGuire
Lt (N) Jack T'manntje

Land Force Atlantic Area Band Directors of Music
Capt Mike Chalmers
Capt William F. Eberts
Capt Patrick Forde
Capt David Jackson
Maj Gerry S. Pheby

Band of the Ceremonial Guard Directors of Music
Capt Scott W. Attridge
Capt Jacques Destrempes
Capt Brian Greenwood
Capt Ray Murray
Lt Christian Richer

Liaison and Special Project Coordinators
LCol Ernie Beno
George Borden
Mick Hanlon (Assistant)
John MacNeil
LCol Bob McLean

Cadet Coordinators
Capt S.L. Cater
Maj P.A. Chatterton
LCdr Ray Halliday
Capt Blair Hawco
Maj E.C. Lantz
SLt E.A. Lindsay

Capt J.E Orr

Orderly Room
WO K.J. Bakes
Cpl D.E. Bazinet
LS D. Holt
LS S.E. Hunter
Sgt K.J. MacDonald
PO2 R.A. Smith

Computer Programmers
LCdr A.D. Gorman
Leonard Landry

Graphic Artist
WO Owen Kingwell

Military Stores
Cpl R.V. Bolger
MCpl M.A. Brooks
LS L. Clifford
Capt K.W. Elloway
MWO R.L. Gracie
MCpl Robert Hendsbee
PO2 P. Horne
Cpl S.R. Lafleur
MS Krista L. Langille
GNR Alexandra Lothian
Cpl J.P. MacIsaac
PO2 B.M. Marsh
Cpl J.A. Matheson
MS D.M. Monk
LS Ryan Moores
MS W. Oldford
MS Justin Pare
Pte G.J. Walker
MCpl G.F. Walsh
LS W.E. West

Food Service Coordinators
SLt T. Helm
Lt Mario Hubert

Medical Coordinators
Sgt M. L. Devine
Sgt D.G. Godin
Sgt Barry Grahlman
WO D.E. Libby
CPO2 Christiane Lonergan
MCpl Kim Pitre
33 (Halifax) Medical Platoon

Transport Supervisors
MCpl L. Brown
Sgt O.C. Burton
Sgt J.J.L. Dionne
MCpl Joe Godbout
Sgt H.A. Greer
Sgt Grant Grills
Sgt T.B. Hutchinson
MCpl C.P. Kennedy
Sgt J. Kozeil

Sgt W.L. Lloyd
Cpl Peter Marwick
MCpl Gilles Sanschagrin
Sgt G.E. Sherritt
Sgt E.W. Vallis

Security Coordinators
Sgt K.R. Briggs
Sgt J. Devries
Sgt D.E. Galloway
MCpl F. Hallett
Sgt J.A. Leclerc
MCpl G. Martin
Sgt D.Y. Pelletier
PO2 I.R. Rice
Sgt O.L. Richard

Liaison Officers
Lt (N) M.J. Alexander
CPO Serge Becelaere (Belgian Navy)
PO2 Ralph Beckerschoff
SLt A.P. Bedard
LS T.R. Bourgoin
CWO P.J. Buiteman
Lt G. Caladrino (U.S. Navy)
WO J.F. Cameron
SLt A.M. Chang
Capt M.A. Chisholm
Seung Hyuk Choi
Dae-Jin Chun
CPO2 Perry Colley
Lt (N) H.P. Collins
Lydin Daly
Lt (N) Marc De Carufel
Vincent De Cramer
Francois Deschacht
Cdr (Ret'd) Mike Duncan
Lt (N) P.M. Egener
CPO Rudy Eneman (Belgian Navy)
Lt (N) R.D. Espey
Fernando Fernandez
Lt Kimberley Gingell
MS M. Grant
WO Jean-Marc Grenier
Geon Soon Han
Brian Hanley
PO2 Susan Hayes
CPO1 Noël Henri (Belgian Navy)
Capt Willard Hinkley
PO1 Al Hirtle
PO1 A.E. Hone
Lt (N) Roman Husiuk
Lt (N) John Hutchinson
Capt Lloyd Jackson
Sgt G.G. Jensen
Lt (N) Tammy Joudrey
Lt (N) A.C. Kados
PO1 Stefan Karsch
Lt (N) Gregg Kerr
Kyung-Oh Ko
Natalya Koutovenko
Lt (N) Christian Kowalski

Capt J.P. Lafleur
LS S.R. Legault
Judith Lothian
Lt (N) Aaron Malek
LS Oleg Mamontov
PO1 R.E. Martin
PO1 J.E. Matheson
Poul Mathieson
PO2 Andres C. Mazurimm
Eddi Melka
Gail Melvin
LCdr P.G. Miller (U.S. Navy)
Capt Gerd Moritz
PO1 E.P. Muehleisen
Lt(N) S.E. Nelson
Capt Terry Otsuji
Dr. Felix Park
Jaqueline Park
Cst. A. Pattison
Lt (N) (Ret'd) Paul Phillips
Tiit Rammo
Elsbeth Reid
Maj F. Rhese
Lt (N) K. Riebe
Gordie Rowe
Lt (N) Johannes Sauerteig
SLt M.J. Schultz
MS P.H. Sellhorn
MS N.H.Sigrist
MWO F. Stubbert
Lt (N) S.W.D. Swan
Capt Ward A. Sweet
Lt (N) D. Taylor
LCdr M. Taylor (Russian Ships Visit)
Lt (N) B. Traenor
PO1 Bill Uhrig
Ian Urquhart
Joseph Wallin
LS Frank Wanke
Lt (N) M.B. Watson
Lt (N) D.L. Wells
WO H. Wesenberg
Guthrie Woods
Lt (N) Gregory Zuliani

Fight Choreographer
Robert Seale

Military General Duties Supervisors
LS Wayne Boone
MS A.J. Gaudet
LS S.J. Locke
Sgt D.J. Meldrum

Hull Technicians/Carpenters
D. Barrett
PO2 J.R.Y. Bouthat
LS Terry Connors
LS C.C. Cummings
LS T.M. Deazley
LS F.C.P. Frenette
AB P.D.V. Gerroir (Assistant)

MCpl J.S. Green
Cpl F.J.P. Hétu
PO1 J. Jackson
PO2 L.M. Keizer
MS E.L. Kellner
MS Lloyd Kerslake
Cpl J.F. Lassard (Assistant)
MS J.E. Mason
PO1 P. Russell
PO1 Trevor Spring
MS B.E. Woods
Sgt P. Woodward

Safety Officers
Lt (N) D. Anderson
Sgt B. Archambault (Assistant)
Peter Beech
Lt (N) D.B. Collins
CPO2 Denis Descoteaux
SLt P.S. Duke
PO1 P.M. Harrod
PO1 T.R. Johnson
PO1 L. Legaarden
PO1 John Matheson
PO2 K.C.S. Melchior (Assistant)
Lt (N) Gary Reid
Lt (N) D.W. Rutherford
PO1 J.F. Sheppard
OTMC L.R. Vargas (U.S. Navy)

MS L.R. Waye

Public Affairs Coordinator
Jeri Grychowski
Lt Ron Kronstein
Lt (N) S.M. Stefko

Accommodations Supervisors
CPO2 B.J. Amirault
MS J.M.C. Bergeron
PO2 M. Breault
LS G.R. Harris
PO2 W.H. Hutching
LS D.G. MacMullin
LS A.R. McDow
Sgt A.M. Richard
PO1 (Ret'd) A.J. Simpson
LS J.G.D. Villeneuve

Military Stores Driver
LS C.D. Broyden

DND Customs Brokers
WO Don Forbes
Mike Smith

RCMP Coordinators
Supt C.A.J. Bungay
Insp Joanne Crampton

Insp J.P. Curly
Insp Wayne Jacquard
Insp Keith Sherwood
Chief Supt W.B. Vye

RCMP Instructors/Trainers
SM Robert Gallup
Cpl Brian McCarthy
Sgt Garth Patterson
Cpl Bill Price
SM Debbie Reitenbach

We pay tribute to all who have played a part in the production of the Royal Nova Scotia International Tattoo over the past thirty years. The names of literally hundreds of participants may be unknown and could not be included here — thank you all!

Many people have performed multiple roles in the Tattoo since its inception and a number are only listed in their most recent position.

Special thanks to Capt Ian Briggs, RCA, and Charlie Johnson, RHC.

Eero Druus from Estonia

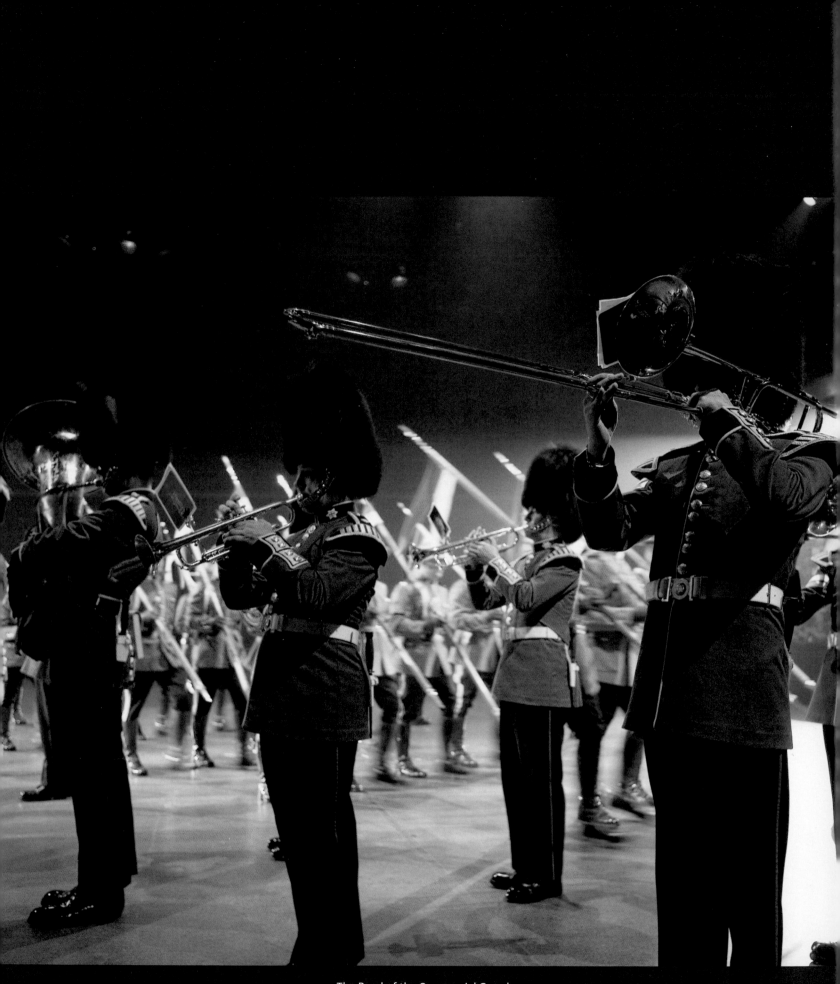

The Band of the Ceremonial Guard

TATTOO
Performers, 1979-2009

GROUPS

1st Battalion, Nova Scotia Highlanders (North)

1st Battalion, Nova Scotia Highlanders Pipes and Drums

2nd Battalion, Nova Scotia Highlanders (Cape Breton)

2nd Battalion, The Royal Canadian Regiment

2nd Battalion, The Royal Canadian Regiment Pipes and Drums

12 (Nova Scotia) Field Squadron Royal Engineers

12 Wing Shearwater

12 Wing Shearwater Pipes & Drums

14 Airfield Engineering Squadron

14 Wing Greenwood

14 Wing Greenwood Pipes & Drums

16 Wing Borden

33 Service Battalion Pipes and Drums, Halifax, Nova Scotia

36th Canadian Brigade Group

48th Highlanders of Canada Pipes and Drums

78th Highlanders

78th Highlanders Ross Shire Buffs

84th Regiment of Foot (Royal Highland Emigrants)

428 Tactical Helicopter Squadron Band, St-Hubert, Quebec

Aberdeen Universities Officer Training Corps Drums & Pipes, United Kingdom

Afro Jambo Acrobats, Kenya

Air Command Band, Winnipeg, Manitoba

Air Command Pipes and Drums

Air Command Precision Drill Team

American All Star Dancers, Texas

Amethyst Dancers, Nova Scotia

Army Gun Race

Atlantic Region Tri-Service Cadet Brass Reed Band

Atlantic Region Tri-Service Cadet Pipes and Drums

Atlantic Swells, Halifax, Nova Scotia

Atlantica Gymnasts, Nova Scotia

Australian Army Band, Brisbane

Bagad de Lann Bihoué, Brittany France

Balmoral Girls Pipe Band, Stellarton, Nova Scotia

Band of 1 Canadian Air Division, Winnipeg, Manitoba

Band of 51 Highland Brigade, United Kingdom

Band of Her Majesty's Royal Marines, United Kingdom

Band of the 1st Airborne Division, Stuttgart, Germany

Band of the 1st Mountain Division, Garmisch-Partenkirchen, Germany

Band of the 3rd Armoured Division, Lüneburg, Germany

Band of the 10th Armoured Division, Ulm, Germany

Band of the 12th Armoured Division, Veitscöchheim, Germany

Band of the Ceremonial Guard, Ottawa, Ontario

Band of the Governor General's Foot Guards, Ottawa, Ontario

Band of the Royal Air Force Regiment, United Kingdom

Band of the Royal Netherlands Air Force, The Netherlands

Barbershop 8, Halifax, Nova Scotia

Bedford Skippers Gymnastics Team

Bermuda Islands Pipe Band

Bermuda Regiment

Blue Hackle Pipe Band, Amherst, Nova Scotia

Blue Thunder (Halifax and Dartmouth Police)

Bluenose Jugglers, Nova Scotia

Bremerhaven Dancers, Germany

Brigade de Sapeurs-Pompiers de Paris, France

Bugle Corps of The Royal Band of the Belgian Guides

Bugle Platoon of the 3rd Battalion The Light Infantry, United Kingdom

C.B. Hoare Pipe Band, Sydney, Nova Scotia

Cadets de Genève, Geneva, Switzerland

Calgary Fiddlers, Calgary, Alberta

Calgary Highlanders, Calgary, Alberta

Calgary Police Service Pipe Band, Calgary, Alberta

Calgary Stampede Showband, Calgary, Alberta

Canadian Airborne Regiment

Canadian Forces Base Borden Pipes and Drums, Borden, Ontario

Canadian Forces EME Jeep Display Team, Borden, Ontario

Canadian Forces Fleet School (Atlantic)

Canadian Forces Music Detachment Pipes and Drums, Borden, Ontario

Canadian Forces Recruit School, Cornwallis, Nova Scotia

Canadian Forces School of Music

Canadian Forces Vimy Band, Kingston, Ontario

Canadian Naval Boarding Party

Cape Breton Fiddlers, Nova Scotia

Cavalier Skippers, Nova Scotia

Ceilidh Pipe Band, New Glasgow, Nova Scotia

Celtic Isle Dance Company, Ireland

Central Band of the Canadian Forces, Ottawa, Ontario

Central Band of the Japan Air Self Defense Force, Japan

Central Band of the Swedish Army, Sweden

Ciosmul Dancers, Barra, United Kingdom

Circus Circle, Kentville, Nova Scotia

City of Invercargill Caledonian Pipe Band, New Zealand

City of Lakes Chorus, Dartmouth, Nova Scotia

Clan MacFarlane Pipe Band, St. Catharines, Ontario

Club Piruett, Estonia

Cobequid Spartans

Colchester Legion Pipe Band, Colchester, Nova Scotia

Commissioner's Own Ontario Provincial Police Pipes and Drums

Continuity Drill Team of The Ceremonial Guard, Ottawa, Ontario

Copenhagen Police Band, Denmark

Côr Meibion Morlais, South Wales, United Kingdom

Corps of Drums of the 1st Battalion, The Royal Canadian Regiment

D'Holmikers Comedy Gymnastics Team, Switzerland

Dalhousie Boys Gym Club

Dalhousie Gym Club

Dance Troop "Jeans," The Netherlands

Dartmouth Boys Pipes and Drums, Dartmouth, Nova Scotia

Dartmouth Legion Pipe Band, Dartmouth, Nova Scotia

Dartmouth Titans, Dartmouth, Nova Scotia

Delta Police Pipe Band, Delta, British Columbia

Drill Team of the 3rd Company of the Federal Ministry of Defence's Guard Battalion, Seigburg, Germany

Drill Team of the 5th Company of the Federal Ministry of Defence's Guard Battalion, Berlin, Germany

Dukes of Kent, Kentville, Nova Scotia

Dunvegan Girls Pipe Band, Westville, Nova Scotia

Dutch Show and Marching Band "Door Vriendshap Sterk," Katwijk, The Netherlands

Edinburgh Tattoo Ceilidh Dancers, United Kingdom

Electrical and Mechanical Engineers from 3ASG Gagetown, New Brunswick

Euroband, Rotterdam, The Netherlands

Fanfarekorps Koninklijke Landmacht

Flygrossing Team, Estonia

Flying Danish Superkids, Aarhus, Denmark

Flying Grandpas, Hamburg, Germany

Flying Saxons, Zwickau, Germany

Flying Stevens, Sweden

Fraser Holmes Memorial Ladies Pipe Band

Fredericton Society of St. Andrews

Pipe Band, Fredericton, New Brunswick

FUNKtion, Halifax, Nova Scotia

German Rock 'n' Roll Acrobatic Dancers

Ginásio Clube Português, Lisbon, Portugal Gospel Heirs

Gym Wheel Team Taunusstein, Germany

Gymnastic Club of Mels, Parallel Bar Team, Switzerland

Halifax City Gymnastics Club, Halifax, Nova Scotia

Halifax Police Association Pipes and Drums, Halifax, Nova Scotia

Halifax Tumblebugs, Halifax, Nova Scotia

Hamburg Police Dog Team, Hamburg, Germany

Hants East Gym Club, Nova Scotia

Heeresmusikkorps 1, Hanover, Germany

Heeresmusikkorps 4, Regensburg, Germany

Heeresmusikkorps 7, Düsseldorf, Germany

Heeresmusikkorps 9, Stuttgart, Germany

Heeresmusikkorps 10, Ulm, Germany

Heeresmusikkorps 100, Münster, Germany

Heeresmusikkorps 300, Koblenz, Germany

Highland and Scottish Country Dancers

Highland Band of the Royal Regiment of Scotland, United Kingdom

Highland Society of Antigonish Gaelic Choir, Antigonish, Nova Scotia

Highland Village Pipe Band, Iona, Nova Scotia

His Majesty The King's Guards' Band and Drill Team, Oslo, Norway

HMCS *Athabaskan*

HMCS *Charlottetown*

HMCS *Halifax*

HMCS *Preserver*

HMCS *Ville de Québec*

Imps Motorcycle Display Team, London, United Kingdom

Infantry Section, 2nd Battalion The Royal Canadian Regiment

International Taekwondo Mission Display Team, Republic of Korea

Japan Training Squadron Band

Jürgen Baumgarten, Germany

Juliana Bicycle Team, The Netherlands

La Baie en Joie, La Baie Sainte-Marie, Nova Scotia

Land Force Atlantic Area Army Band

Langley Ukulele Ensemble, Langley, British Columbia

Light Infantry Corunna Band, United Kingdom

Lochiel Champion Drill Team, New Zealand

London Irish Rifles Regimental Association Pipes and Drums, United Kingdom

Lord Strathcona's Horse (Royal Canadians) Ceremonial Mounted Troop, Edmonton, Alberta

Lord Strathcona's Horse (Royal Canadians) Pipes and Drums, Edmonton, Alberta

Lothian and Borders Police Pipe Band, Edinburgh, United Kingdom

Luftwaffenmusikkorps 1, Munich, Germany

Luftwaffenmusikkorps 2, Karlsruhe, Germany

Luftwaffenmusikkorps 3, Münster, Germany

Luftwaffenmusikkorps 4, Berlin, Germany

MacDougall Girls Pipe Band, Glace Bay, Nova Scotia

MacNaughton's Vale of Atholl Junior Pipe Band, United Kingdom

Malmo Girls, Malmo, Sweden

Marinemusikkorps Nordsee, Wilhelmshaven, Germany

Marinemusikkorps Ostsee, Kiel, Germany

Maritime Forces Atlantic Gun Run Display Team

Maritime Forces Atlantic Naval Display

Men of the Deeps

Metropolitan Toronto Police Pipes and Drums, Toronto, Ontario

Middlesex County Volunteers Fifes & Drums, Boston, Massachusetts

Milling Frolic and Step Dancers

Motorcycle Display Team of the Berlin Police Force, Germany

Motorcycle Display Team of the Hamburg Police, Germany

National Band of the Naval Reserve

National Ceremonial Troop of the Royal Canadian Mounted Police

Naval Display Team of Maritime Forces Atlantic

North Irish Territorial Army Band, United Kingdom

North Preston Ancestral Community Choir

Nova Scotia Highlanders Combined Pipes and Drums

Nova Scotia Tri-Service Cadet Display Team

Novatones, Truro, Nova Scotia

Old Guard Fife and Drum Corps, Washington, DC

Orchestra of The Estonian Defence
 Forces
Ozscot Dancers, Australia
Parc & Dare Band, South Wales,
 United Kingdom
Paris Police Gymnastic Team, France
Pipes and Drums of 152 (U) Transport
 Regiment RLC (V), United
 Kingdom
Pipes and Drums of the 2nd Battalion,
 The Royal Canadian Regiment
Pipes and Drums of the 7th Battalion
 The Royal Regiment of Scotland,
 United Kingdom
Pipes and Drums of the 51st Highland
 Regiment
Pipes and Drums of the Black Watch
 (RCR) of Canada
Pipes and Drums of the Edinburgh
 Universities Officer Training Corps,
 United Kingdom
Pipeworkz, New Zealand
Polska-Lechowia Polish Canadian Folk
 Dance Company, Toronto, Ontario
Pomorze Polish Dancer Ensemble,
 Halifax, Nova Scotia
Princess Louise Fusiliers, Halifax,
 Nova Scotia
Princess Patricia's Canadian Light
 Infantry Band, Calgary, Alberta
Princess Patricia's Canadian Light
 Infantry Regimental Drum Line,
 Calgary, Alberta
Principal Band of the French Foreign
 Legion, France
Privateersmen, Liverpool, Nova Scotia
Quantico Band of the United States
 Marine Corps, Quantico, Virginia
Queen Victoria School Pipes, Drums
 and Dancers, United Kingdom
Queen's Colour Squadron of The
 Royal Air Force, United Kingdom
Queen's Gurkha Engineers Pipes and
 Drums, United Kingdom
Queen's Own Cameron Highlanders
 Pipes and Drums
Queen's University Officer Training
 Corps Dancers, United Kingdom
Rec N Crew, Halifax, Nova Scotia
Regimental Band and Corps of
 Drums of the Royal Welsh, United
 Kingdom
Rent a Sportstar Showteam, Frankfurt,
 Germany
Rhythm Project, Norfolk, Virginia
Royal Air Force of Oman Band, Pipes
 and Dancers
Royal Artillery Animation Unit
Royal Australian Navy Physical
 Training Display Team
Royal Band of the Belgian Air Force,
 Brussels, Belgium

Royal Canadian Air Cadet Squadrons,
 Nova Scotia
Royal Canadian Army Cadet Corps,
 Nova Scotia
Royal Canadian Artillery Band,
 Montreal, Quebec
Royal Canadian Mounted Police
Royal Canadian Mounted Police Dog
 Display Team
Royal Canadian Mounted Police Pipes
 and Drums
Royal Canadian Regiment Band
Royal Canadian Sea Cadet Corps,
 Nova Scotia
Royal Fire Brigade Band, Malmo,
 Sweden
Royal Military College of Canada
Royal Nova Scotia International
 Tattoo/Black Watch Association
 Pipes and Drums
Russian Army Paratroopers Song and
 Dance Ensemble
Russian Cossack State Dance Company
Sackville Taisos
Scotia Legion Pipe Band, Halifax,
 Nova Scotia
Scots College Pipes and Drums,
 Sydney, Australia
Show Boxtramp, Germany
Sizzle, Halifax, Nova Scotia
Soldier's Obstacle Race
Song and Dance Ensemble of the
 Northern Fleet of the Russian
 Federation
Sons of the Sea, Lunenburg, Nova
 Scotia
South Shore Kippers, Nova Scotia
Souwesters, Yarmouth, Nova Scotia
Sprigs of Heather Pipe Band, North
 Sydney, Nova Scotia
St. Keverne Village Youth Brass Band,
 United Kingdom
Stadacona Band of Maritime Forces
 Atlantic
STV Wettingen, Switzerland
Tattoo Barbershoppe's Chorus
Tattoo Children's Chorus
Tattoo Choir
Tattoo Dancers
Tattoo Fanfare Trumpets
Tattoo Gymnasts
Tattoo Junior Dancers
Titans Gymnastics Club, Dartmouth,
 Nova Scotia
Top Secret Flying Drumsticks,
 Switzerland
Toronto Scottish Regiment Pipes and
 Drums
Traditional Dancers from the Korean
 Institute of Missionary Arts,
 Republic of Korea

Trick Factory, Estonia
Trinidad and Tobago Defence Force
 Steel Orchestra
Trompetterkorps Bereden Wapens
 (Band of the Mounted Arms), The
 Netherlands
Trompetterkorps der Koninklijke
 Marechaussee, The Netherlands
Truro Flyers
United States Army Drill Team,
 Washington, DC
United States Army Herald Trumpets,
 Washington, DC
United States Atlantic Fleet Band,
 Norfolk, Virginia
United States Continental Army Band,
 Norfolk, Virginia
United States Navy Band "Country
 Current," Washington, DC
VanGorder Illusionists
Wehrbereichsmusikkorps 1,
 Neubrandenburg, Germany
West Nova Scotia Regiment,
 Aldershot, Nova Scotia
Woods Manufacturing Company Brass
 Band, Stittsville, Ontario
Wylde Thyme Pipes and Drums,
 Halifax, Nova Scotia
Youth Singers of Calgary, Calgary,
 Alberta

INDIVIDUAL PERFORMERS
Lone Pipers
Capt Fred Alderman
PM Seann Alderman
PM Katherine Buckland
Capt Donald Carrigan
General A.J.G.D. de Chastelain
CWO Sandy Dewar
Sergeant Jeff Donnolly
Capt Jermaine Downey
WO Bryan Duguid
WO Ian Ferguson
CWO Bill Gilmour
Capt Andrew Kerr
Cpl Curtis Leblanc
Jack MacIsaac
Capt Douglas Moulton
PM Malcolm Odell
PM Scott Pollon
PM Dan Smith
PM Bruce Topp
PM Chris Yeo

Featured Vocal and
 Instrumental Soloists
PO2 Aldwin Albino
Buffy Andrews (Fiddle)
Allison Bent
Roselle Billy (France)
Janine Blanchard

Steven Booth (Baritone Horn, United Kingdom)
Measha Bruggergosman
Cpl Keith Brumwell
Willy Cochrane (Dewars Piper)
Brenna Conrad
Diane Covey
Jason Davis
Joe Donahue
Charlotte Dort
Sandra Forrest (Clarsach)
Earl Fralick (Piano)
Tara Gibson
Jane Godley
Helen Goodwin-Price
Cpl Rebecca Hiltz LeBlanc
MSgt Hokazono (Euphonium, Japan)
Andrea Jeffrey
Anita Lathigee
Nancy MacCready
Cassie Anne MacDonald (Fiddle)
Maggie Jane MacDonald (Piano)
Alan Manchester
LCpl Nicola Maynes (Fiddle)

Derrick Paul Miller
Nicholas Miller
Laura Newton
Ruth Phillips
MU2 Inge Preuss (U.S. Navy)
Leah Randell
Liz Rigney
Barbara Rushton
Gregory Servant
Kathryn Servant
Kjersti Wiik (Norway)
PO2 Raef Wilson (Trumpet and Vocal)

Guest Conductors
Capt Graeme Abernethy, United Kingdom
Cdr Michael Alverson, U.S. Navy
LCol J.J.D. Bouchard, Canadian Forces Supervisor of Music
LCol G.W. Klaassen, Canadian Forces Supervisor of Music
Cdr G.L. Morrison, Canadian Forces Supervisor of Music

Oberstleutnant Kurt Ringelmann, Germany
Oberstleutnant Dr. Michael Schramm, Germany
Fregattenkapitän Horst Wenzel, Germany

Acrobat
Anaïs Guimond

Gym Wheel Performers
Wolfgang Bientzle
Julius Petri

Juggling Coordinators/Magician
Carol Baker
Joe Baker
Michael Hirschbach
Jason Neary

Pogo Performer
Daniel Mahoney

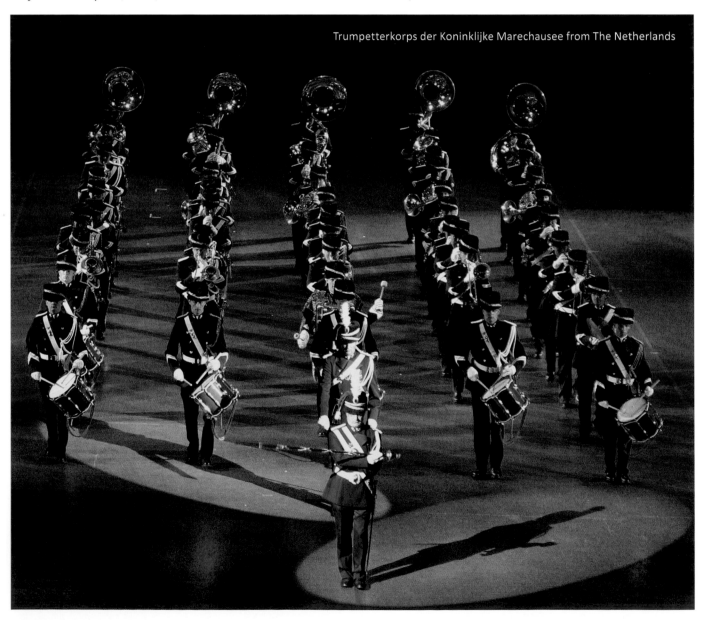

Trumpetterkorps der Koninklijke Marechausee from The Netherlands

INDEX

For a list of the Royal Nova Scotia International Tattoo Society, please see page 171.
For a list of the Nova Scotia International Tattoo Foundation, please see page 173.
For a list of Tattoo Staff and Crew, please see pages 175 to 183.
For a list of Tattoo Performers, please see pages 185 to 188.